Centre for Business, Arts &Technology
444 Camden Road
London N7 0SP
020 7700 8642
LibraryCBAT@candi.ac.uk

CITY AND ISLINGTON
COLLEGE

This book is due for return on or before the date stamped below. You may renew by telephone. Please quote the barcode number or your student number. This item may not be renewed if required by another user.

Fine : 10p per day

1 WEEK LOAN

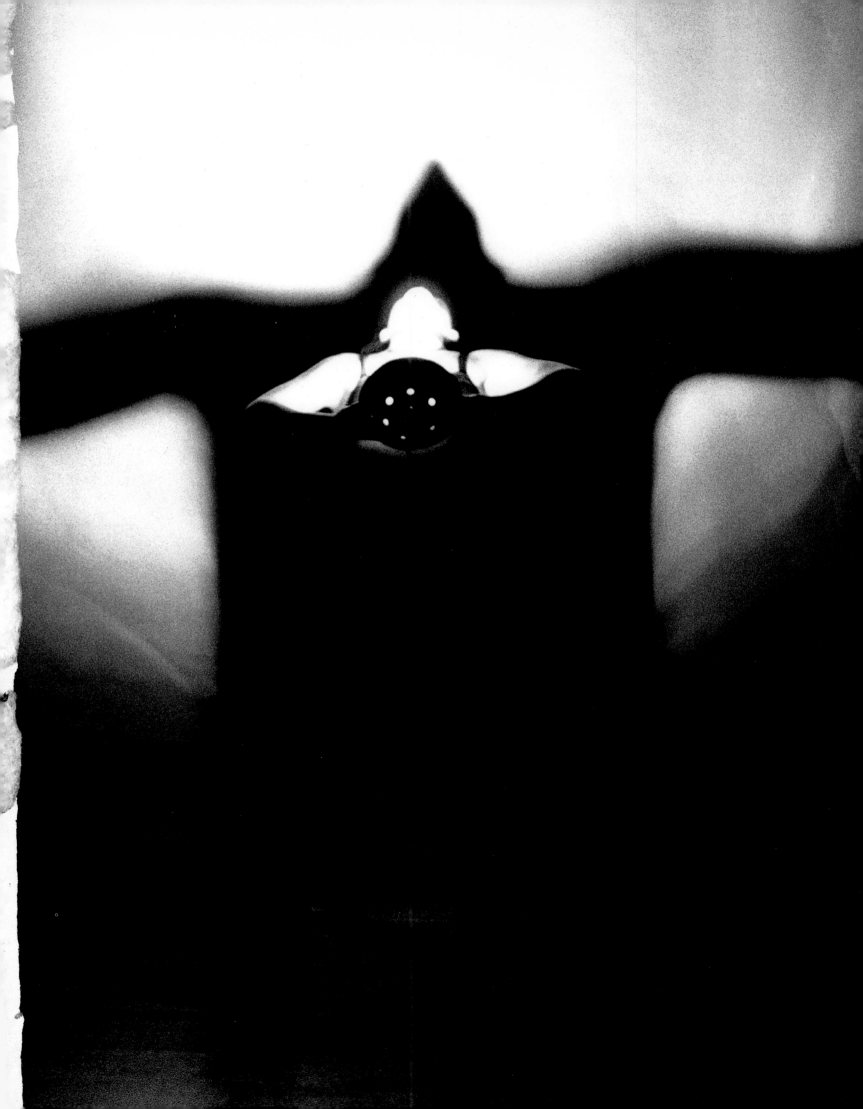

CAUGHT IN THE ACT

A LOOK AT CONTEMPORARY MULTIMEDIA PERFORMANCE

PHOTOGRAPHS BY DONA ANN McADAMS

INTRODUCTION BY C. CARR / AFTERWORD BY EILEEN MYLES

APERTURE

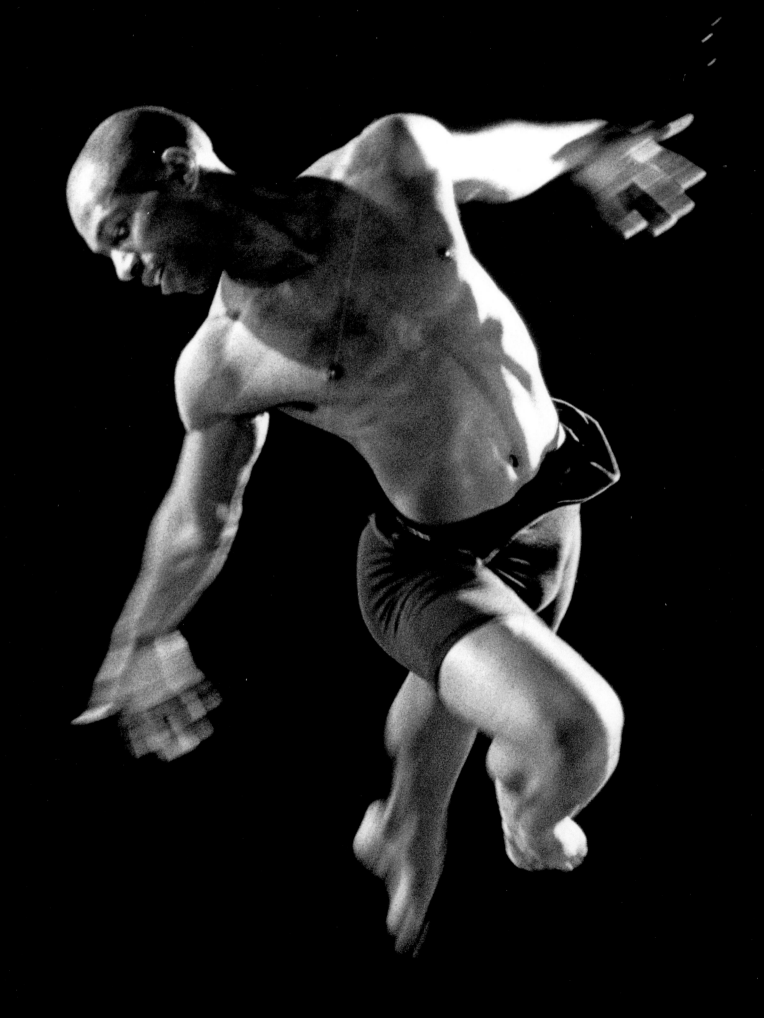

FOR VIOLET

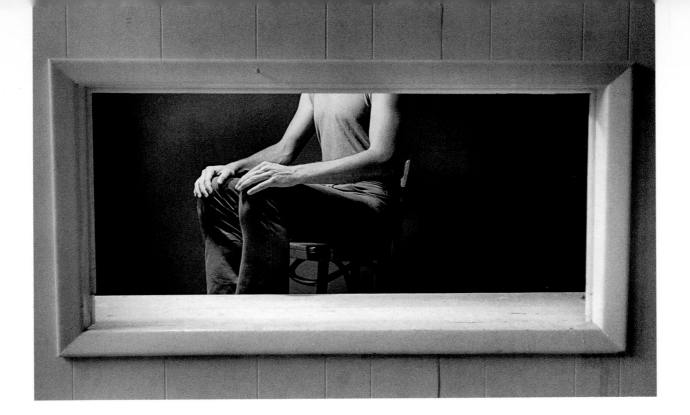

OUR GOLDEN AGE IN HELL — AND WHAT CAME AFTER BY C. CARR

Dona Ann McAdams began documenting performance artists in New York's East Village in 1983, and she has emerged with a singular record of life in the autonomous zone.

First she just photographed friends. Within a year, though, she'd become house photographer at P.S. 122, the newest art world venue for cutting-edge work. This was not exactly the photography career she'd set out to have. Nor did performance seem an artform destined for national notoriety. But then, life clearly *is* a John Cage piece—and so much about "chance operations."

When I first visited P.S. 122 with artist friends in the late seventies, it was not yet a "space," and we scavenged through abandoned classrooms full of discarded school supplies, old flash cards, battered books. Those were such innocent days. Community groups in the not-yet-gentrified East Village had invited artists to take the old classrooms as studios in order to keep the building occupied, and in 1979, performances began in what had once been the school gymnasium.

Tim Miller, who'd cofounded the space, used to do a new show there every Monday night back in 1980 and '81. I wasn't then writing about performance and wasn't taking notes, but I do recall a piece in which he danced with a little television tuned to prime time, and I remember in other weeks a certain obsession with Mayakovsky, and one show canceled "on account of insanity"—or so claimed the note that he'd posted on the door. Tim was experimenting. In fact, the whole neighborhood was experimenting, exploding, expressing, and neo-expressing.

We were about to enter our Golden Age in hell. When we thought that hell was Ronald Reagan's face.

By the early eighties, the art world was agog over something called East Village art, then on display in dozens of tiny storefront galleries. No accident that the first of them was named Fun. No matter that for every good gallery there were five (at least) stuffed with unspeakable neo-drek. The East Village was still juiced on that postpunk energy: anything goes; anyone can do it. And everyone was welcome at the nonstop art opening.

An even more festive ambiance ruled in the performance clubs where there was much less scrutiny from the art world and mainstream press. At first, anyway. Club 57 had opened in 1979 in the basement of a Polish church on St. Mark's Place. By mid 1983, that club was history. But under the direction of Ann Magnuson, this refuge for the unsuburban had created a style other neighborhood clubs would soon emulate. Much of the performance at Club 57 parodied pop culture. Their *Sound of Music* starred John Sex, for example. Other nights, club-goers screened bad and beloved old television shows or kitsch artifacts like *The Terror of Tiny Town* (an all-midget musical Western). Even the theme parties became performances; the "Twisting in High Society" evening, for example, meant that everyone came in formal attire and played Twister.

The playfulness, the love/hate relationship with popular entertainments, the broken barrier between audience and performer—all of this colored the East Village club scene for the couple of years in which it thrived (roughly 1983–85). Not that the Pyramid Club, 8BC, WOW Café, Limbo Lounge, Club Chandalier, and Darinka were all the same. No doubt the Pyramid had more drag, but every club had some drag. No doubt

8BC was the place for elaborate spectacles of quasi-Butoh, but it was also where Karen Finley hosted her own special version of *The Dating Game*. Outside the East Village, hot spots like Danceteria, Palladium, and the Cat Club also booked artists for short shows. But those shows were jobs and no place to fool around. Back in the neighborhood, the clubs were run *by* artists *for* artists. They'd been set up in basements and railroad flats and ex-bodegas, all within blocks of each other, and they created a feeling of community, a fragile ego-system that broke down once the tourists and trendies invaded.

During the heyday of club performance, denizens of the scene looked at the lowly P.S. 122 as though it were Lincoln Center. In the clubs, loud and fast ruled, audiences were half-smashed, shows usually started at least an hour after the posted time, and any critic present might spend that hour looking for a vantage point from which to see the stage. Meanwhile, P.S. 122 took reservations, had chairs for spectators, and wasn't about to start a show at two or three in the morning. It was the serious, "real" art world.

As the East Village clubs collapsed, mostly because of building-code violations and general burn-out, some performers worried about making the transition to that other world—which would soon be the only one left. By the fall of 1985, when 8BC closed, for example, Holly Hughes's hilarious lesbian soap-opera *The Well of Horniness* had had five one-night stands in five different East Village venues, none of them P.S. 122, and she worried: "There's something about my aesthetic that clashes with blond wood." Of course, she's been working at P.S. 122 ever since.

Artists did try to keep the club thing going, though. For several years in the late eighties, for example, Anne Iobst and Lucy Sexton, who perform together as DANCENOISE, curated shows at King Tut's Wah-Wah Hut on Avenue A. But even the Hut's tiny "stage"—actually a back-room alcove about as big as a dining-room table—seemed a reminder of what could never happen again. And P.S. 122 became more and more of a community center for performers as more and more of these fringe venues closed.

While P.S. 122 became home to all things experimental in performance art, dance, and music, a few artists became particularly identified with this space. Ethyl Eichelberger had once worked the Pyramid and Chandalier, and he'd really been Mr. (or Ms.) 8BC. But eventually, P.S. 122 became his one true home. For one thing, he always did a summer show in the smaller downstairs theater, when no one else would work in such a sweat-box. And Ethyl really worked, often playing several parts at a manic pace, make-up dripping. It was more than drag. He simply wanted to play all the great women—and then all the great men, doing all the great bits, with all the great emotions. He played Nefertiti, Jocasta, Clytemnestra, and their queenly ilk, and then Leer (his King Lear). These characters may have started in literature or history, but they landed in an Ethyl show by way of some nineteenth-century chautauqua company and the Ridiculous Theater. His *Leer* reshaped Shakespeare's tragedy right down to its name, stripping away most of the characters and all of the Bard's immortal words while adding vaudeville, psychodrama, allusions both literary and local (the drug dealers down the street), and of course the usual Ethyl-tunes.

The joy and the dread of performance art is that you can never know what to expect. It's an uncodified form that may bring together many genres, or may describe what falls in the cracks between them. So you enter the carnival and cope with the beasts. I began covering this artform in the mid eighties, for what turned out to be a rich period in its history (and I mean in every way but financial). After the clubs collapsed, after WOW Café moved and became a regular theater, I was reminiscing one night with a WOW regular about Variety Nights at the old Café. And I think her comment sums up the pleasures of that Golden Age: the regular told me that one of those old Variety shows had been so perfect, "I could have died that night and been happy for the rest of my life."

Looking through an old binder at the notes I obsessively typed up after every show I saw between 1985 and early '87, I keep wondering how to summarize the wonders for those who were not there. I could talk about Pat Oleszko's typically amazing costumes for *Where Fools Russian* (at P.S. 122) but that wouldn't get the pre-show hubbub when hawkers milled through the audience offering "nice brown socks" ($1) and "nice novelty gifts" (French ticklers), while smoke and circus music and someone dressed as a table all wafted through the space. And how can I do justice now to *The Diary of a Somnambulist* (at Limbo), John Kelly's brilliant adaptation of *The Cabinet of Dr. Caligari*—the way the music became the narrative, the way Kelly seemed a menace, but ineffective as a menace, and how Huck Snyder built that warped world into his set. I even made drawings but they tell me nothing now. They're as cryptic as this observation written about one moment of a Jo Andres dance piece: "like the walk of a Dagwood without feet." Hmm. I'll never know. And I was the witness. But this is a form as fleeting as life.

Luckily, at many of these shows, I would arrive to find

Dona Ann McAdams sitting there—unobtrusive but front row center, making the pictures that are now all that's left from those times.

McAdams's photographs are more than a simple record, more than just a still from someone's show. Her photo of Karen Finley in *We Keep Our Victims Ready* actually captures something of the emotional force of Finley's piece. It reminds me of that old idea that photography is magic and feeds on someone's power.

From 1984 on, Dona photographed every piece done at P.S. 122 and for a couple of years in the late eighties, she also shot every show at WOW, while following certain artists, like Finley, wherever they happened to perform. The key to McAdams's work is the relationship she has with the artists. She empathizes. They trust. Finley, for example, has never allowed anyone else to photograph her in performance.

McAdams came to New York City in 1979, but she didn't then commit to life in this city. Born in Queens, raised on Long Island, she'd attended the San Francisco Art Institute to study photography. During her first stint back in New York, she lived in Williamsburg and got involved with the anti-nuke movement. After Three Mile Island, she went to Australia for about a year, documenting political work around the land rights of aborigines. Then, in 1980, she landed back in Manhattan in an apartment near the fledgling P.S. 122. Not that she ever went there in those days, but she had become friends with performance artist Beth Lapides and began to document her shows at other downtown venues.

McAdams had no reason to think she'd become known as a "performance photographer." In 1983, she began a project (still ongoing) called "The Garden of Eden," photos of people living with mental illness in a Coney Island facility. She'd been documenting gentrification in the East Village ("Alphabet City") ever since she got to the neighborhood. Similarly, her "Olympic City" portfolio recorded the old Barcelona neighborhoods that were knocked down to build the Olympic Village. Another focal point: ACT UP demos. She was gathering evidence of communities in transition, and couldn't have known how aptly that would describe the performance world she was about to enter.

Choreographer John Bernd brought McAdams to P.S. 122 for the first time in 1983. The two had met in a copy shop where McAdams worked and Bernd was a customer. He became the first artist she photographed at P.S. 122. In that picture, Bernd is partly visible through a narrow window, seated on the little red chair that he would use in each of his pieces. Soon, McAdams also met Tim Miller; she even performed with him in *Democracy in America*. ("Never again. Only for Tim.") And on it went. She'd found a community of like minds.

Her working relationship with Karen Finley illustrates the dynamic she developed with performers. It began when McAdams came to photograph Finley's first show at P.S. 122, a double bill she was sharing with her then-husband Brian Routh (Harry Kipper) in 1985. As Finley remembers the encounter, "I started yelling." She really didn't want to be photographed.

Finley's monologues expose unspeakable acts and unforgivable feelings, holding a mirror to what people try to hide. For these things, there are simply no polite words: rape, AIDS, incest. Finley has often been accused of obscenity. But she has no interest in four-letter words—only in the emotion propelling those words.

Thanks to her post-1990 notoriety, Finley is now very concerned with the ways in which this work can be misrepresented and sensationalized, but she's always been hypersensitive about what's happening in the audience. Finley performs in a concentrated state that is close to trancelike, and photographers destroy it. She says she can feel their presence near the stage. She especially hates flashes, hates hearing the shutter click, hates "watching someone watching."

When they first met, McAdams listened calmly to this list of complaints and convinced Finley that none of these things would happen. Finley remembered seeing McAdams at school in San Francisco; they'd attended the Art Institute at the same time, though they'd never been friends. She decided to take a chance. The results, as McAdams remembers it: "Karen said, 'Wow, you're really good. You didn't make noise. You didn't move around. You're not a jerk. You're not in my face.'"

McAdams never uses flash and shoots with a quiet Leica, and according to Finley, doesn't take too many photos during a show. Finley decided that she liked working with a woman, that men would try to make her work sexy. She also appreciates that she can say "no more pictures" from the stage, and the pictures will stop. "I learn something from seeing her work," says Finley, "because the image speaks to what the piece is about. It makes my work real."

Many performance artists want control over the images that represent them in the wider world. McAdams has no problem with this. She does not regard herself as a journalist but as a collaborator with the artists, and they always get their say. McAdams will go so far as to claim, with a gesture towards the photographs: "This is not my work."

Throughout the eighties, the powerful waged war on the marginal, and by the end of the decade, the same East Village streets where the clubgoers once made their rounds exhibited raw evidence of the crises in homelessness and the AIDS epidemic. Toxic conservatism was also corroding the art fringe.

The war on art began after the fall of communism, when the well-organized networks of the religious right needed a new enemy to mobilize against—and raise money on. In the art world, they found a rich motherlode of sin. The American Family Association, the Christian Coalition, and other right-wing groups began attacking the National Endowment for the Arts in 1989, first picking on visual artists Andres Serrano and Robert Mapplethorpe.

Then the target shifted to performance art—a form familiar to few and easy to ridicule, a form that isn't well-supported even in the art world. When N.E.A. chair John Frohnmayer decided to toss a few scapegoats to the right-wing frothers in the summer of 1990, he revoked the grants already awarded to performance artists Karen Finley, Holly Hughes, Tim Miller, and John Fleck. They became known as "The Defunded Four," and that year their lives changed forever. As Holly Hughes put it, "I went from being a political artist to being a political football."

McAdams's life changed as well. Not only did she have portfolios on each of these artists; she had photographed the specific performances singled out for censure. In Finley's case, she had the only pictures there were, and Finley had become an emblematic figure in the culture wars. About a month before the defunding, Evans and Novak had singled her out in their syndicated column and labeled her "the chocolate-smeared woman." Naturally, they had never seen Finley perform, but they happened to be referring to that soulful moment McAdams had captured in *We Keep Our Victims Ready.*

Suddenly the pictures had new significance—as evidence against the artist-outlaws. McAdams fielded phone calls from major news organizations all over the country, who asked, then harassed, then questioned her journalistic integrity when she refused to release what she calls "the chocolate shot." Finley did not want it distributed. In fact, McAdams refused to release any photos of the Four that they hadn't approved or that might add fuel to the right-wing fires. The Four had suddenly been catapulted out of their art-world home onto a national stage, where they faced an audience almost guaranteed to misunderstand and find them intolerable. Being responsible for this imagery weighed on McAdams. Eventually, the experience made her decide that it was time to leave the art world, time to get a Master's degree and a teaching job (currently at Rutgers), time to focus on documenting other embattled communities.

Meanwhile, the right wasn't going to settle for targeting just the Four when attacking artists won them both financial and political capital. They pounced on Annie Sprinkle, the porn-star-turned-performance-artist—an easy target who got even easier when they lied about her work. Writer/artist David Wojnarowicz actually took the American Family Association to court in 1990 over the way they'd misrepresented his work in one of their direct-mail fund-raising drives. That same year, Senator Jesse Helms directed the General Accounting Office to investigate Finley and three other artists—Johanna Went, Cheri Gaulke, and Frank Moore—for performances done and funding received dating back to 1984. Never had this art-form had so much scrutiny from so many.

Many of the targeted artists were either feminist or gay. Their art challenged the sexual hierarchy. And all of them were guilty of working with primal imagery, trafficking in the "unclean," forcing contact with the body as it is. This remained true down to 1994 and beyond, when the scapegoat of choice became Ron Athey, who uses piercing, bloodletting, and s/m imagery to create rituals of redemption. The $150 in N.E.A. money funneled his way by the Walker Art Center in Minneapolis generated heated debate in the House of Representatives. And here's a clue to the level of that discourse: reading through the Congressional record at the time, I found a reference to "porno jerk Tim Miller," and other artists had been described similarly.

Sometimes I wonder if my so-called Golden Age was maybe the last good time in the cultural margin. Perhaps not, given that people have been mourning over lost bohemias for the past hundred years. But for me, the story of the East Village scene and performance art at the end of the century always has this tragic trajectory. First, too many beloved spirits were wiped out by AIDS. Like Ethyl Eichelberger, John Bernd, Huck Snyder, David Wojnarowicz. Too much about arts funding became political, thus impossible, threatening the very venues where performing artists work. And then there's the awful inappropriateness of that congressional debate—the way artists have been held up as people worthy of hate from the general public.

The photographs in this book answer the question of why, then, artists even do this work and why for some of us, it's a must-see. In the dynamism and the strangeness and the passion these photos reveal, there's a kind of incandescence, and you can almost feel it open up a window in your mind.

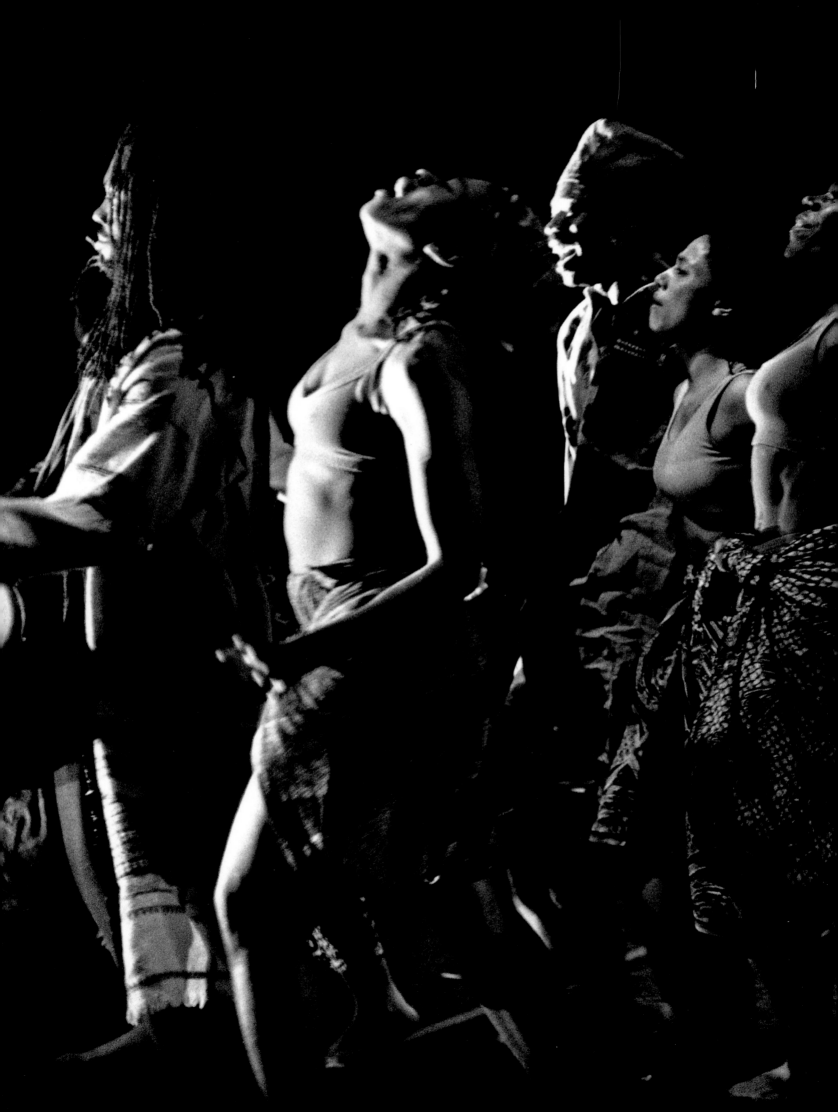

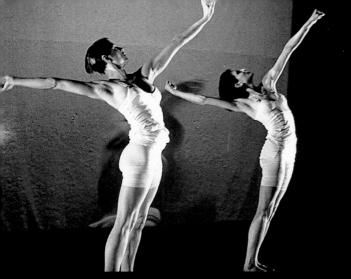

▲ MARIA CUTRONA ▼CLARINDA Mac LOW

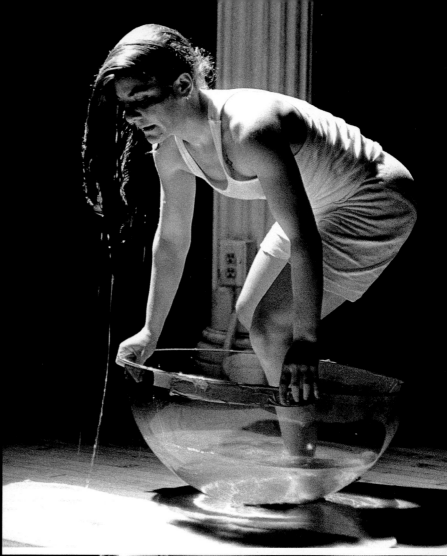

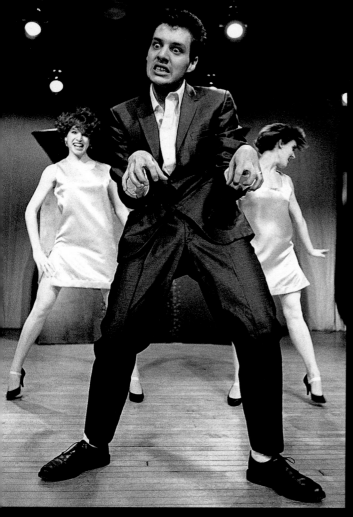

▲ DIANE MARTEL ▼CLARINDA Mac LOW

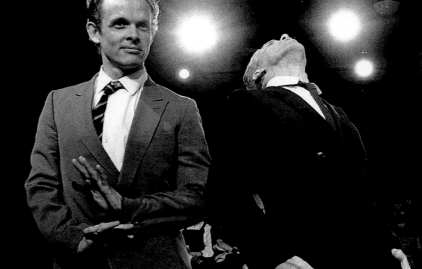

▼QUENTIN CRISP ▼PLAN K ▲ PHILLIP MacKENZIE & SIMON

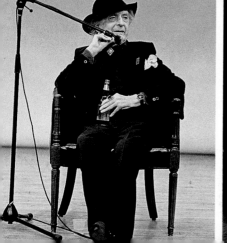

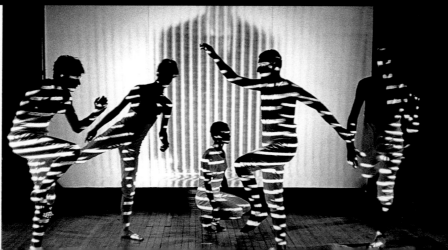

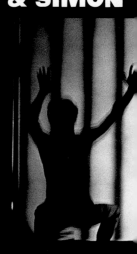

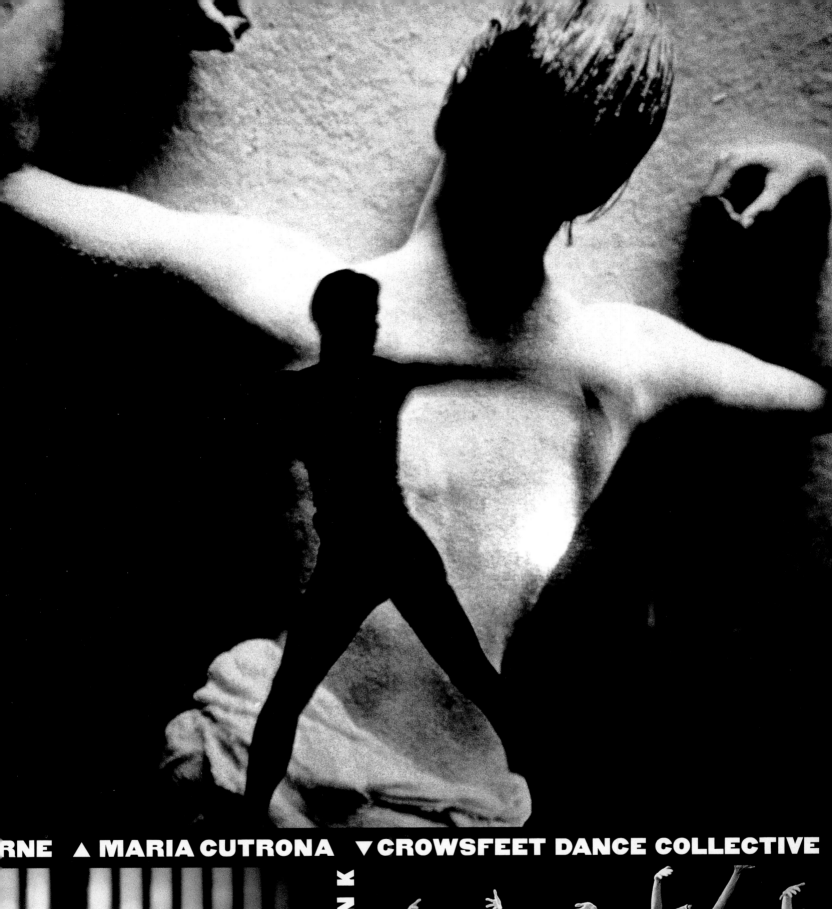

RNE ▲ MARIA CUTRONA ▼CROWSFEET DANCE COLLECTIVE

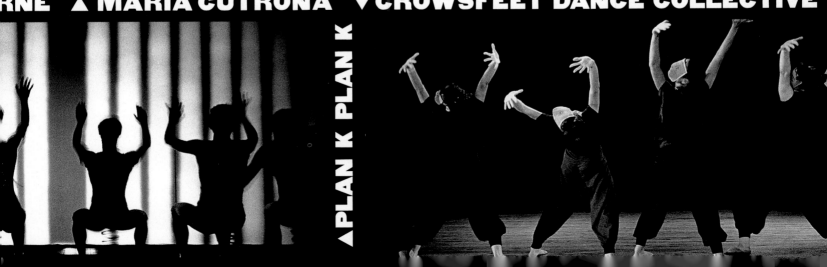

▲PLAN K PLAN K

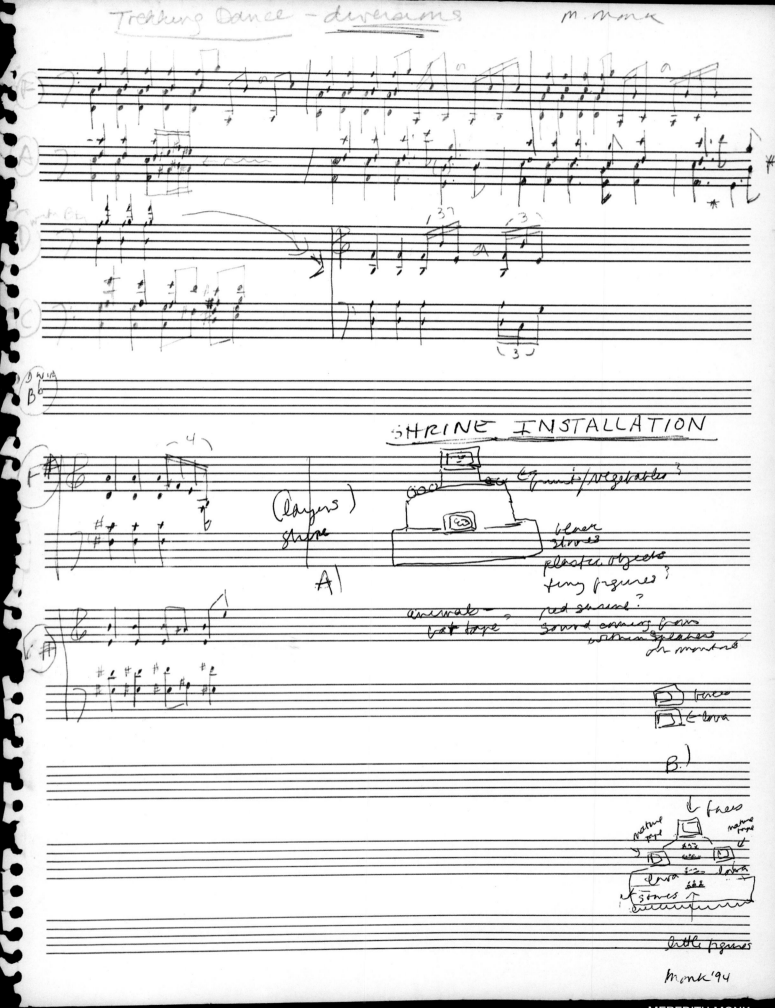

SHRINE INSTALLATION

—MEREDITH MONK

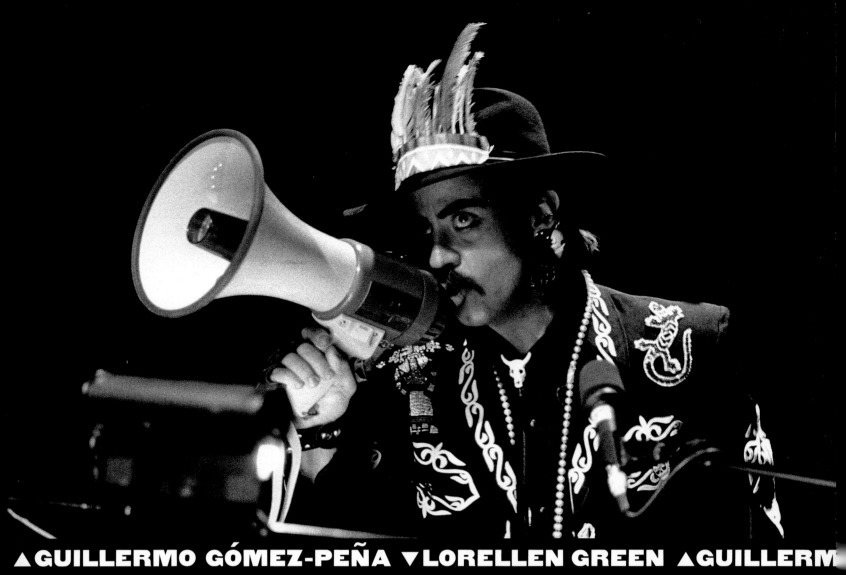

▲GUILLERMO GÓMEZ-PEÑA ▼LORELLEN GREEN ▲GUILLERM

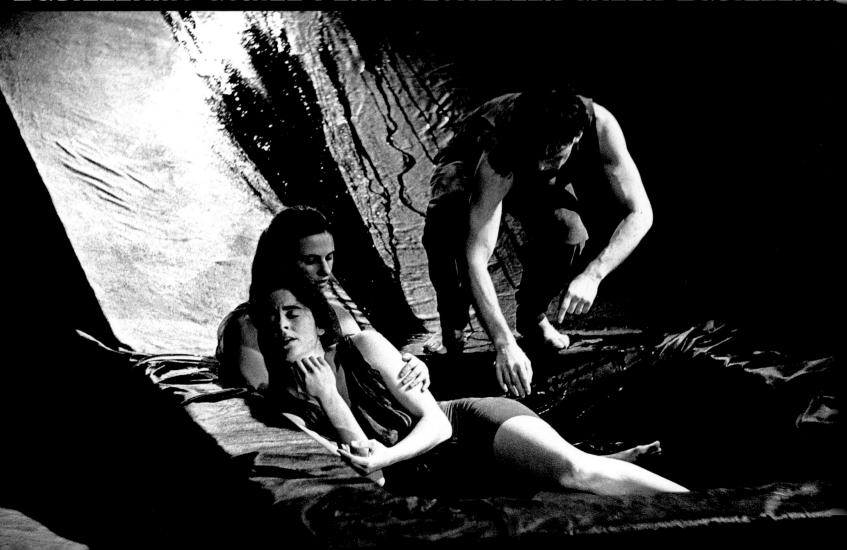

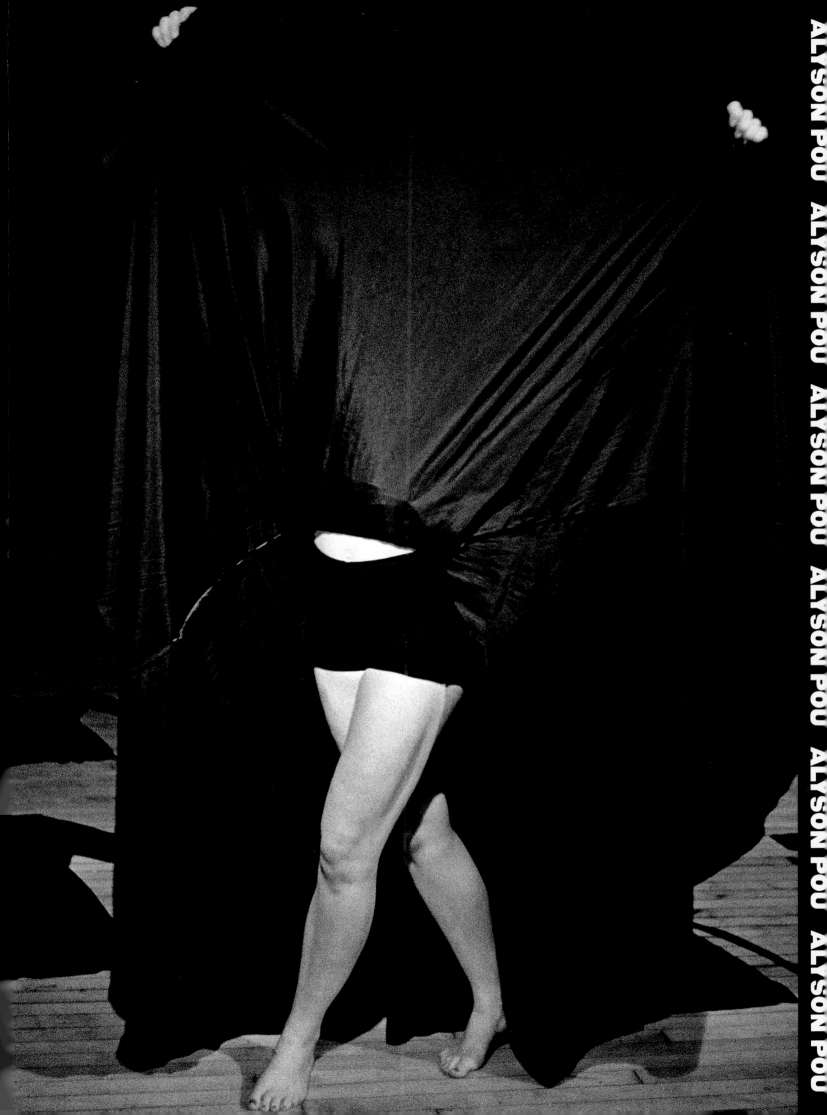

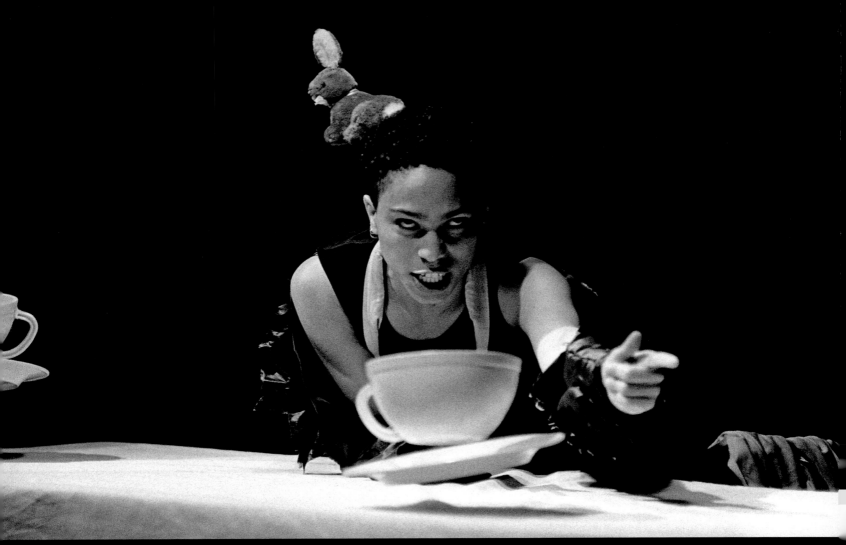

▲GRISHA COLEMAN ▼PENNY ARCADE ▲GRISHA COLEMAN

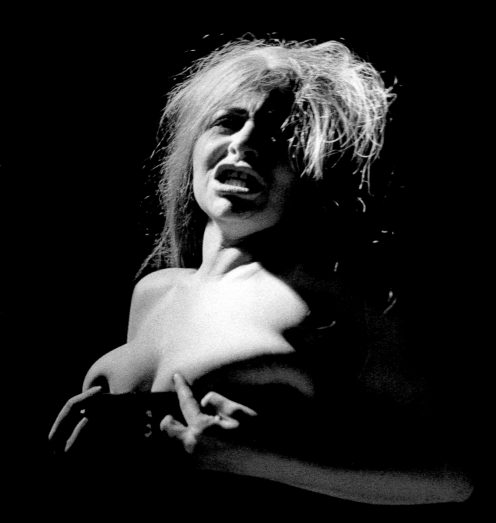

FROM "ANDREA WHIPS"

IT'S SHOWTIME DARLING! And everything is coming up roses! Is everybody happy? I'm a real Warhol superstar darling! I'm a real woman! I'm gonna be on top tonight! Andy Warhol was my husband! Lou Reed was my wife! And you are all my beautiful children. You're beautiful because you understand how beautiful the world is, how beautiful I am and I told the world, "You're not paying Andrea Whips because she's beautiful but because the world is beautiful and the world must pay! You may not realize who I am. This generation is the slow group. Sesame Street caused brain damage! MTV makes the brain cells stick together! **HAVE YOU SEEN THE HIP SCENE LATELY?** You know, the **WHO ARE THOSE YOUNG FASCISTS WITH** ones who keep **TATTOOS AND MULTIPLE PIERCINGS?** telling us how fab everything is. Couldn't they afford a longer adjective? It's like the made-for-TV-movie of the 60s and it isn't even in living color! Thank God I'm an acid freak! Thank God I'm a country girl! I'm a real acid freak darling, I've got some very freaky things in my bag! I'm a real blonde darling! Look at these grapefruits! Yesterday I ran through the mall whispering, "Who will fill me full of jelly, custard and cream? People ran out shrieking! When I shriek in public people take notice darling! I'm a first, I'm a second, **I'M A DING DONG BABY AND I'M ON** Up there with James Dean and **MY WAY UP THERE!** Marilyn Monroe! Marilyn's been dead so many years, you better love me while you can! Yesterday I rode down in my elevator 108 times to make sure that the doorman was staying awake for the other tenants. He called me a stupid cunt! But I told him darling, "A cunt is a useful thing!" It's getting dull out there. Haven't you noticed? Dangerously dull! It's turning into a mall out there! Oh! I just had a vicious acid flashback! I was completely surrounded by colored fish and I just know that nobody would believe me! So I brought them back! **LOOK AT THESE FABULOUS COLORS! DON'T WORRY!** This is not performance art. Performance art is the vinyl mini-skirt of the 80s darling! I'm going to throw an I Ching for all of you! You look like you could use it. See! A circle of psychedelic fish! That's very, very good. And three red fish in a row! That's very auspicious darling. And a changing fish! If you were real homosexuals you would know that this color was Chartreuse! Have you noticed how they keep maligning homosexuals? Why? Homosexuals are so fabulous and they give flawless dinner parties, it's the romosexuals that they should worry about the ones who roam the streets. Not the homosexuals who stay home! Look at your social ecology? It's like the sinking of Atlantis! I myself come from a long line that doesn't have many people left standing in it. Fifteen years from now people will be standing around at cocktail parties saying, "I remember when there were faggots and it was fabulous!" Sometimes less is more but darling a lot of times less is less.

—PENNY ARCADE

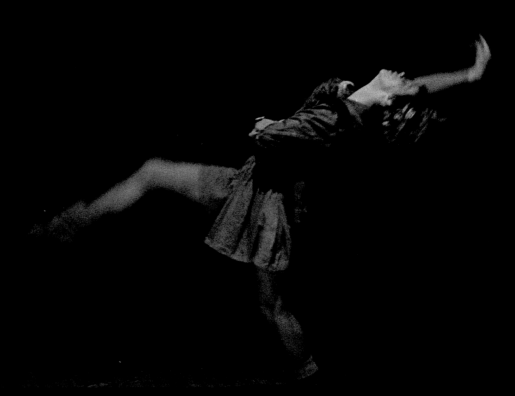

▲JUDITH REN-LAY ▼MARY ELLEN STROM ▲JUDITH REN-LAY

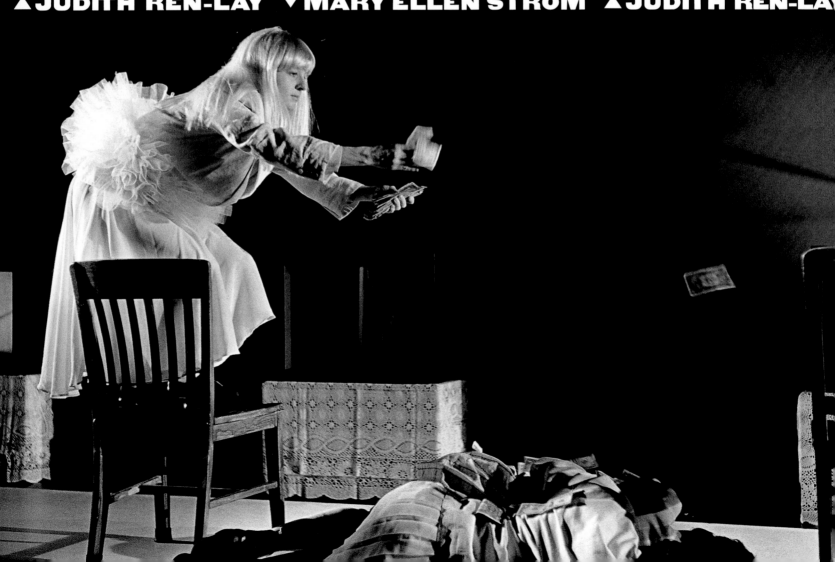

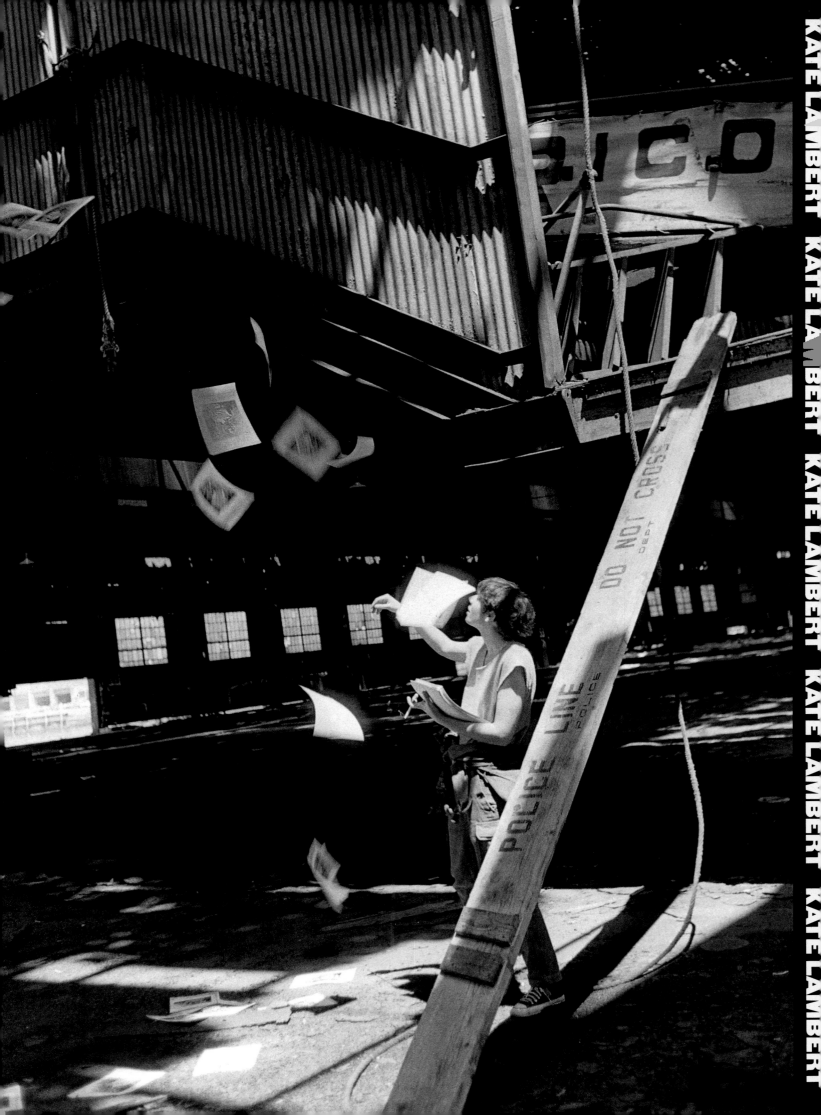

KATE LAMBERT KATE LAMBERT KATE LAMBERT KATE LAMBERT KATE LAMBERT

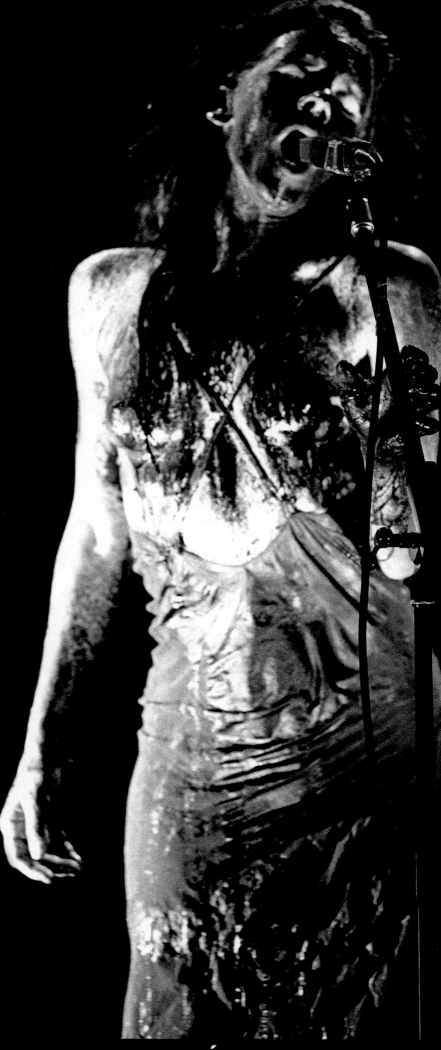

FROM "THERE ARE NO MORE TICKETS TO THE FUNERAL"

And on that holy day
And on that bloody day
Were you a witness?
Swing Swing Swing
I looked over Jordan and what did I see
coming for to carry me home
A band of Angels coming after me
Coming for to carry me home
Swing Swing
A band of Devils! calling out my name
coming for to drag me to the grave
Swing
But I will not go
And I shall not go
I shall wake up and I shall walk from this room
into the sun
where the dirty angel doesn't run
where the dirty angel cannot go
and brothers in this time of pestilence do know
Each time that we meet we hear another sick man sigh
Each time that we meet we hear another man has died
And I see Angels Angels: Devils!
Angels Angels: Devils!
Angels Angels: Devils!
Coming for to carry me home.
Swing Swing
Mr. Sandman makes a filthy bed for me
But I shall not rest
And I will not rest
As a man who has been blinded by the storm
And waits for angels by the road
while the Devil waits for me at night
with knives and lies and smiles
and straps me down
and sings the *swing low sweet* chariot
of death knells
one by one like a sentence of the damned,
and one by one they come to warn me
of the *perils* of resistance,
and one by one of my brothers
die unsung unloved unwanted: Die!
and faster please
we've got no money for extended visits
says the sandman
But we who have gone before
Do not rest in peace
We who have died
Shall never rest in peace
Remember me?
Unburied I am screaming in the bloody furnaces of hell
And only ask for you
to raise your weary eyes into the sun
until the sun has set
for we who have gone before do not rest in peace
We who have died
shall never rest in peace
There is no rest
until the fighting's done
And I see Angels Angels Devils!
Angels Angels Devils!
Angels Angels Devils!
coming for to drag me to the grave
—DIAMANDA GALÁS

DIAMANDA GALÁS DIAMANDA GA

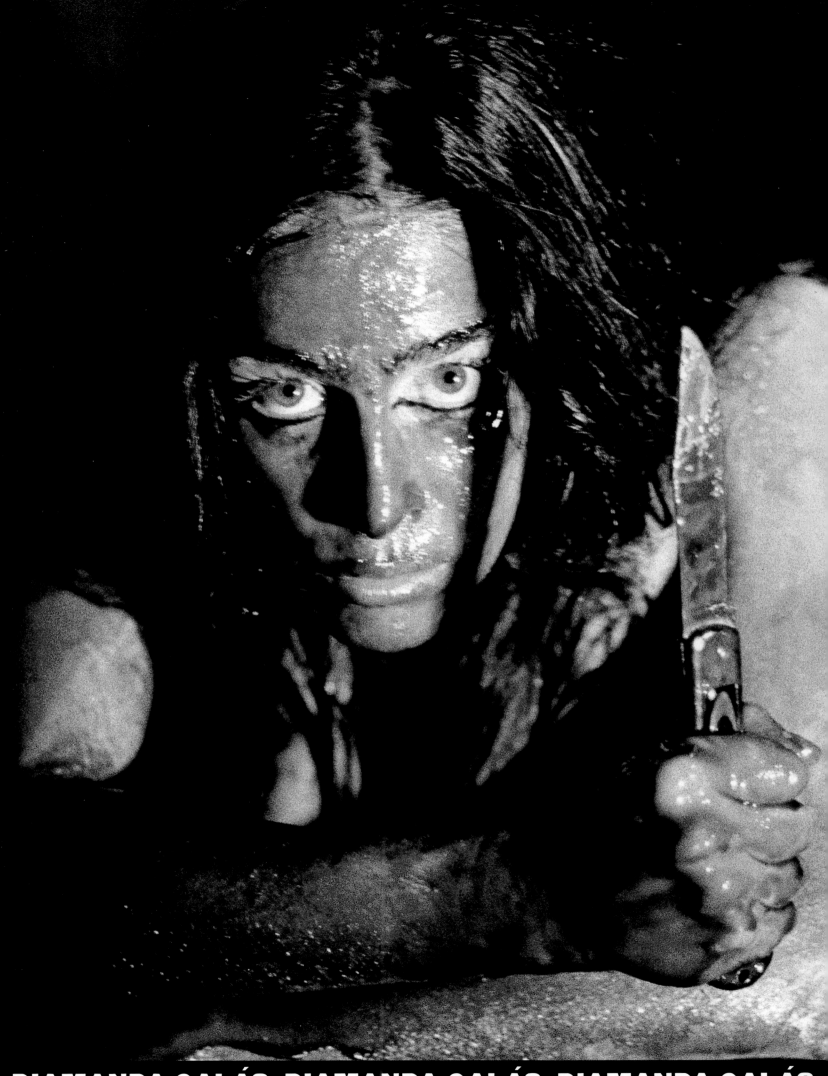

DIAMANDA GALÁS DIAMANDA GALÁS DIAMANDA GALÁS

640 numbers between 1 and 64

```
15  16  58  39    61   4  20  38    10  43  13  57    22  17   8  40
27  20  16  15    11  28  47  45     3  26  63  26    26  30  16  21
24  36  61  42    40  62  11  41    61  57  48  36    10  38  16  21
61  10  23   2    56  50  57  32    46  36  39   4    21  34  11  45

17  26  53  14    38  43  55  48    44  20  12  11    56  55  18   9
47  45   1  29    17  58  46  15    49  14   1  38    43   1  31  48
63   4  64  49    13  29   7  25    21  14  38   3     5   6  12  62
36  13  34  44    49  31  34   1    64  25  23  62    40  13  11  32

46  14  19  58    64  59  48  28    34  14  42   3     9  23  33  55
 1  10  58  53    55   3  31  49     3  42  59  20    62  30  47  16
22  24   6   1    35  12  16   8    40  64  32  29    44  25  51  35
59   7  52  26    49  43  58  14    58  64  54  12    20  23  27  38

30  38  24  23    20   9   5  29    27   9  18   1    38  62  26  22
23  34  43  27    41  51  16  28    45  34  54  56    64  60  48  32
58  38  56  40    64   6  29  45    16  62  46  50    18  57  56  35
34  40  29  55    11  35  49  55    19  60  21  38    62  16  24  19

11  51  55   1     6  49  55  58    53  52  43  30     2  39  20  61
63  31  12   6    55  39  32  27    55  12  25  30    27  53  61  42
58  63  51  56    52  40   1  25    21  15  26  18    39  15  35  20
21  57  33  21    30  55  50  43     1   2  16  22    27  20   8   3

39   2  60  62    43  48  55  11    58  27  41   1    13  40  46   5
52  23  59  14    30  40  47  14    57  48  45  62    48   5  13  33
58  28  64  18    42   9  37  31    49  22  30  11    46  57  56  35
54  62  36  62    32  20  42   3    24  22  40   6    11  34  43  34

 7  52  39  15    15  52  53  37    24  15  10   1    15   7  46  14
50  16  36  44     1   2  24  20    45  55  38  16    62  11  26  61
42  47  55  14    36  55  36  36    17  64  35  43    19  24  41  53
31  46  17   8    32  54  10  25    24  27  23  31     4  27   4  40

16  38  55  56    44  59  45  16    62   8  60  30    49  43  11  46
15  16  51  55     6  12  47  45    60  19  40  48    10  17  38  61
14  39  28  15    18  46  32  31    61  51  64   6    57  34  32  33
56  33  40   7     4  21  36  63    44  58   7  39    25  64  31  48

28  47  19  46    19  46  48  23    16  54  27  38     2  23  51  14
29   8  64  52    24  17  21  46    45   1  44  42    17  47   5  59
23  48  17  44    57  49  49  32    13   1  39  37     7   2   8  19
54  16  35  23    27  62  56  60    59  58  17  49    17  48  43  28

 7  40  17  45     8  52  18  16    17  27  41  13    34  50  48  15
 3   8  20  19    37  60  48  15    15  63  41  38    15   8  48  35
 4  45  31  55    34  20  12  43    51  61  27  10    61  52  30  50
21  36  46   5    60   7   8  27    24  15  31  59     4  56   4   8
```

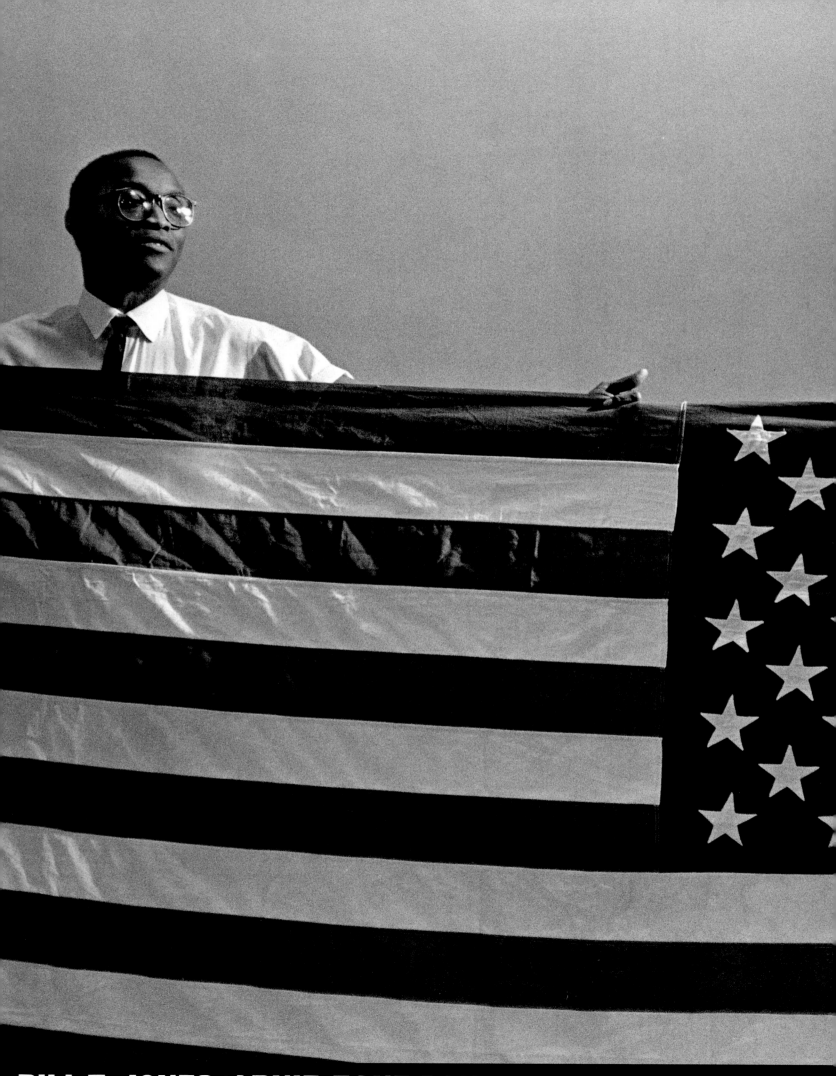

BILL T. JONES/ARNIE ZANE DANCE COMPANY BILL T. JO

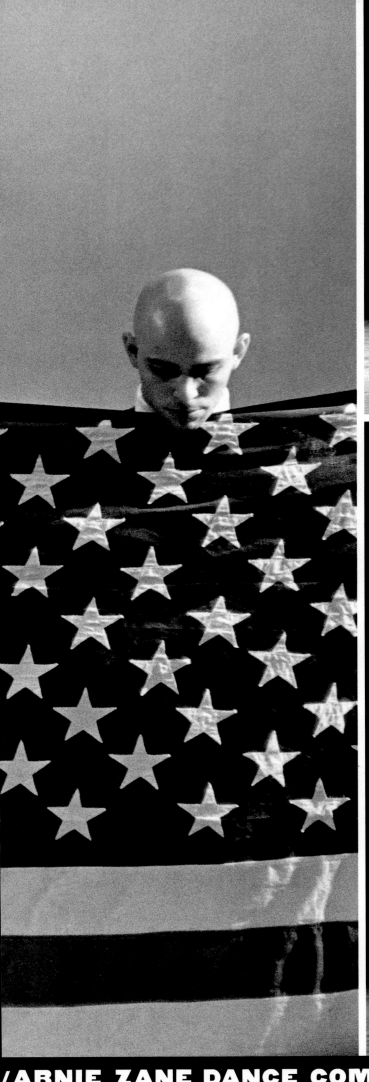

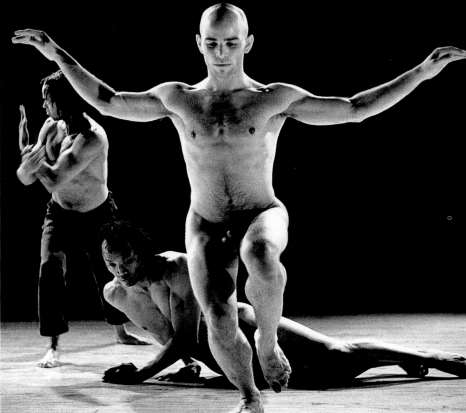

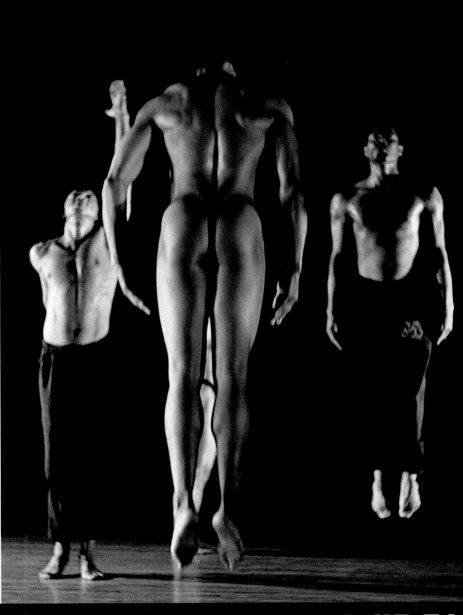

/ARNIE ZANE DANCE COMPANY BILL T. JONES/ARNIE ZAI

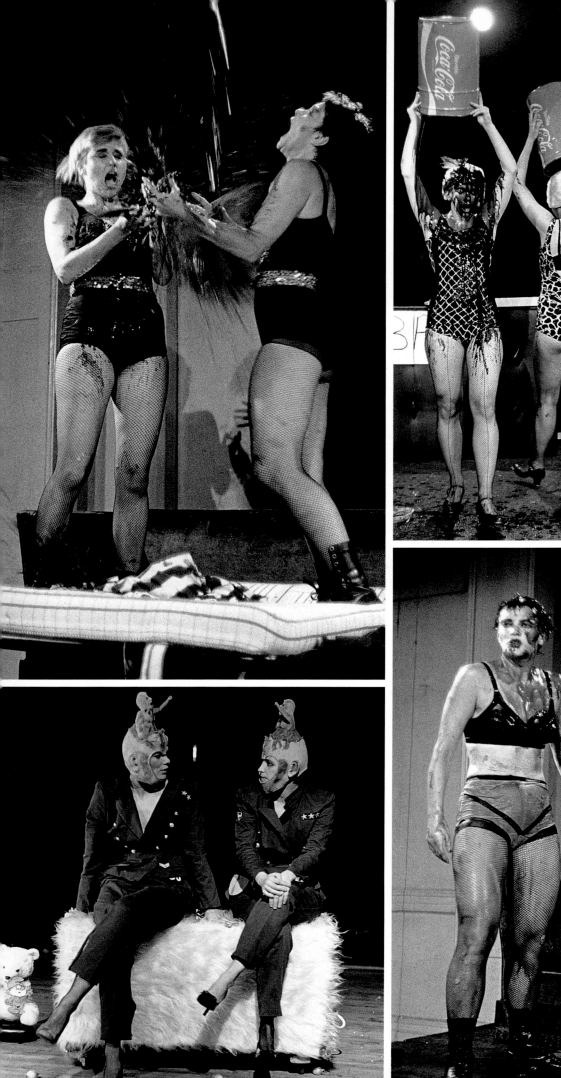
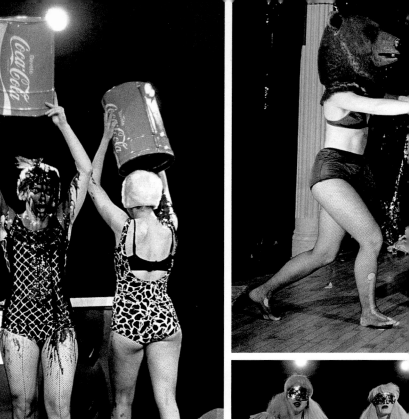
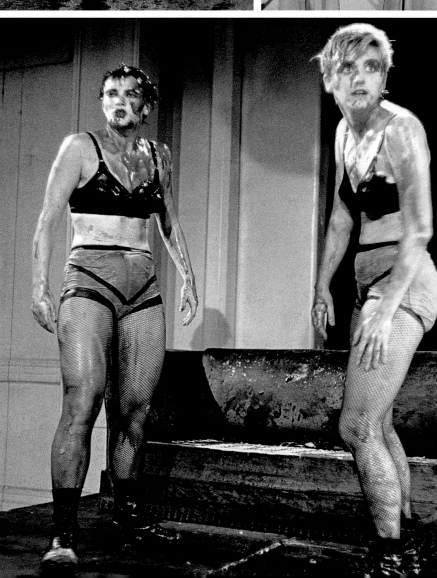

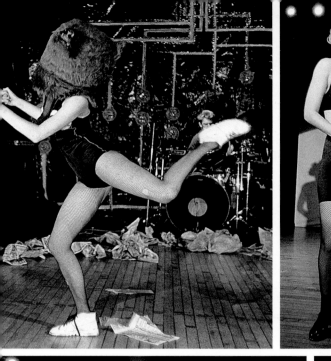
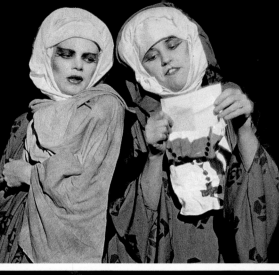
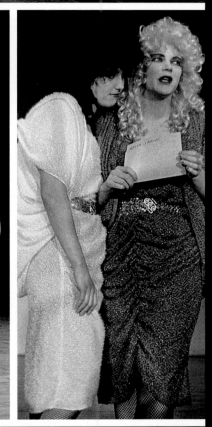
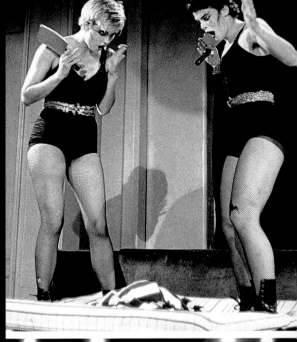
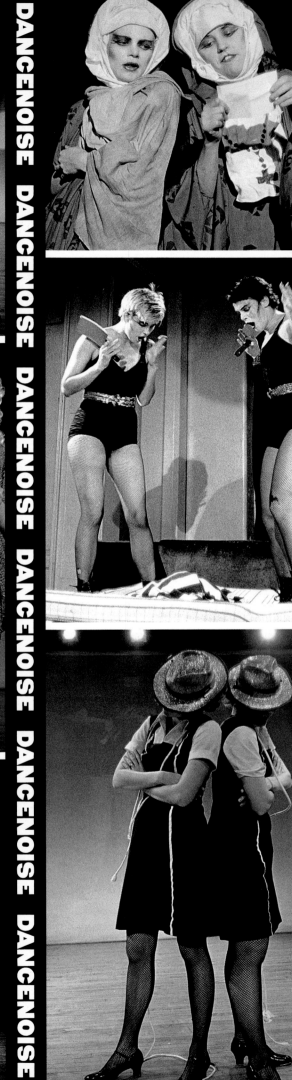
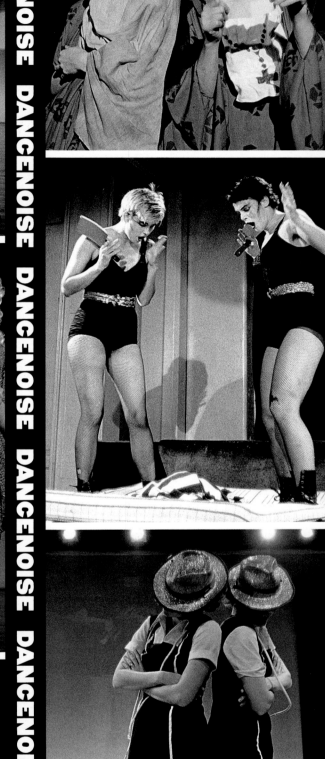
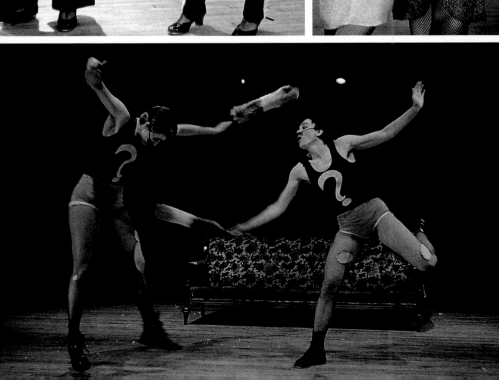

FROM "PASSAGES"

As an alien, I register
in feminist writing
enter temples of Woolf, Stein, Daly
where there are no books by
Black Women
The priest is a smocked, liberal,
woman, white
Her disciples wear Birkenstocks
burn bras and blow smoke
from sacred pipes
To survive, I imagine my grandmother,
first woman of a Baptist church
Betty and Verdaya at "The Institute,"
my mentors on Black history
Leal who taught me,
abortion is a woman's right
my mother's courage
to raise an orphan
and I think to lend ears
balance budgets
diaper babies and find
moments for love
like fish swimming in schools
of piranha isn't theory
but survival.
My term paper is about
a Black Woman in Harlem
with three kids
who works all night to support them
I ask the smocked, liberal,
woman, white
IS THIS FEMINISM?
She says, "yes"
If nothing else,
segregation gave me an identity
system that wouldn't let me starve
from hunger
Here, I was a skeleton,
reminder of deep dark past.
Transition to freedom for slaves
was swamp
pitch black
barking coughs
an unknown place
bare floors
sacks of belongings
lonely tasks
to carry heavy bundles
jobs for which there were
no assistants
whites with benevolent smiles
but nothing concrete
no real estate
Like Frederick Douglass,
Harriet Tubman
Sojourner Truth,
parishioners marching from Selma to

Montgomery Alabama
singing off key "this little light"
I become an abolitionist
hurling like an Arab into an
Israeli suburb
After one battle where I've
denounced Woolf
am an avowed atheist
sitting on a bench by myself
collecting senses, lost
staring into the glare of neon bulbs
when the smocked, liberal,
white woman
sidles up to me with the
assured stance
of someone who's never knelt
had to pick, cater, mask
stumble through customs,
pray they don't discover you
and says to me in a saccharin voice
"If you aren't happy here, leave"
burrowed into my head
like axes in the final scene
buckets tossed from roaring crowds
cars driven into stumps of paraplegics
I experience paralysis
am unable to move my tongue
until 8 years later
when complaining to a white woman
about years in the business
and relative anonymity
and she says "GO TO EUROPE"
10 years as an activist, poet,
teacher student
learning to pick, plow, haul litter
sweat in factories of
"alternative theater"
play same scenes of obsessed lovers
trying to break free
miming my way through drudgery,
and extra hours
like the clerk at a neighborhood 7-11
and begin again as an unknown
walk streets of new cities
be an overnight success
with people I have no ties to
given benefits of being foreign
treated with royal regard
as long as I'm distant
never close enough to suspect
of being an ordinary Black girl
to kick, smear in feces and leave like
Tawana Brawley
I hear my voice raise octaves
and snap of elastic
stretched too far. . . .
—PAMELA SNEED

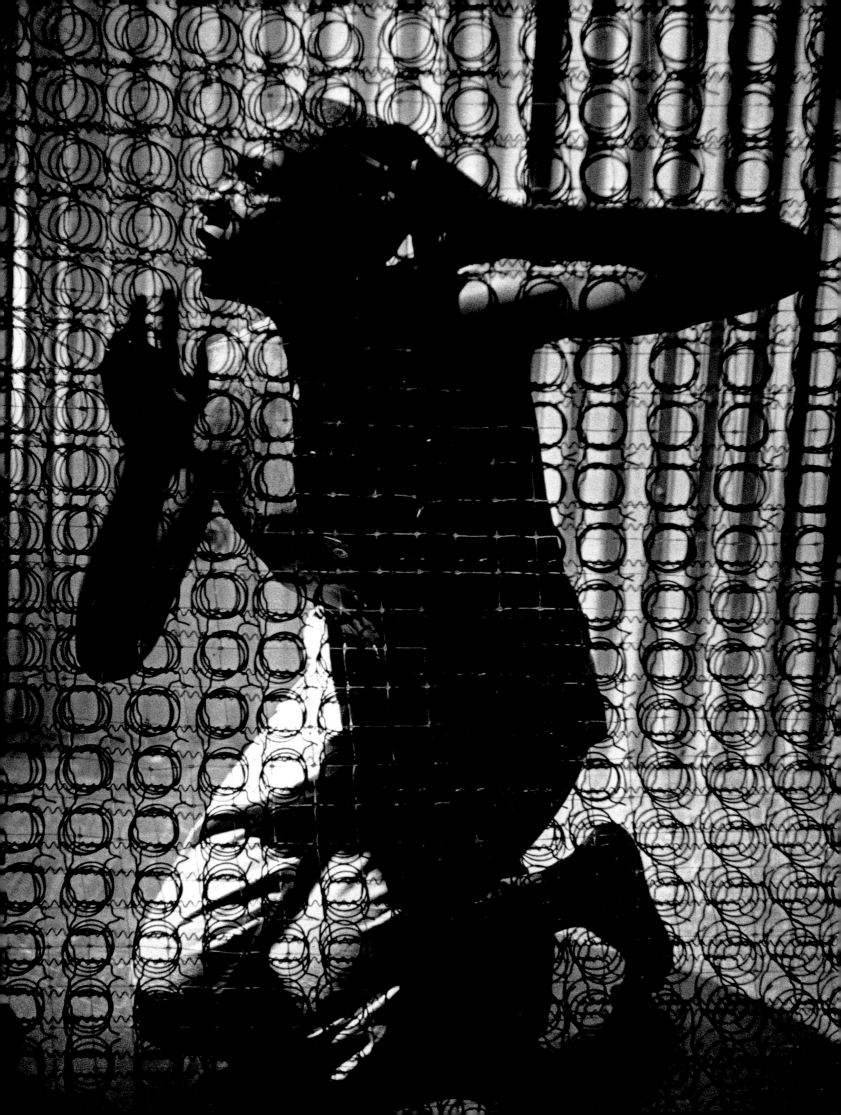

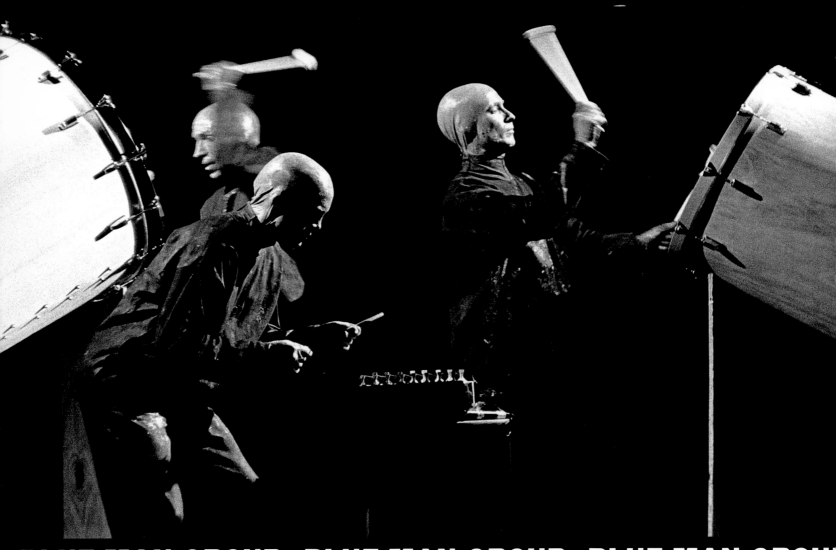

BLUE MAN GROUP BLUE MAN GROUP BLUE MAN GROUP

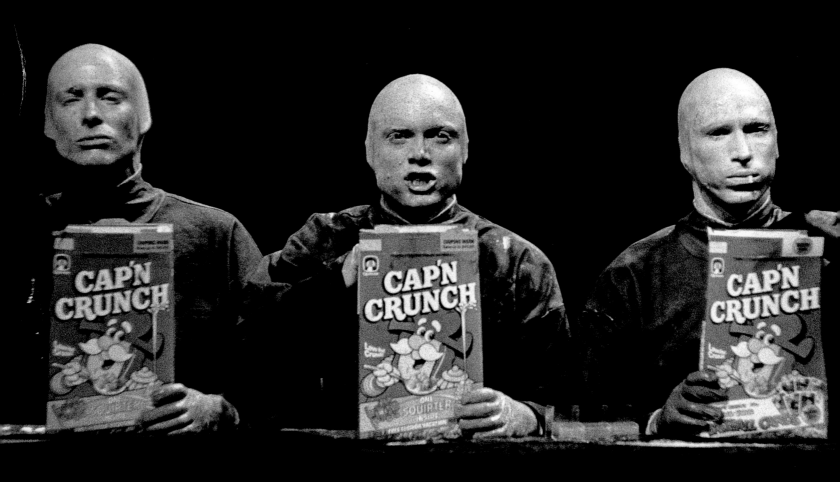

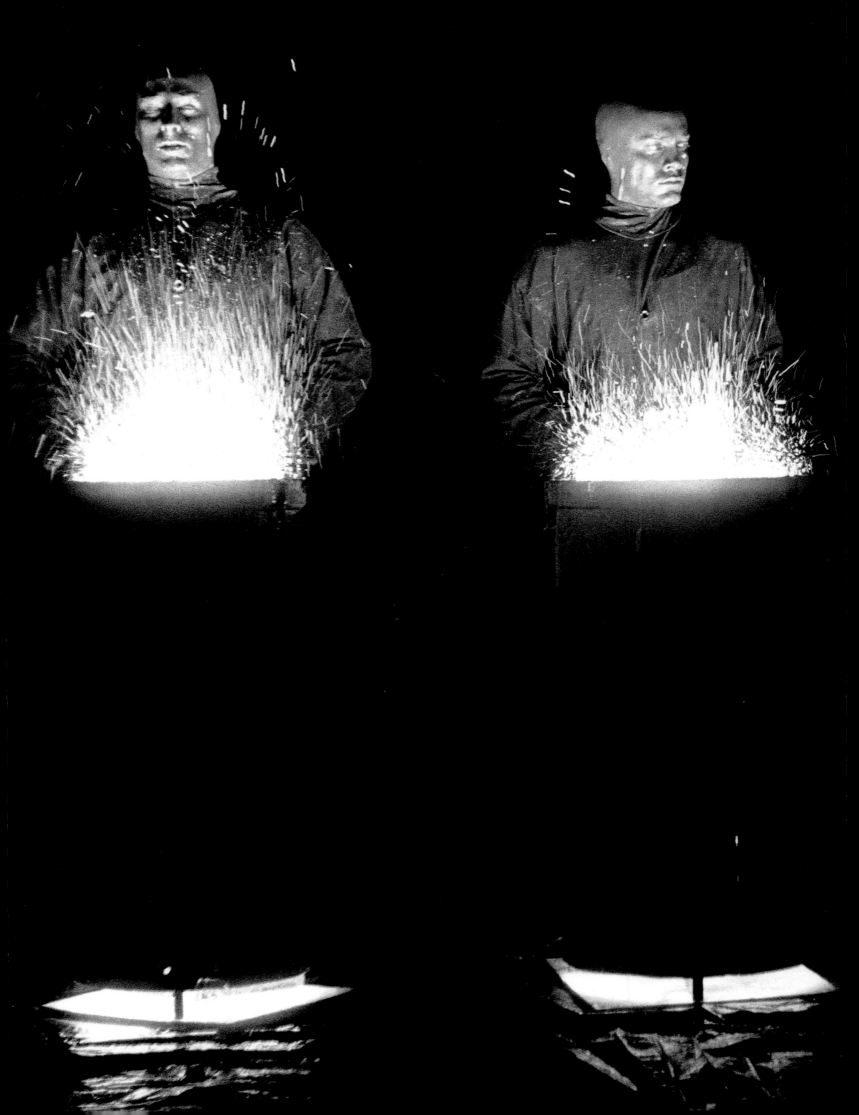

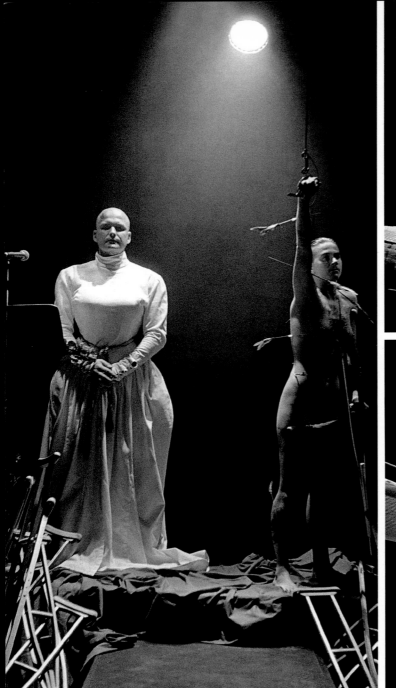
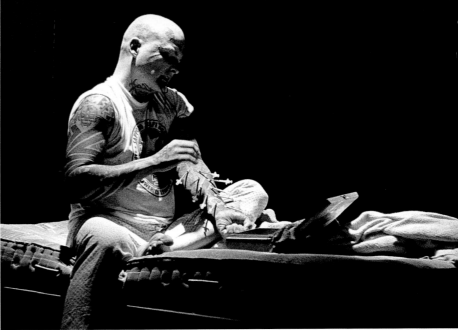
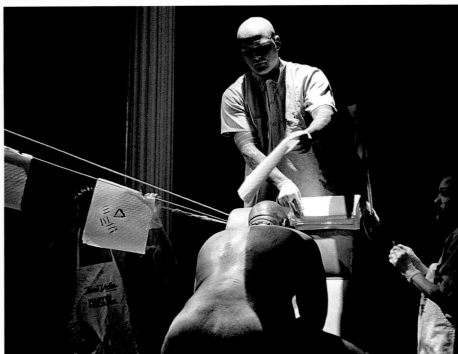
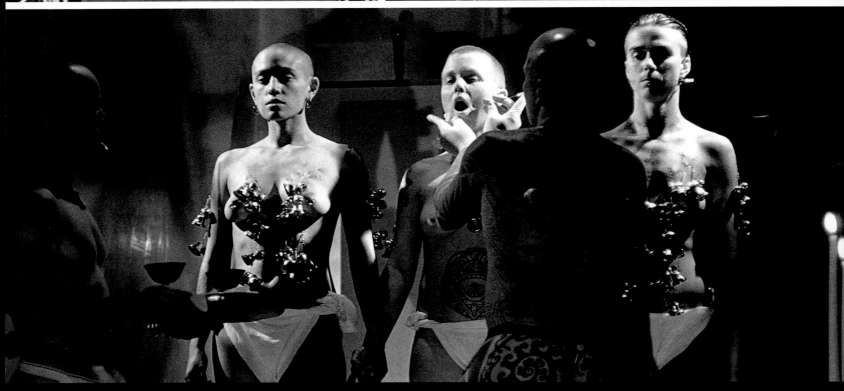

RON ATHEY RON ATHEY RON ATHEY RON ATHEY RON ATHE

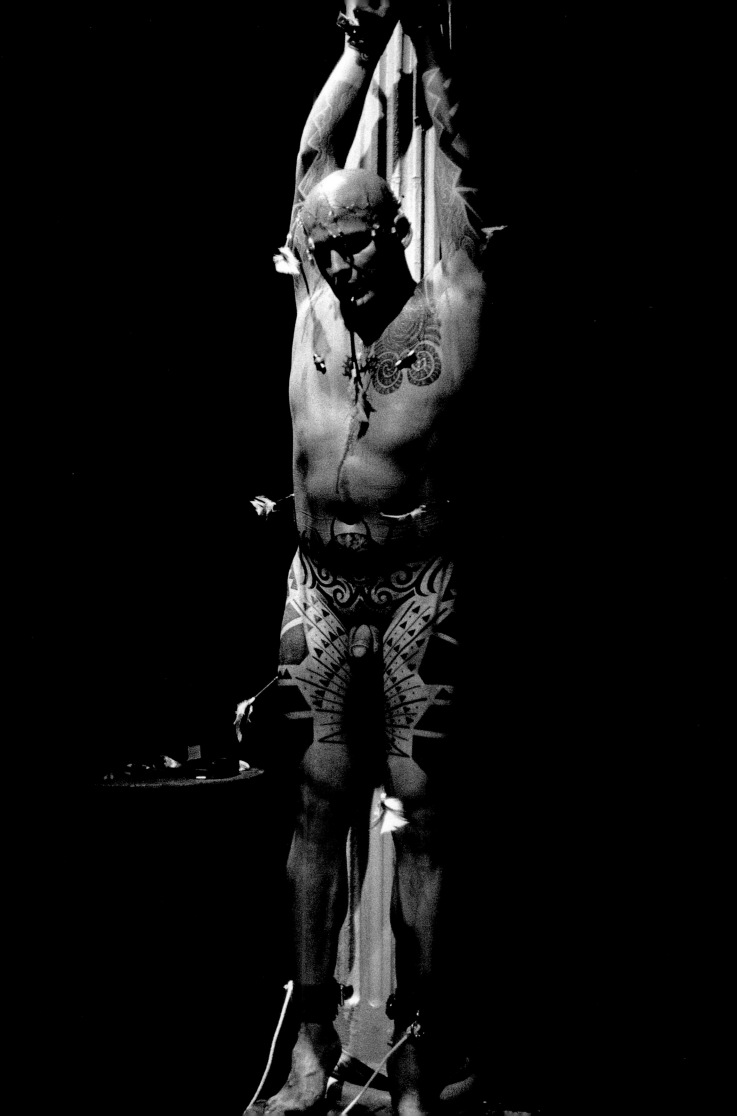

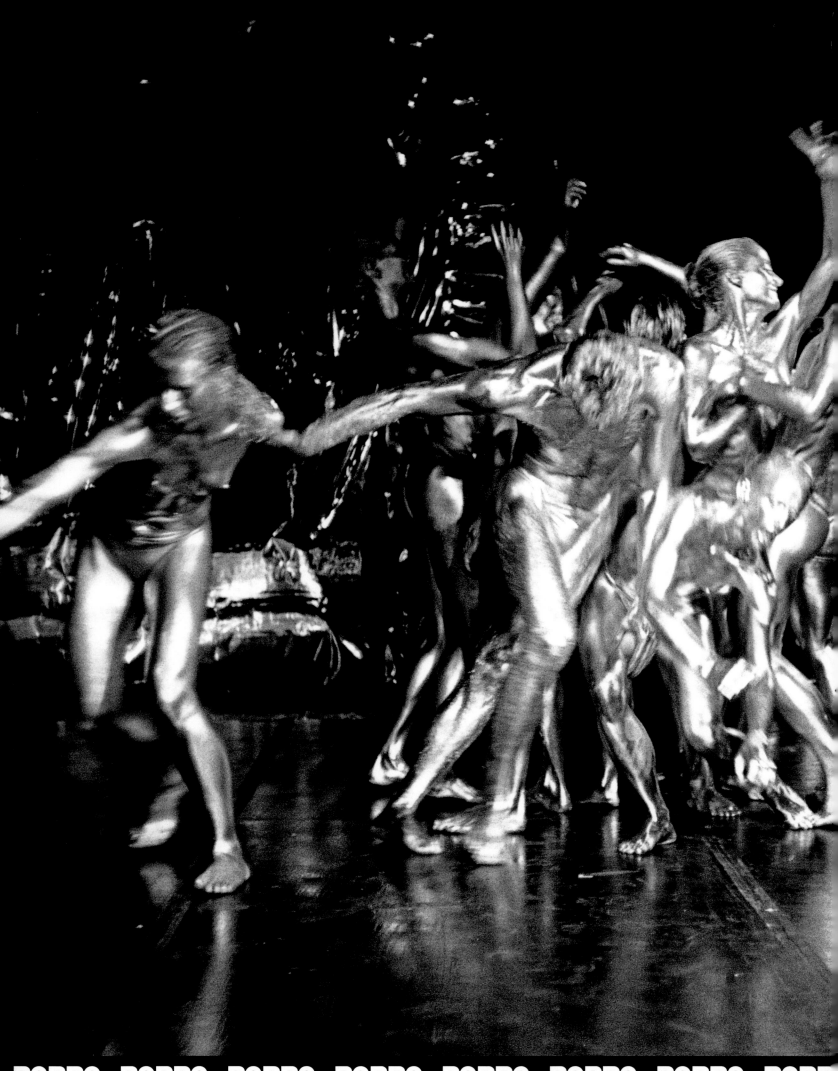

POPPO POPPO POPPO POPPO POPPO POPPO POPPO POPP

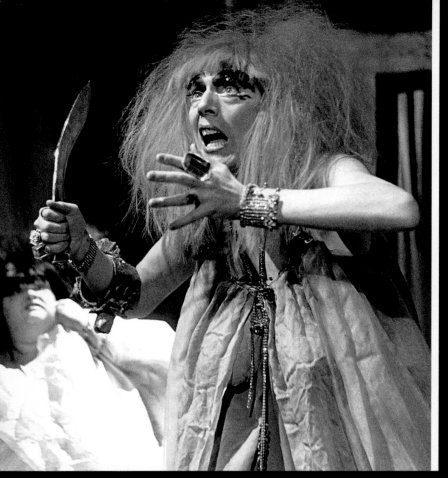

"WE ARE WOMEN WHO SURVIVE"

We are women who survive; our world is hard.
We are women who survive; our world is mean.
We are women who survive; scratch us, we bleed.
We are women who survive, but we will live to fight another day.
The men around us stumble forward.
When they fall we prop them up.
We are there when we are needed to fortify.
And why is that, honey? Why is it?
Cause we are . . .
We are women who survive; our world is hard.
We are women who survive; our world is mean.
We are women who survive; scratch us, we bleed.
We are women who survive; but we will live to fight another day.
When we enter a dark chamber, we open the window and we say,
"We are looking for light; we are looking for love."
In the midst of the darkest shadows,
We will strive to find a better way.
We are women who survive; our world is hard.
We are women who survive; our world is mean.
We are women who survive; scratch us, we bleed.
We are women who survive, and we will fight another day.
—ETHYL EICHELBERGER

ETHYL EICHELBERGER ETHYL EICHELBERGER ETHYL EICHEL

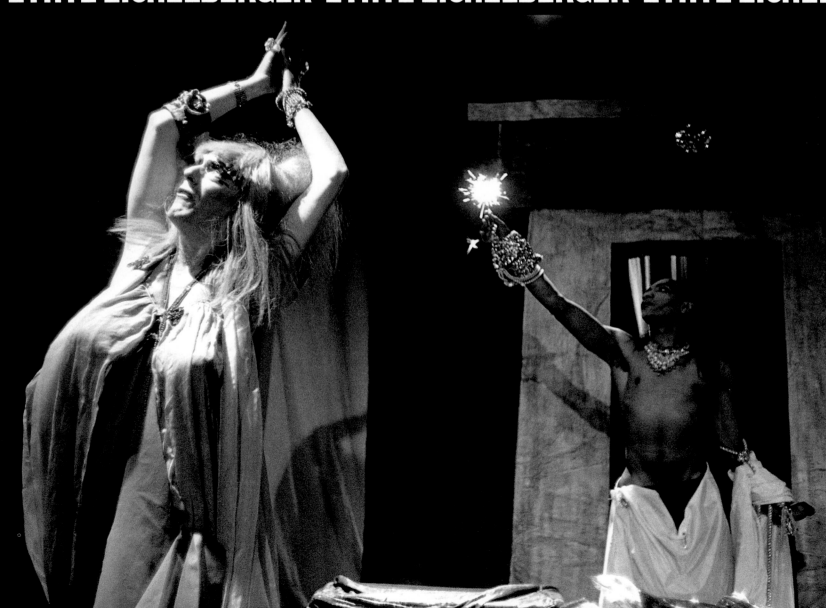

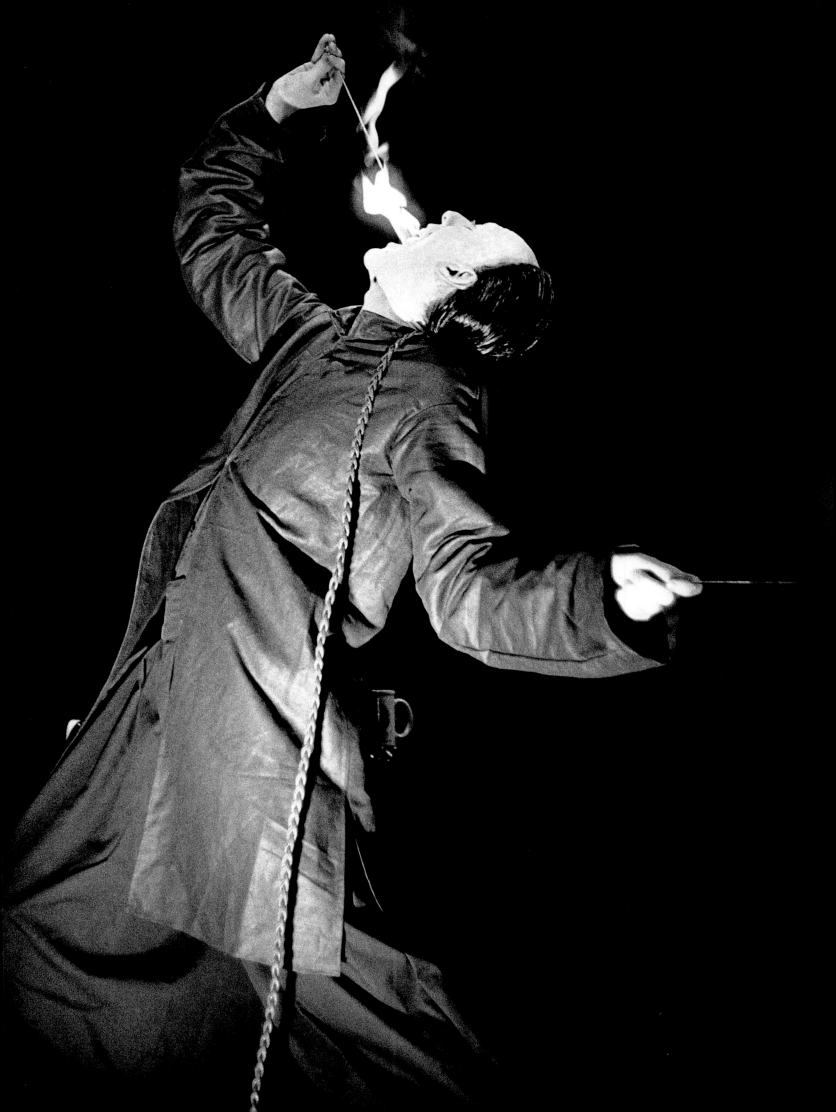

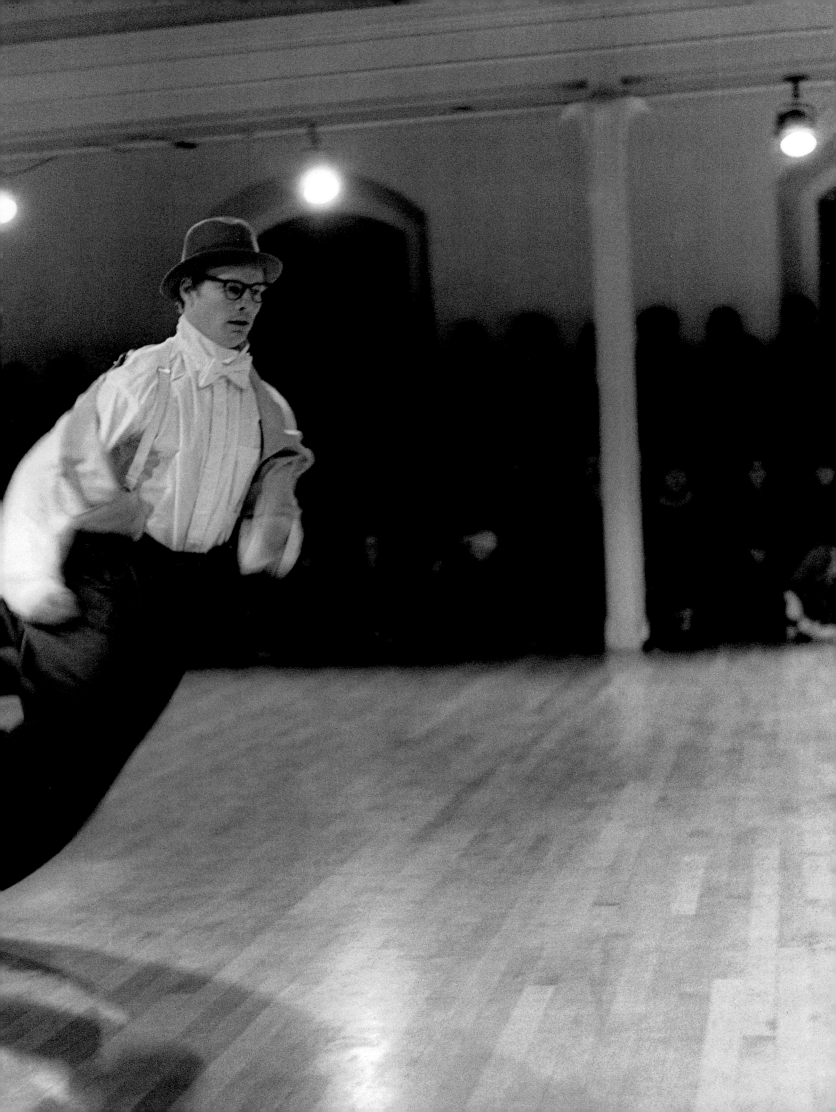

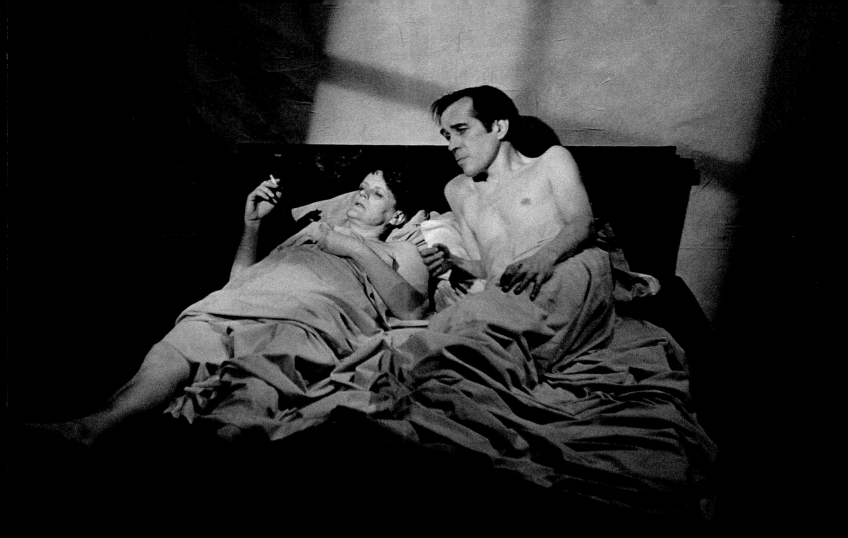

◀ BILL IRWIN ▲ JIM NEU & S. K. DUNN ▼ SUSAN RETHORST

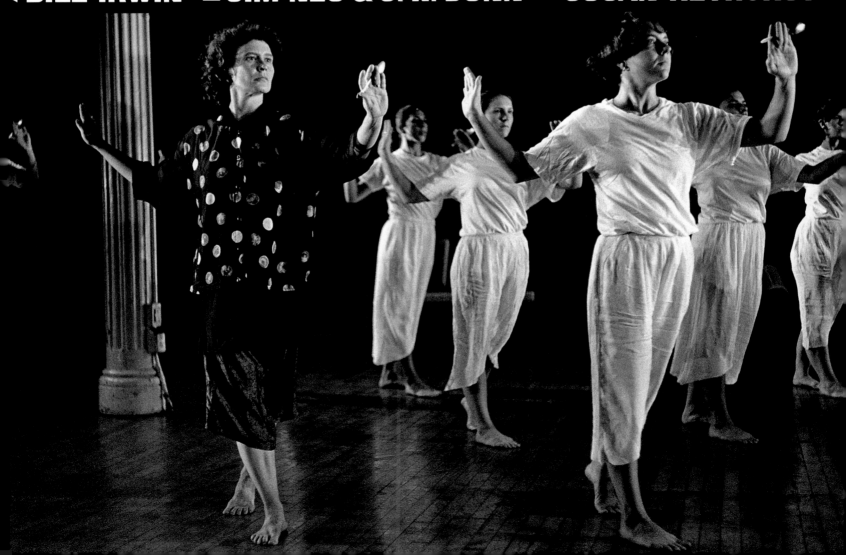

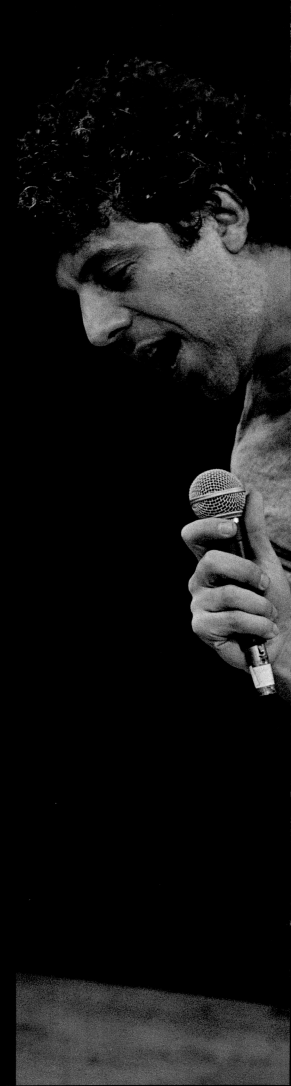

"MELTING POT"

A man in a V-neck T-shirt stands and gesticulates with his arms, shouting with a Greek accent.

LISA! LISA! Get this guy over here. . . . What do you want? What do you want? Huh? Cup of coffee? What else? That's it, cup of coffee? . . . LISA, get this bum cup of coffee. . . .

Where the hell is Jesus? (*shouts at the floor*) JESUS! JESUS! What are you doing down there? . . . Shooting up? Jerking off? Come on, come out of there. . . . What rat? . . . Leave the rat, if it's dead leave it Come up here now, come on, come here, I want to show you something.

OK, come here What is this? Huh? What is this mess? French fries in the fat, french fries on the floor, french fries in the sink, everyplace french fries. Mess, mess, mess, mess, mess, mess. Eh? Huh? Look at me when I'm talking to you! Look at me. Don't look at girl over there, look at me. . . . Who teach you to make mess like this? I don't teach you to make mess. You want Health Department come in here, they close us up, they say, "George too dirty, close up!"?

I show you how to make french fries, you don't make no more mess, all right. . . .

Yeah, yeah, yeah, yeah, yeah. . . . I know you know, I know you know, you know everything, you genius! . . . George show you how to make french fries, no more mistake, all right? No more messy. Yeah, yeah, you watch me, mister. . . .

Take bag, all right, cut corner on bag, all right? Yeah, I know you know, smart guy. . . . Einstein, you watch me. Take bag, put in basket, all right? (*His arms flail wildly.*)

In . . . in . . . not all over . . . in the basket. One shake. Put back, take basket, put in fat, all right? Cooking . . . Cooking . . . Cooking . . . Easy, nothing to it! . . . Cooking. . . Cooking. . . .

Then shake, shake, bim, bim, boom, boom, zip, zip! Back in. Cooking. . . . Cooking. . . . Cooking . . . All right, take it out . . . brown, white, don't make no difference, nobody eat it anyway. . . . All right, now you show me. Show me, I want to see, come on. I don't got all day here, please, I'm busy. . . . (*watching*) All right, OK, yaaaaa, ummmmm, all right, put it in, ummmmm, yaaaaaa, OK.

You know, I don't have to hire you, you know. Lisa, she tell me you good. That Chinese guy, he was great! Buck an hour that guy, huh? . . . Too bad he die on me. . . . Come on, come on, put it back now, you're spilling, you're spilling! . . .

You know what your problem is, Jesus? You Puerto Rican. You go back whenever you want to go back. You come, you go, you don't need green card, you be citizen when you want be citizen. I can't go back. I have to stay in America. You want to stay in America, you have to work all the time. . . . I want to be big success in America. I work sometimes twenty-four hours a day, I work. Sometimes I don't eat, I don't sleep, I don't piss. Nothing. Working all the time. That's it. You know what I'm saying?

You don't work all the time, you know what's gonna happen to you? You gonna be like all these these these bums, these junkies, these winos . . . they come in here, they hang around all the time, night and day. "Gimme cup a coffee. Gimme cup a coffee. Gimme glass a water—I wanna shoot up. I wanna throw up! Cup a coffee. Glass a water. Cup a coffee. Glass a water. . . ."

You want cup a coffee? You want glass a water? You go back to Puerto Rico. They got water there, they got coffee, all day long. You want to be in America, you work. That's it. Working all the time. All right? That's it. Work.

No time for this . . . wine . . . this drugs . . . this hanging around, pinball, disco, girlfriends, TV, movies . . . bullshit. (*pounds chest*) WORK! WORK! WORK! WORK! WORK!

You work, you make money, you buy house . . . you go in melting pot, you melt. That's the American way. You know what I'm saying? Think about these things. All right. All right.

Come on, OK, that's good. A little burn, but OK. All right, that be your lunch today. . . . Double order french fries. Is good for you. Lots of vitamins. (*pats Jesus on the back*)

Don't worry. Don't worry. Don't cry. You learn how to make french fries, don't worry . . . two, three years you make as good as George. Good boy. LISA! LISA! Take over for me, I'm going to the bank. I gotta make deposit. . . . (*walks off*)

—ERIC BOGOSIAN

Ironically, if I've done a good job there's no sign of my ever being involved. A solo show is a writer/performer phenomenon, at its best it has an immediacy and energy that appears to be of the moment, an improv inspired by the particular time and place and audience. I act as facilitator to the performer's sensibility. I help translate what are often gut emotions and thoughts into a coherent, staged performance. I'm dealing with the double whammy of writer/performer in one ego so I have to develop my own strong vision for the work in order to have a criterion for making decisions. I ask a lot of questions: Why *this* character or anecdote? How does the bit differ from a TV skit or prose—how is it theatrical? Do the moments culminate in a singular vision, theme, attitude or do they just remain isolated, entertaining observations? Is the whole greater than the sum of the parts?

I edit (a lot is put aside); it's easy to be ruthless if you're not the writer. I ask the performer to make themselves more vulnerable, to not fear being awkward. Again, it's easier to push against the "popularity contest" mentality if you're not the one onstage. Trust is a big factor in this relationship. Out of the endless cycle of improvisation, writing, readings, editing, rehearsals, workshops, improvs and so on, the work finds its shape and tone and the performer can fly.

—JO BONNEY

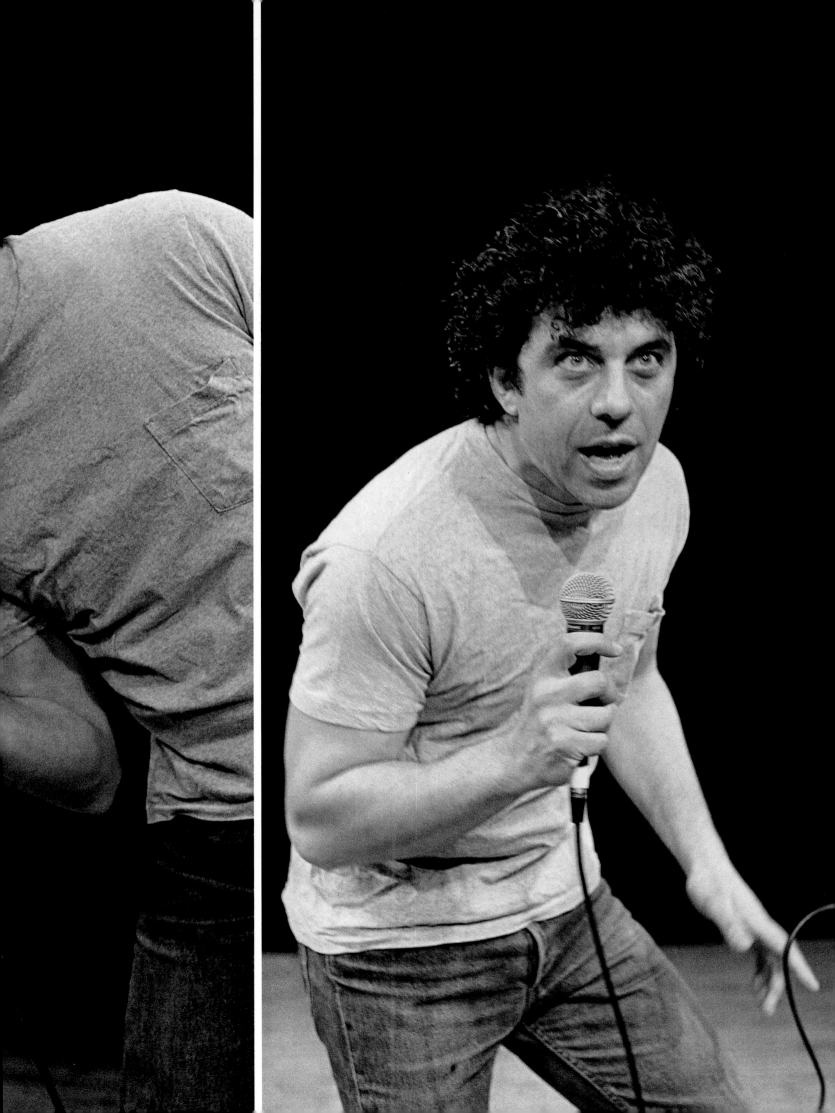

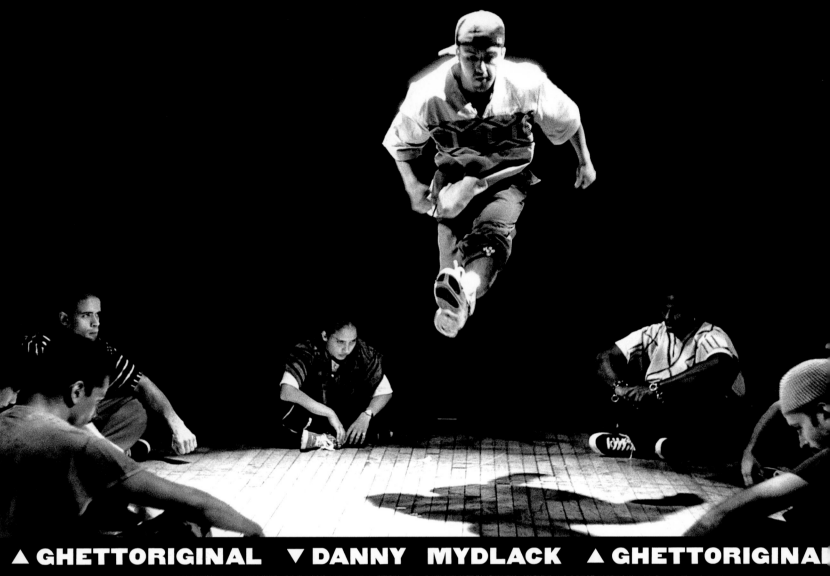

▲ GHETTORIGINAL ▼ DANNY MYDLACK ▲ GHETTORIGINAL

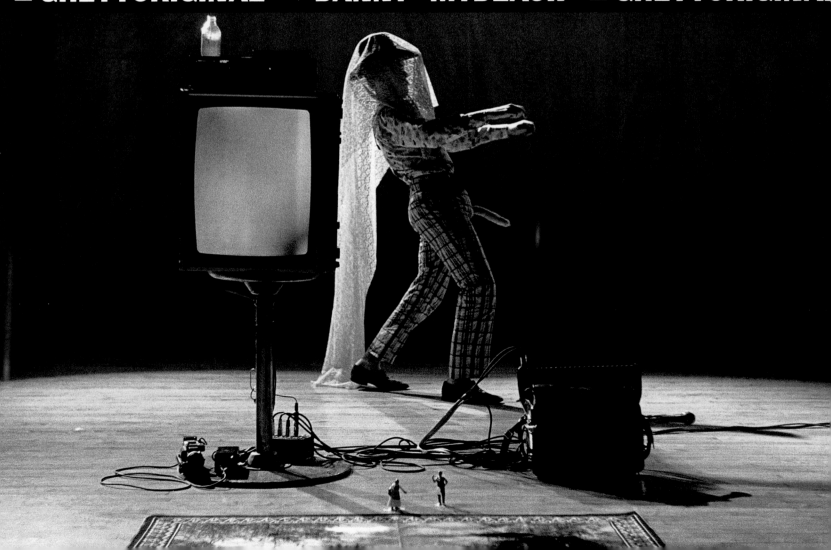

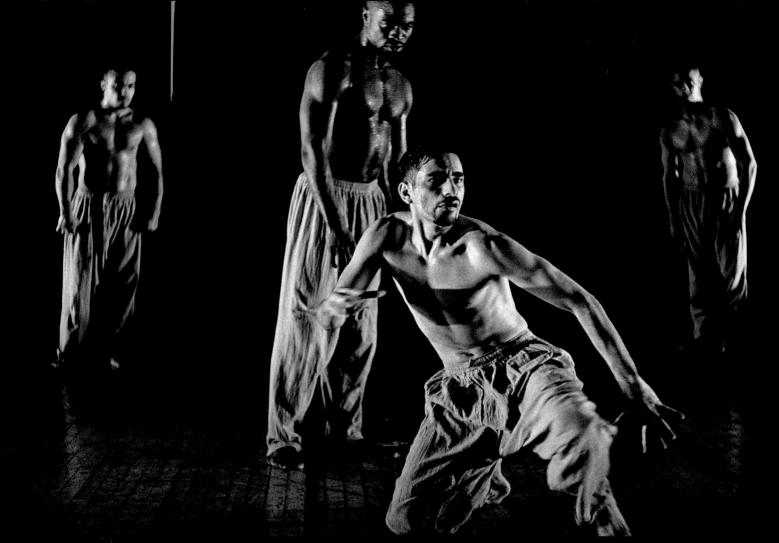

▲ GHETTORIGINAL ▼ STEPHANIE SKURA ▲ GHETTORIGINAL

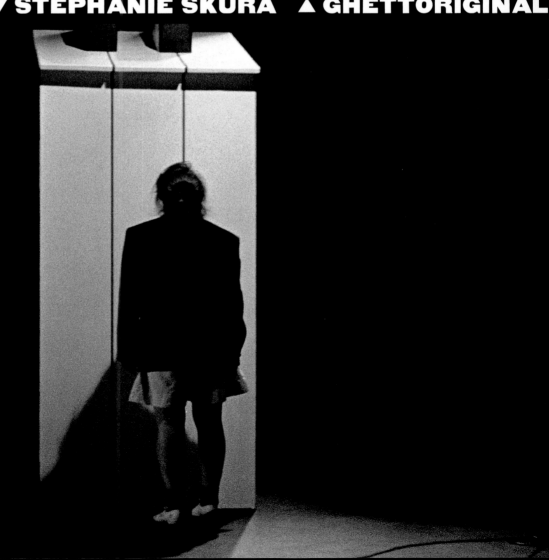

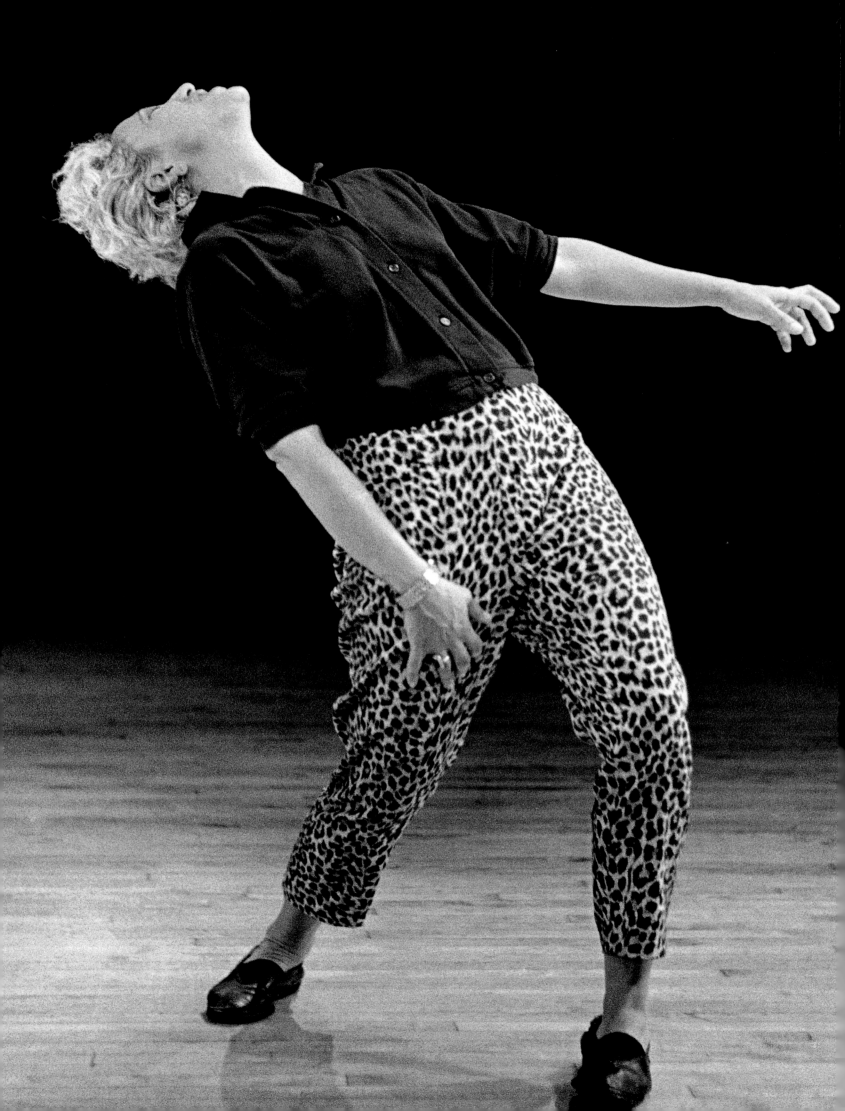

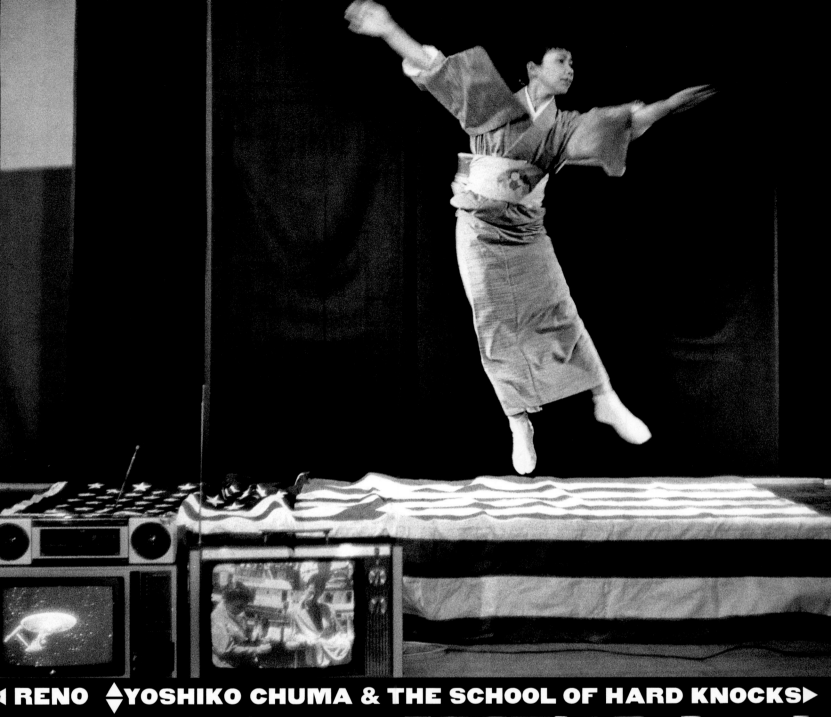

◀ RENO ⬥YOSHIKO CHUMA & THE SCHOOL OF HARD KNOCKS▶

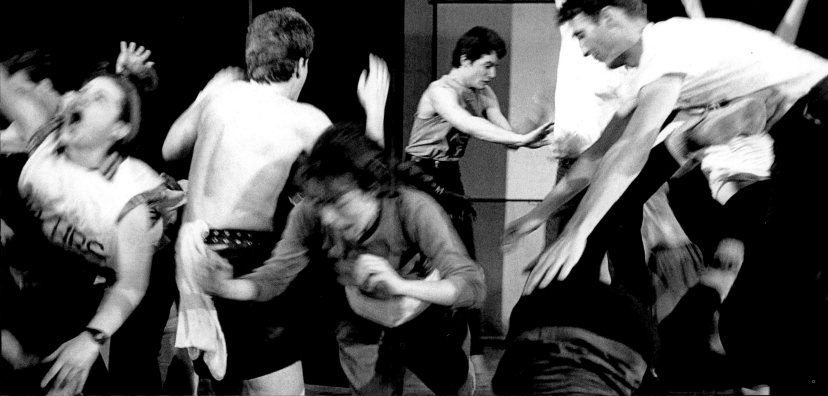

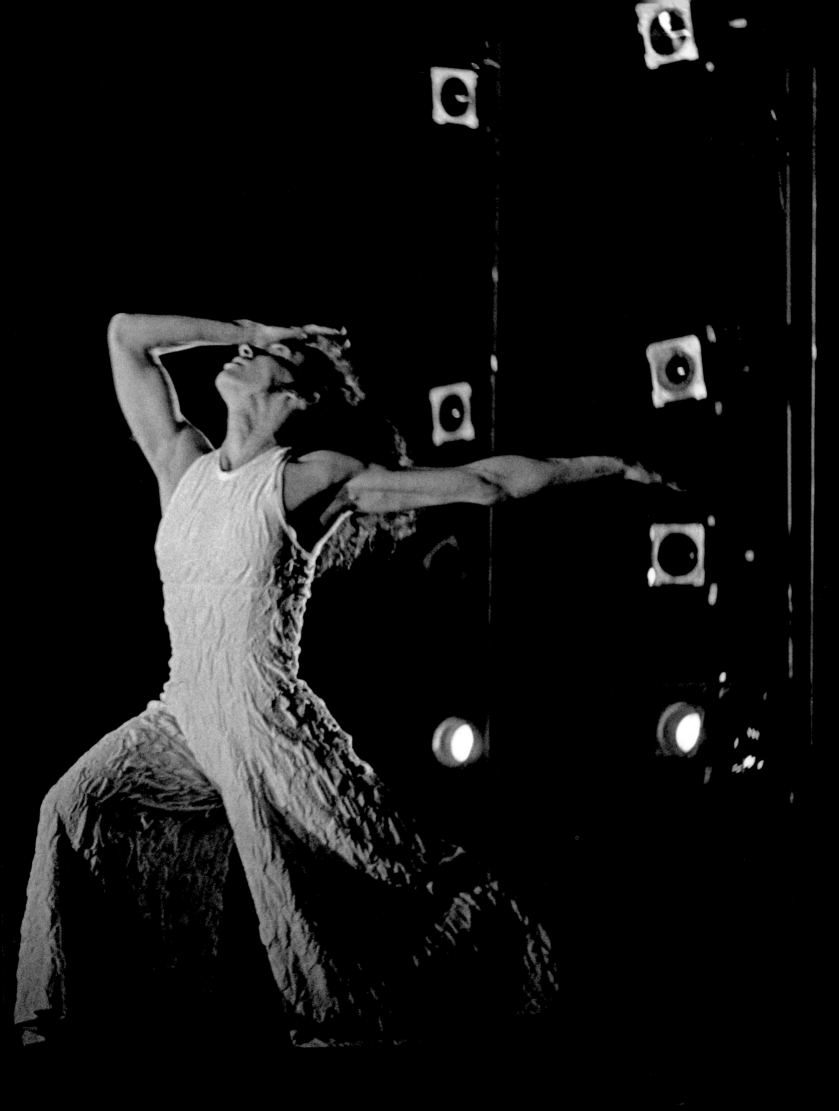

Don't you hate it when people ask you why you are what you are? As if you had any idea? All I know is I am a woman who loves another woman who most people think is a man, and that once when we were in San Diego together, okay? We checked into the best motel, the Hanalei. Polynesian from the word go. Outside a pink neon sign announces: A Taste of Aloha. You can taste it before you even check in. There's Styrofoam Easter Island heads everywhere. The bed's a volcano. Every night there's a luau. It's free, it's gratis. So of course we go. And I love the way they slip those pink plastic leis over your head. I just love that! I love the thought of those Day-Glo flowers blooming long after Jesse Helms is gone. I hope. I look out on the AstroTurf. Kids chasing each other around. Folks sipping mai-tais and piña coladas out of plastic pineapples. They've got a helluva show at the Hanalei. Hula dancers. Fire eaters. A Don Ho impersonator that's much better than the real Don Ho! Nobody cares it's not the real Polynesia. It's all the Polynesia they could take! It's the one we invented. During "Tiny Bubbles," she starts kissing me. Everybody's looking at us. But you can only see what you want to see. And what these folks want to see is not a couple of dykes making out at their luau. So that's not what they see. They start translating us into their reality. What they think they're seeing is Matt Dillon making out with a young Julie Andrews. A young Julie Andrews. Before *Victor/Victoria*. I don't mind. I'm not in the closet! I'm so far out of the closet that I've fallen out of the frame entirely. They don't have any words for us, so they can't see us, so we're safe, right? I get confused. I forget that invisibility does not ensure safety. We're not safe. We're never safe, we're just. . . . You tell me. —HOLLY HUGHES

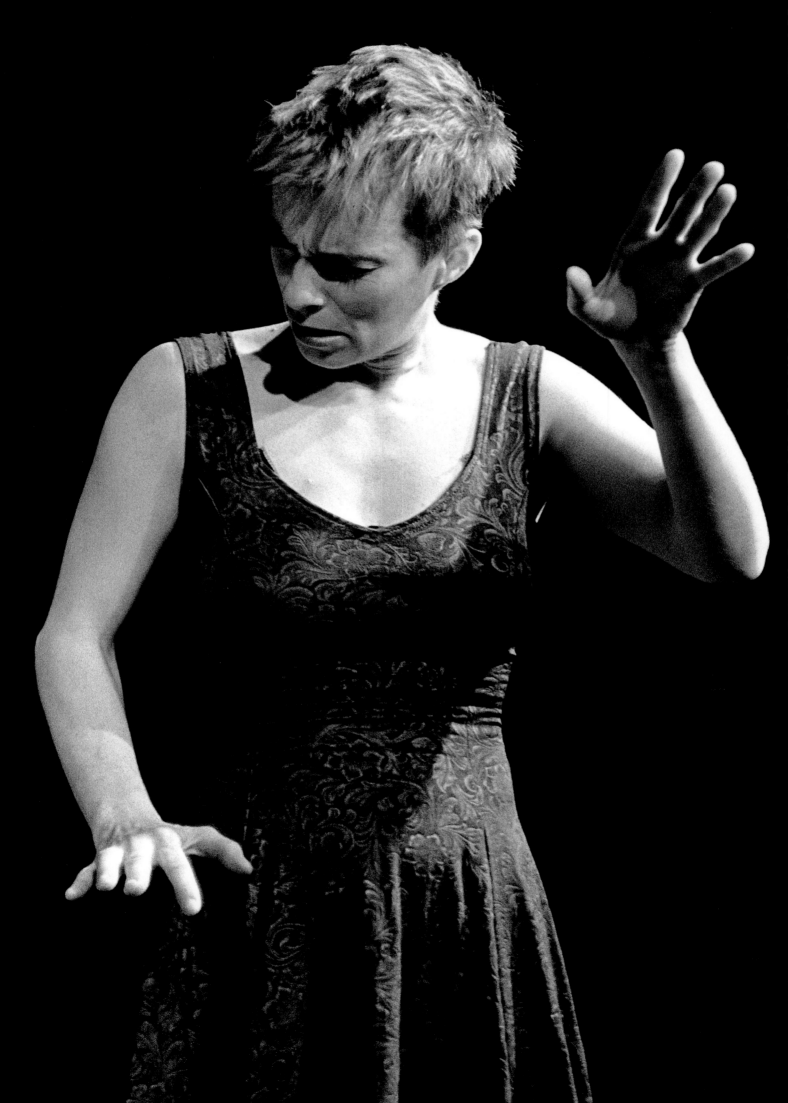

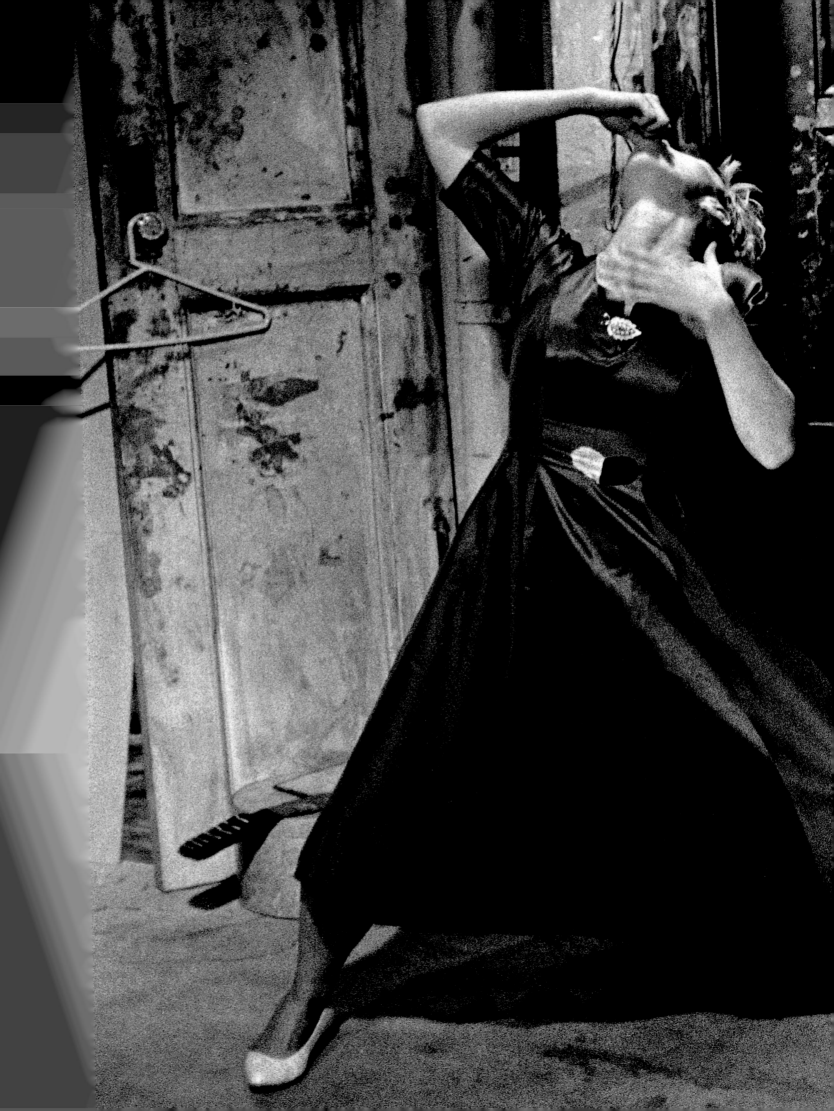

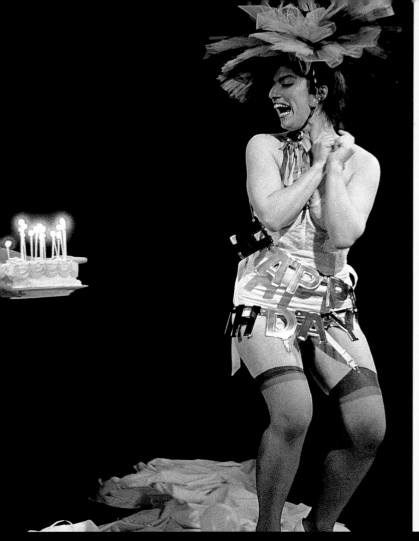
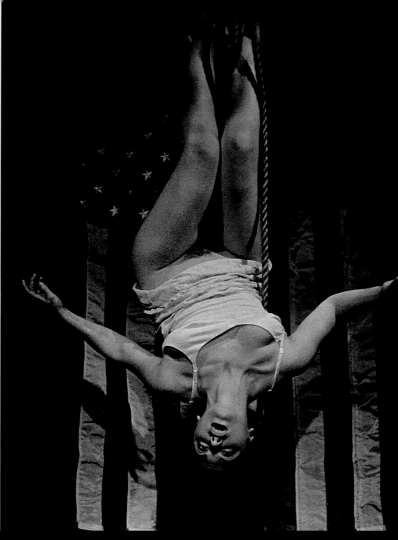

LINDA MANCINI LINDA MANCINI LINDA MANCINI LINDA

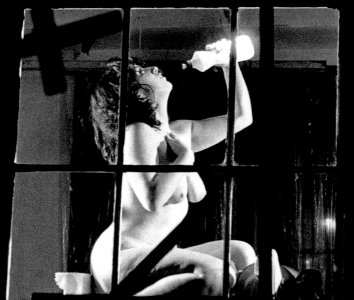
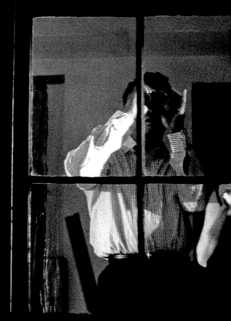

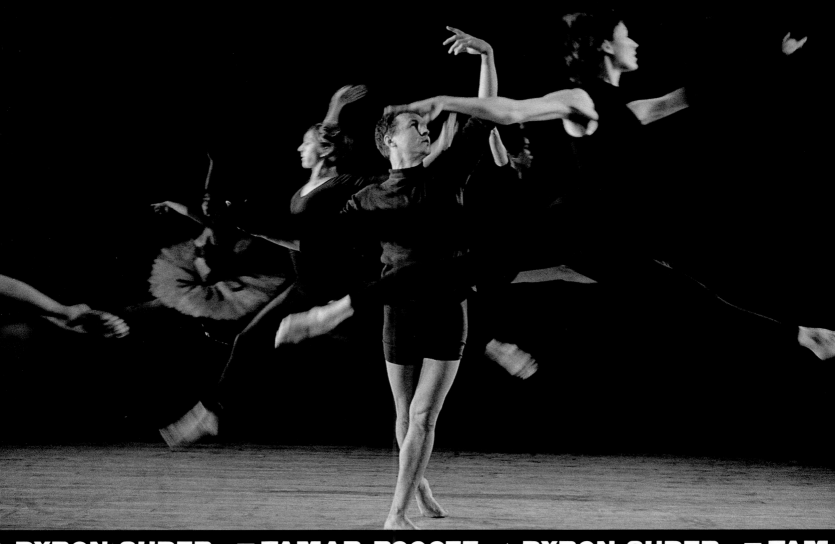

▲ BYRON SUBER ▼ TAMAR ROGOFF ▲ BYRON SUBER ▼ TAMA

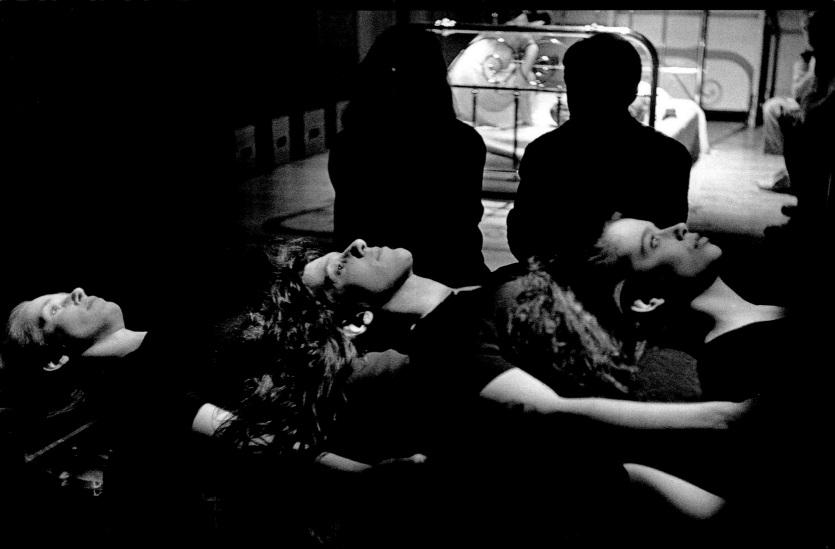

"The airport had been closed for almost two weeks; there was a ban on exit visas; Matt sleeps and dreams . . ."

"THE END OF EVERYTHING"

1. He wakes up, a wrestler defeated by his own sweaty sheet.

2. He wakes up, reassured by the sounds of lizards on his screens and parrots in the trees.

3. He wakes up, takes a piss in a green, plastic bucket, takes a short look at two unhealing sores, spits out some red foamy toothpaste, rinses his mouth with rum, takes a painful, watery, rotten-eggy shit, checks for blood, sprinkles some pine oil into the bucket . . .

4. Matt heads for the cafe. He never liked this cafe. It's in the bourgie quarter across from the Palace Hotel. It's the only one that's still open.

5. He steps over a few new bodies.

6. The heat is bearable, but just.

7. His toes curl up under, inside his boots.

8. There are more bodies than yesterday.

9. And a few left over from the day before.

10. The squads are getting sloppy. Or overworked.

11. He gets to the Palace.

12. The same woman and little girl are begging on the comer.

13. The woman is dead.

14. The girl holds a cup. Stares straight ahead.

15. A sign in her language is taped to her T-shirt.

16. It reads—"Blessed Mother, protect my precious one."

17. He drops some sweat-crumpled bills into the cup.

18. About 25½ cents U.S.

19. The girl doesn't say thank you, in her language, not even automatically.

20. He thinks, this is unusual, he thinks.

21. He thinks—she'll probably be dead by nightfall.

22. At the cafe, his favorite waitress tells him a nephew died last evening.

23. That's four people in her family this month.

24. He expresses his sorrow and orders a rum.

25. He orders a rum.

26. There's an attractive university student reading Franz Fanon at the next table.

27. There are listless parrots in huge cages.

28. There's the busboy he always overtips.

29. He orders a rum.

30. He orders a rum. This one with a bottle of Coke. With the cap still on please. And, he adds needlessly— Of course without ice.

31. He strains to see the headlines on the cute student's newspaper.

32. Death toll, as always, in the upper right corner. And assurances that scientific help is coming from the outside. A message from the First Lady. Something about the World Futbol Cup.

33. And a factory nearby that manufactures binary chemical weapons has been taken over by . . .

34. But the attractive student's nose has begun to bleed.

35. Badly.

36. And people are running down the street past the Palace Hotel. Ripping up shrubbery. Throwing paving stones.

37. It's a lot like TV.

38. The waitress gives the attractive student a kitchen rag and tilts his head back.

39. More people are running screaming in the streets.

40. The parrots wake up to beat their wings against the bars of their cages.

41. He hears what could be fire-crackers or gunshots or mortar fire and he thinks he really should learn the difference.

42. He thinks out loud—"What I should do is get my black ass back to New York and fast."

43. Paving stones are being thrown at the cafe. Tables overturned.

44. The busboy says, "Follow me, you'll be safe," and leads him into the walk-in box.

45. All he can hear is the sound of the motor. All he can feel is cool air. All he can smell is fresh clean blood.

46. The busboy says in his language, *we'll* be safe here.

47. The busboy sticks his tongue in his mouth.

48. Matt thinks of Elizabeth's latest letter asking why he doesn't come home and take that teaching job.

49. The busboy unbuttons Matt's pants, pulls them down and spins him around 180.

50. He thinks of his father teaching him to ride a two-wheeler.

51. He supports himself holding onto the cold slimy carcasses of two calves hanging from meat hooks— skinny as dogs.

52. He hears the busboy's pants unzip behind him and he thinks of paintings by Francis Bacon.

53. The busboy slaps his ass.

54. He hears a loud explosion out beyond the heavy metal door and the cool. More screams. More breaking glass. More parrot squawks and firecrackers.

55. "Your legs are very beautiful but what are those marks," asks the busboy in his language.

56. "It's the end," Matt answers.

57. Then, "No, it's not the end."

58. His fingers dig into the fat and muscle of the two hanging calves.

59. The busboy orders, "Relax!"

60. It's not the end. It's the beginning.

The beginning of the end of everything.
—ISHMAEL HOUSTON-JONES

FROM "THEM"

I saw them once. I don't know when or who they were because they were too far away, but I remember certain things, like what they wore, which wasn't anything special—pants, shirts, regular colors—stuff I've seen thousands of times since. I wanted them to know something. I cupped my hands around my mouth and thought about yelling out, but they wouldn't have heard me. Besides, I didn't belong there. So I sat on a rock and watched them. For some reason, it still matters years later. I thought about love. I think I confused what they did with it. But my belief made the day great. I think I decided to make that my goal, to be like them. I put such incredible faith in the future that I sobbed a little, I think. I can't believe I once felt what I'm talking about. Those tangled guys have become an abstraction, a gesture, a recreation. I wish I'd taken a photo of them. Then I could rip it up because I'm tired of dreaming of what they implied every night of my life, or whenever I close my eyes, whichever comes first. I thought it mattered. It does and it doesn't. They're very beautiful back there, but put all that feeling in motion now and try to make it explode in your face. It can't. It's not built to do that. But they're still there, no matter how I misremember them. And refining whatever it was they were doing is all I can do now. To sit here and see them again, no matter how cold it looks. It wasn't.
—DENNIS COOPER

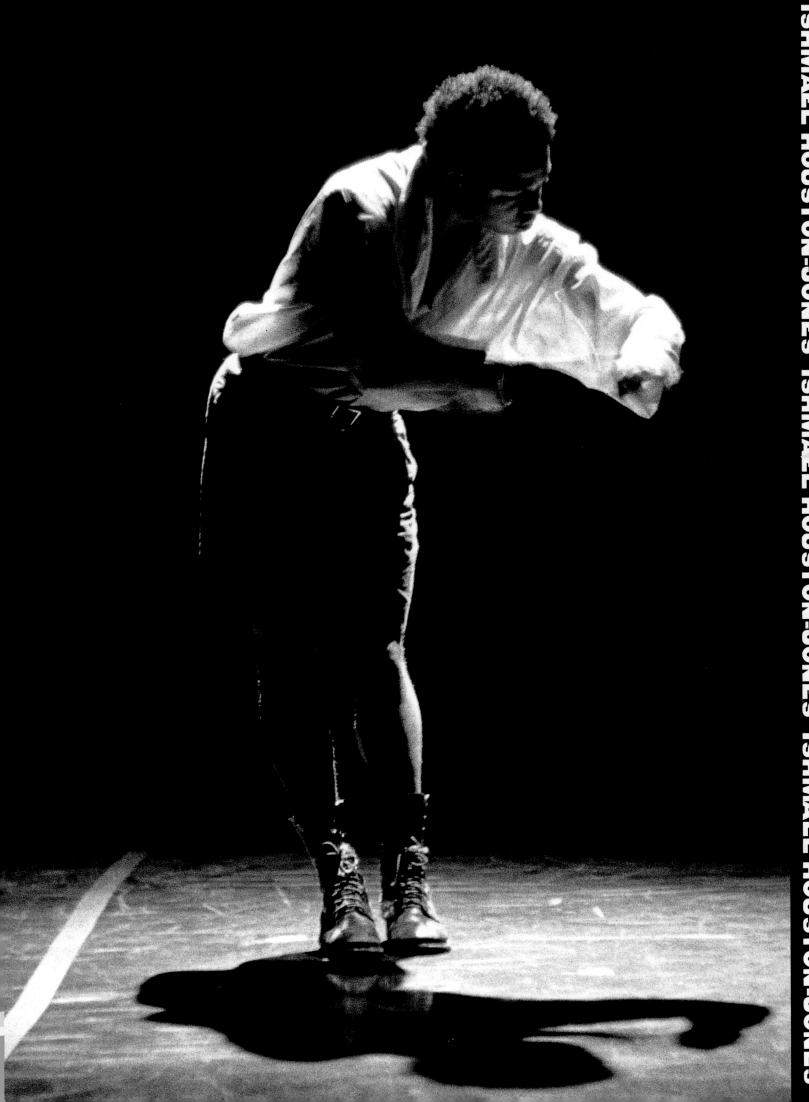

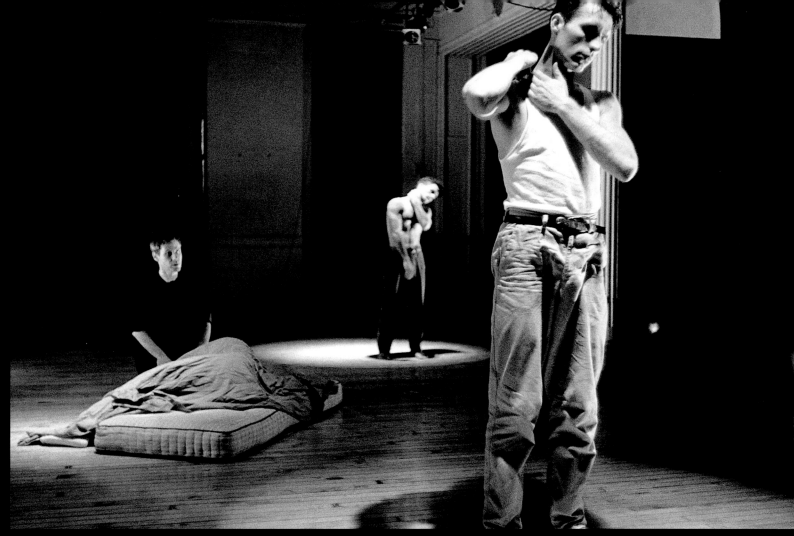

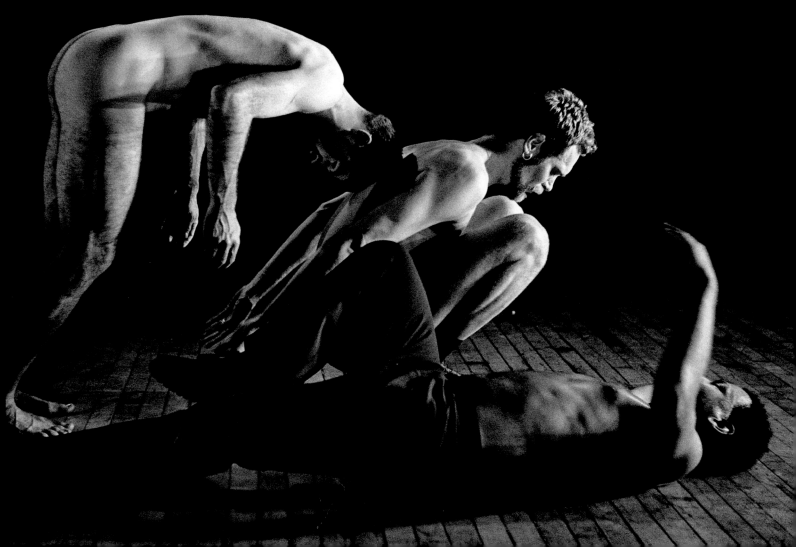

▲HOUSTON-JONES DENNIS COOPER & CHRIS COCHRANE

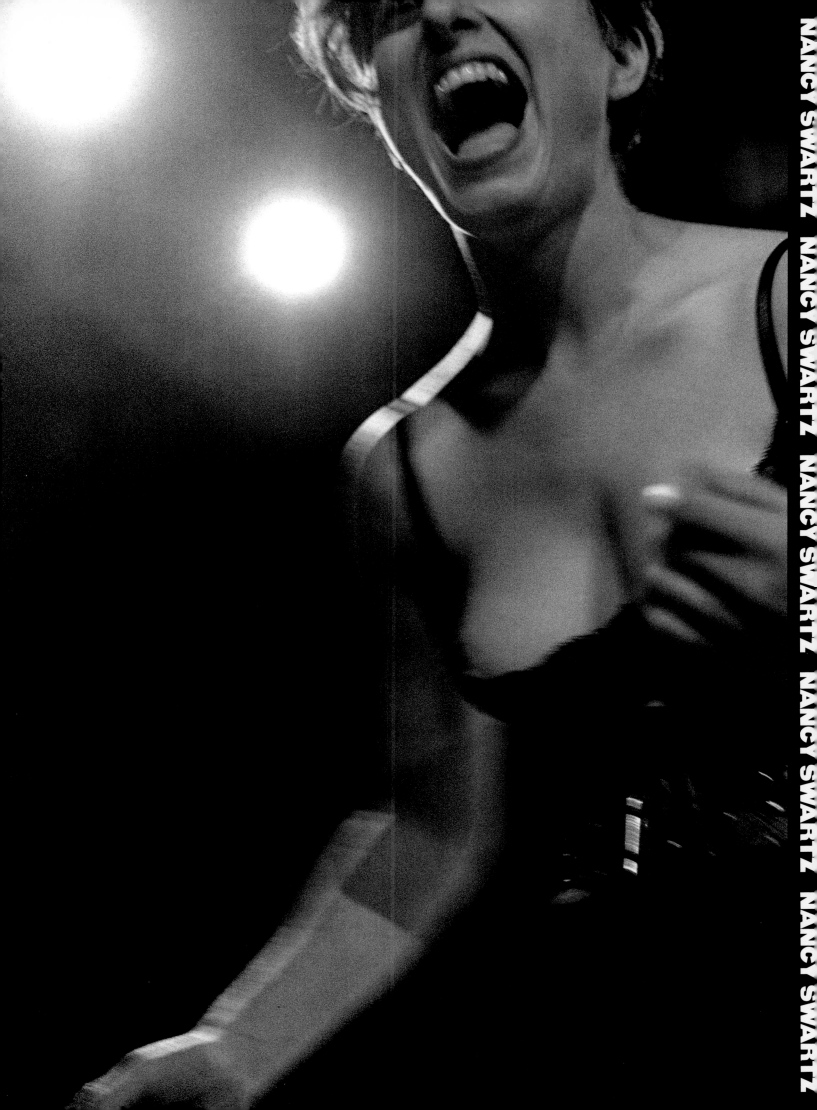

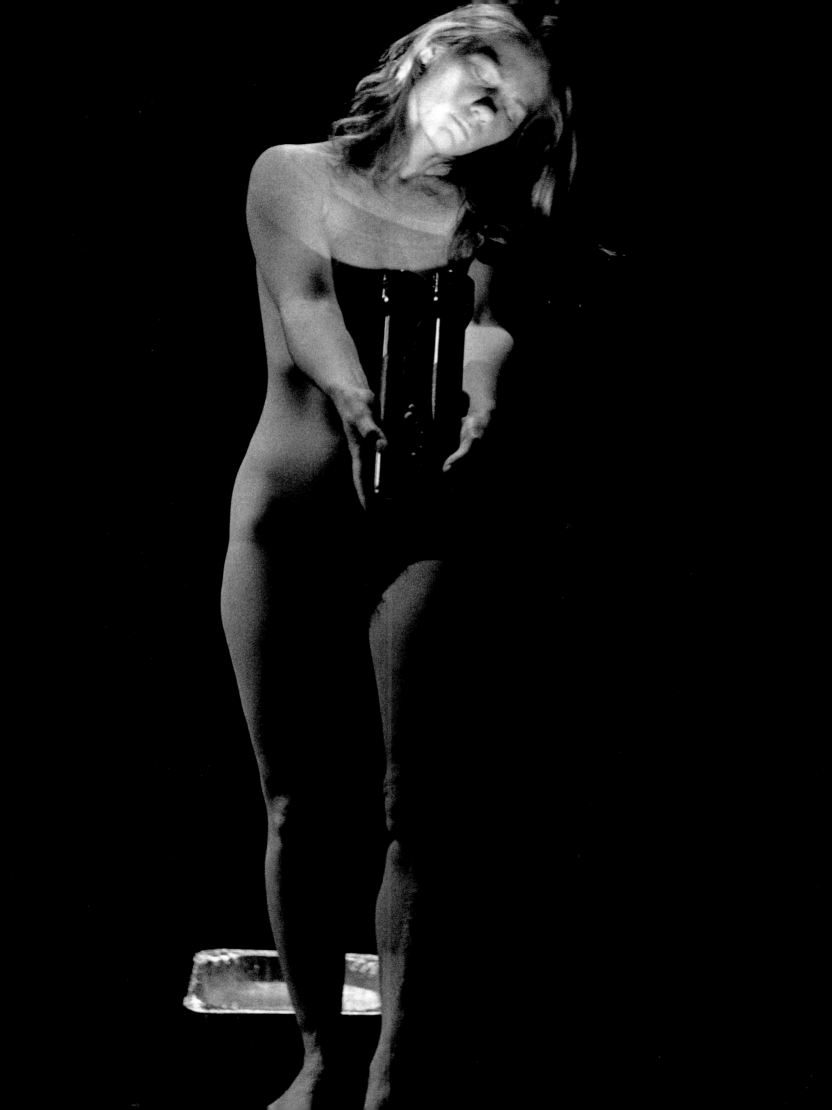

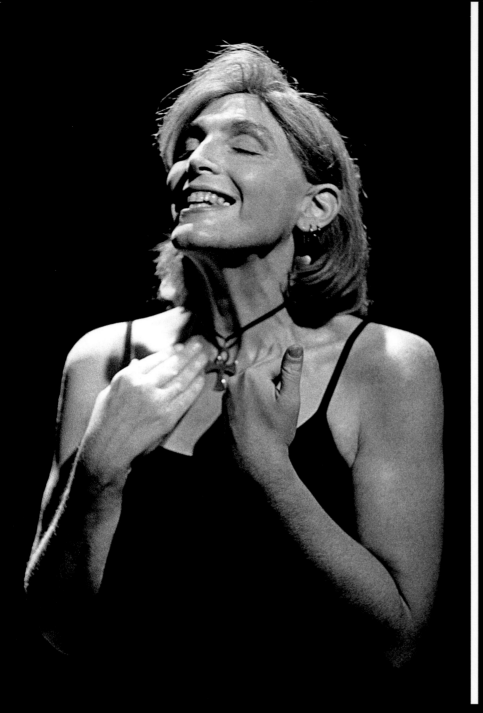

FROM "VIRTUALLY YOURS"

"Tell me something about yourself you have never told anyone," she says to me in a voice that has never known the need for a microphone. And here is what I said:

As a child, you see, my little friends chased after moonbeams and true love. I chased after something slightly more elusive: a 4,000 watt spotlight. "Catch me if you can," the light cried out to me, "catch me if you can." And when I finally caught it, the light whispered to me, "Now I will never set you free." "Thank you for your story, my daughter, my sister, my lover," she says to me, "Now here is a gift for you. This is the way you shall know that Death is approaching: You have a sudden, perfect vision of yourself. You see it all, and you are beautiful. And you will wish that moment of your own perfect beauty to last forever. Then, you die. How painful is your death depends upon how ready you are to relinquish your own perfection. To die well," she tells me, "simply practice achieving perfection and tossing it aside, over and over again." —KATE BORNSTEIN

▼ JENNIFER MILLER ▲ KATE BORNSTEIN ▼ SALLEY MAY

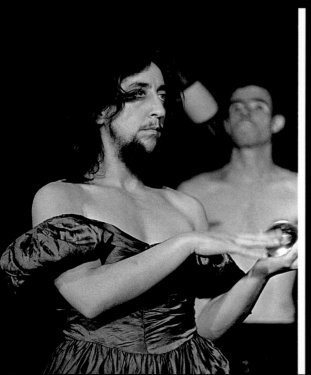

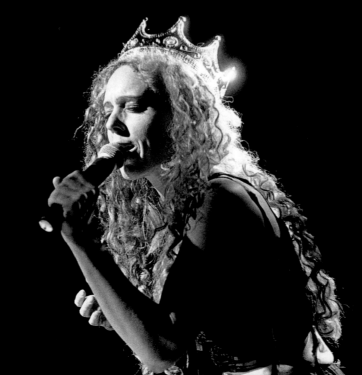

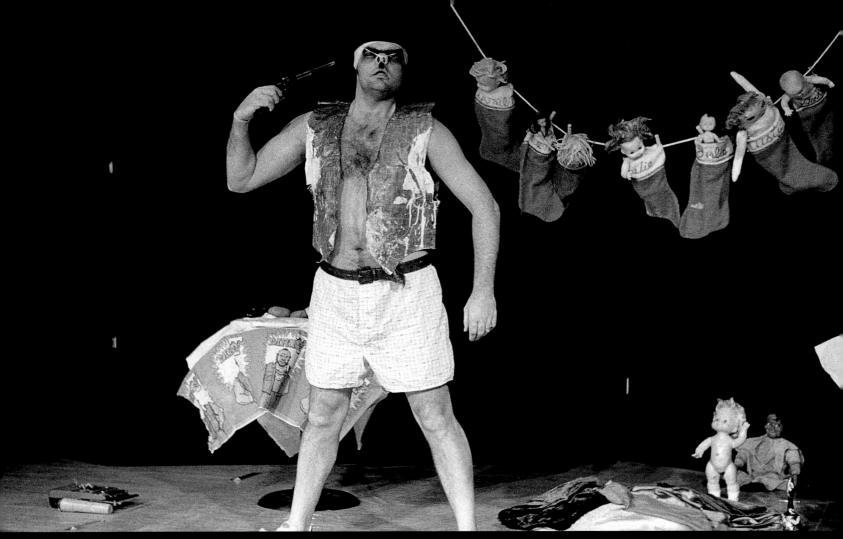

▲ HARRY KIPPER ▼ WOOSTER GROUP ▲ HARRY KIPPEF

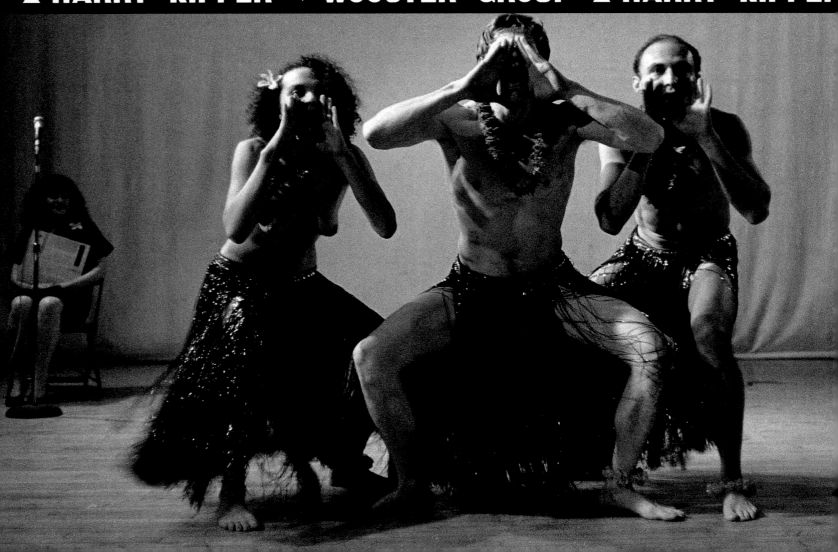

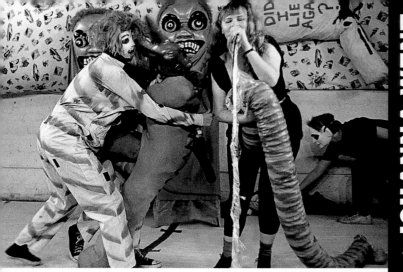

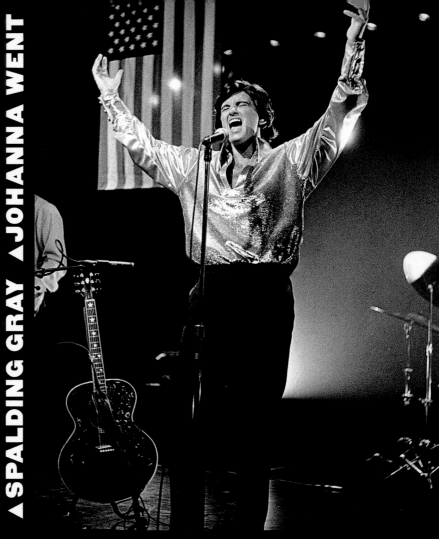

△SPALDING GRAY △JOHANNA WENT

▽ALIEN COMIC △SPALDING GRAY ▽MIKE BIDLO △PHRANC

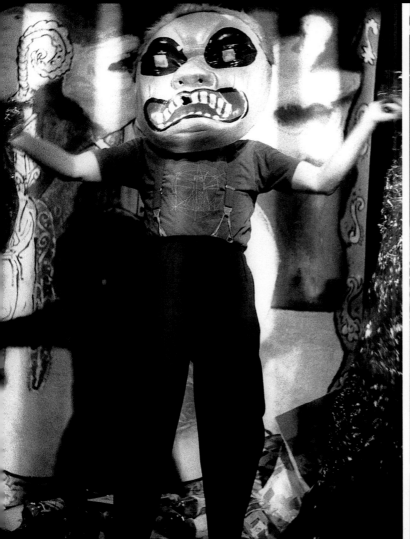

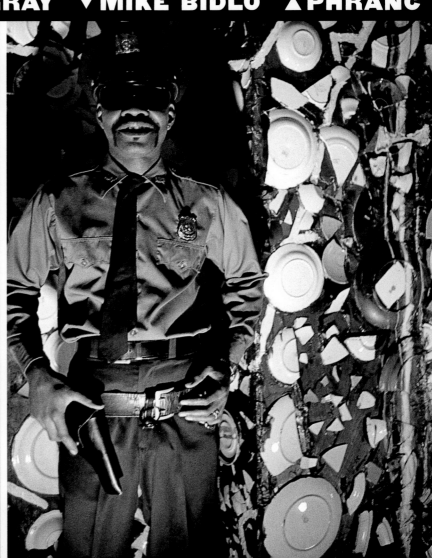

FROM "MEMORIES THAT SMELL LIKE GASOLINE"

Sometimes I come to hate people because they can't see where I am. I've gone empty, completely empty and all they see is the visual form; my arms and legs, my face, my height and posture, the sounds that come from my throat. But I'm fucking empty. The person I was just one year ago no longer exists; drifts spinning slowly into the ether somewhere way back there. I'm a xerox of my former self. I can't abstract my own dying any longer. I am a stranger to others and to myself and I refuse to pretend that I am familiar or that I have history attached to my heels. I am glass, clear empty glass. I see the world spinning behind and through me. I see casualness and mundane effects of gesture made by constant populations. I look familiar but I am a complete stranger being mistaken for my former selves. I am a stranger and I am moving. I am moving on two legs soon to be on all fours. I am no longer animal vegetable or mineral. I am no longer made of circuits or disks. I am no longer coded and deciphered. I am all emptiness and futility. I am an empty stranger, a carbon copy of my form. I can no longer find what I'm looking for outside of myself. It doesn't exist out there. Maybe it's only in here, inside my head. But my head is glass and my eyes have stopped being cameras, the tape has run out and nobody's words can touch me. No gesture can touch me. I've been dropped into all this from another world and I can't speak your language any longer. See the signs I try to make with my hands and fingers. See the vague movements of my lips among the sheets. I'm a blank spot in a hectic civilization. I'm a dark smudge in the air that dissipates without notice. I feel like a window, maybe a broken window. I am a glass human. I am a glass human disappearing in rain. I am standing among all of you waving my invisible arms and hands. I am shouting my invisible words. I am getting so weary. I am growing tired. I am waving to you from here. I am crawling around looking for the aperture of complete and final emptiness. I am vibrating in isolation among you. I am screaming but it comes out like pieces of clear ice. I am signaling that the volume of all this is too high. I am waving. I am waving my hands. I am disappearing. I am disappearing but not fast enough.

—DAVID WOJNAROWICZ

THE PATECHISM OF CLICHÉ

(with a deliberate nod to Myles na Gopaleen)

what forms of address are all relative?

lookit sister, hey baby, pretty mama, and oh brother

the query thru which significant movement is designated?

what's happening

the successful pursuit of everything—

or nothing in particular is called?

getting it together

yet somehow laws of physics notwithstanding,

disparate elements manage to?

keep it together

to what distance are extraordinary events relegated?

far out

through what extremes in temperature

must one project socially?

to look hot and be cool

from what arduous extension must one remain flexible?

to hang loose

a verb to the negative and a common mispronunciation

of a specific article?

dis

what common word compares everything to nothing?

like

can you use it in a sentence

like, like I was just trying to get it together, know what I mean?

what coital exercise connotes an impass?

fucked

and in what direction?

up

is that all?

no, sometimes over

use this word so it offends!

fuck you

use this word so it extends—

unbefuckinglievable

makes amends—

fucked up

use it so it has meaning—

making love

by what congenital inhalation are all negativists known?

they suck

OK, now what bridges the gap between a passive fifties

card game and the active jogging leisure of today?

the running suit

what common article of clothing now

unfortunately inspires comment?

a fur coat

by what announcement do nationalities

recognize their inherent drawbacks?

kiss me I'm polish!

what state of extended animation has become

the popular meditation of the west?

the stairmaster

in what direction is this uplifting activity performed?

getting down

make this term express meaning

getting it on

one's idiosyncratic development is known as?

my thing

the relative weight to which all feats are accorded?

heavy

what visceral mess are things frequently not worth?

a shit

from what is one's behavior homogenized,

relative to and forgiven?

your sign

utter a common agreement

no problem

the form of address that bands the community

of contemporary awareness?

YO!

what exiting flux of temperature indicates the gradual

loosening of one's anxieties?

chilling out

what butchered livestock airs discontent?

beef

withdrawal from a partitioning structure that

indicates instability?

off the wall

a density necessary to call?

a hard one

an inappropriate adverb used to stop all further discussion?

not

the call for mathematics that indicates lunacy?

go figure

by comparison you are a sorry fraction thereof?

my better half

the collection of those bound by

chromosomal and social ties?

the family unit

a person from outer space in your inner space?

my significant other

you are unable to mess up by yourself, you are

co-dependent

what is a relationship that fulfills no one's definition?

dysfunctional

the accepted term for lying and cheating?

denial

and what might this measure be placed under?

terms of endearment

is this killing you?

yes

last one, how does one relegate a

12 hour cycle to cosmetic mediocrity?

have a nice day?

—PAT OLESZKO

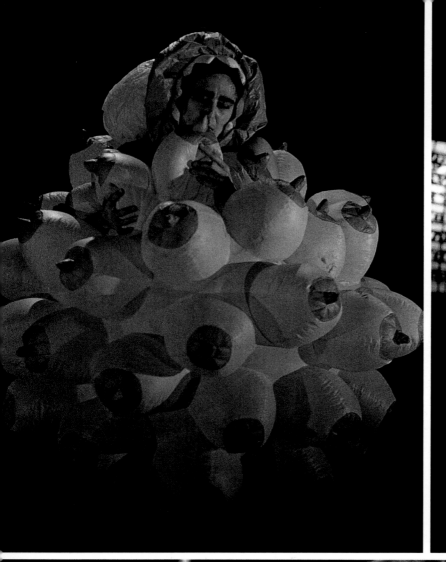

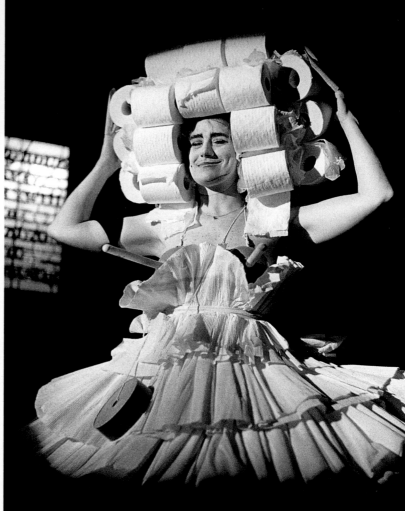

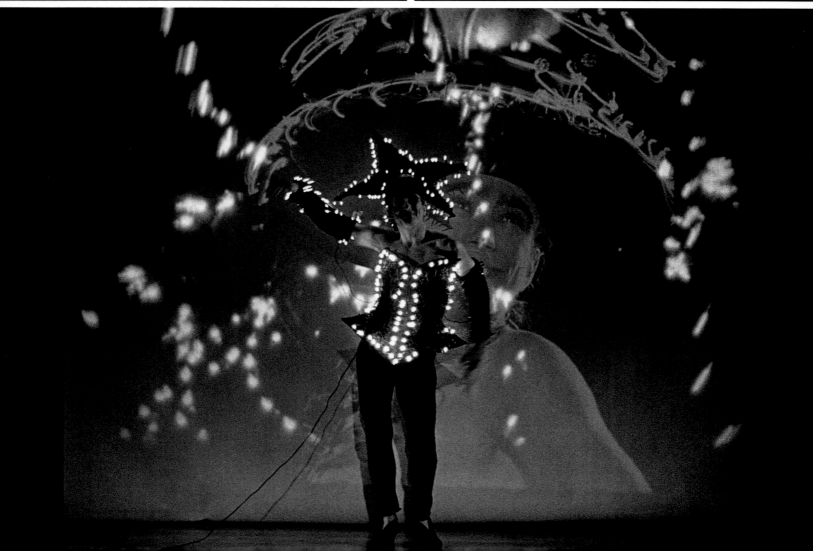

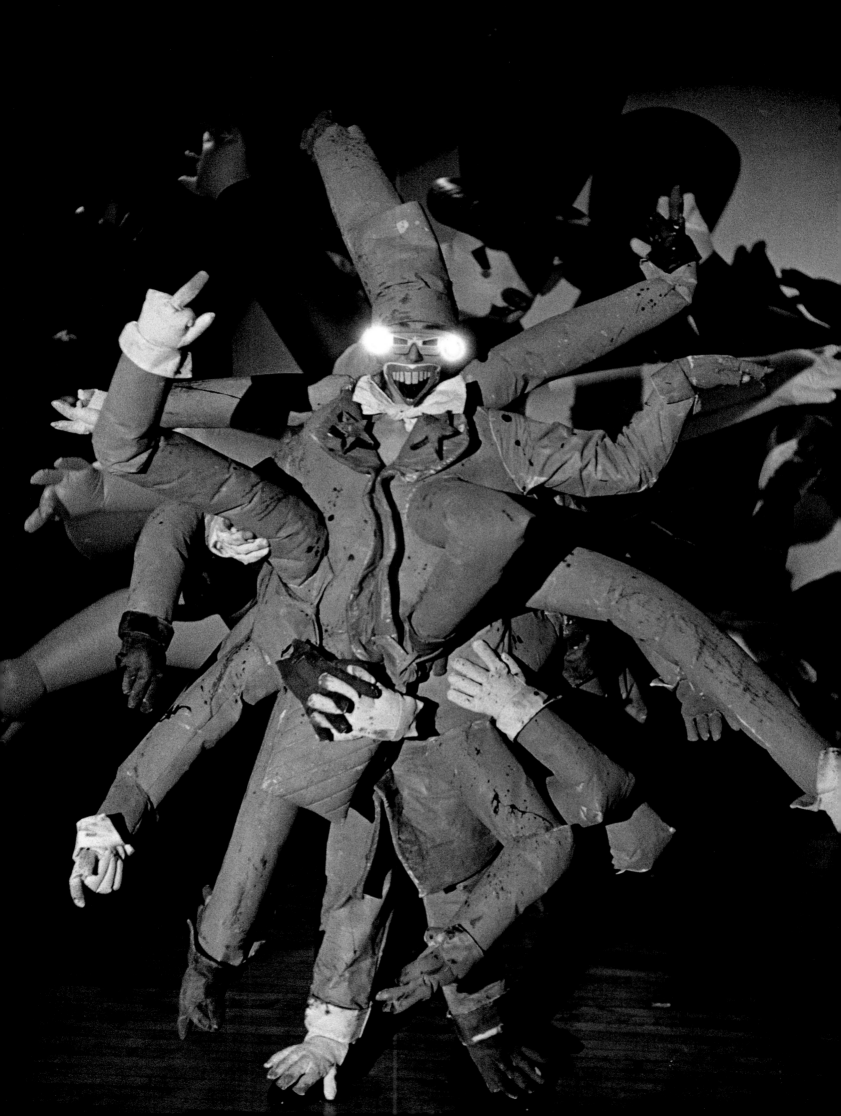

BETH LAPIDES BETH LAPIDES BETH LAPIDES BETH LAPIDES

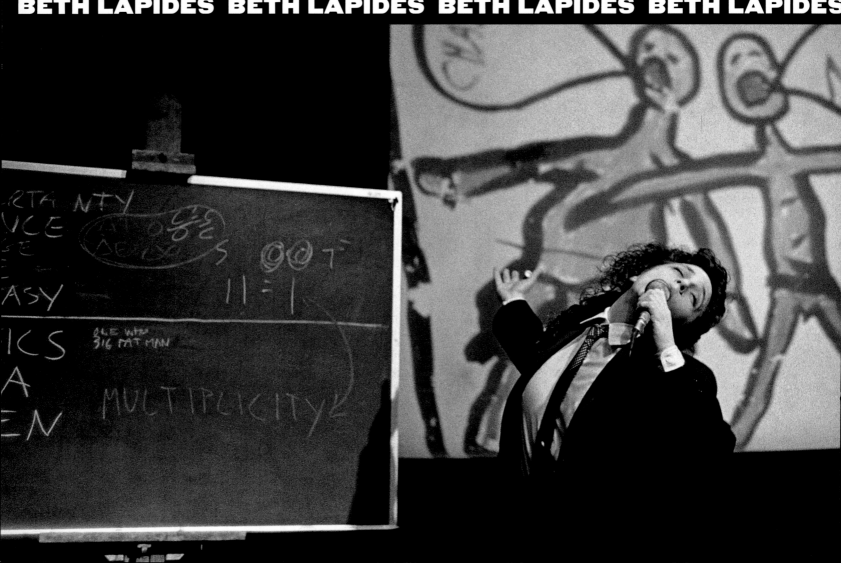

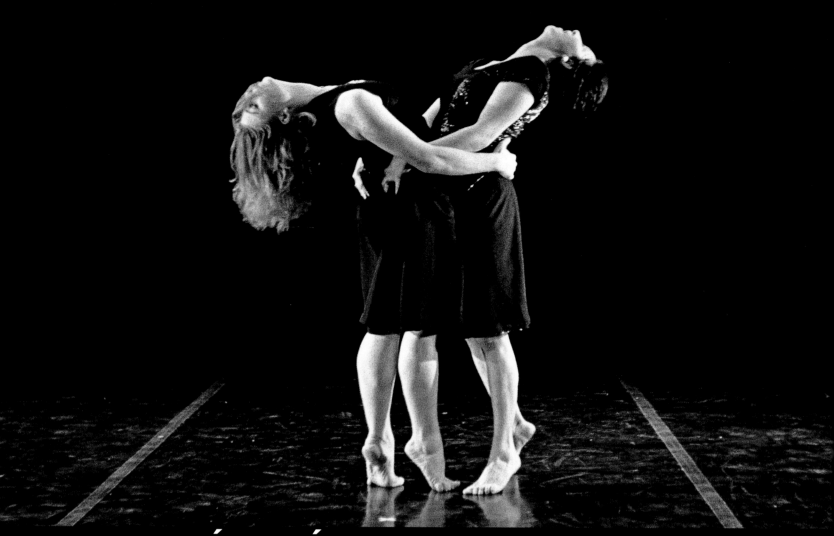

▲ NURIA OLIVÉ-BELLÉS ▼ NINA MARTIN ▶ STEVE SHILL

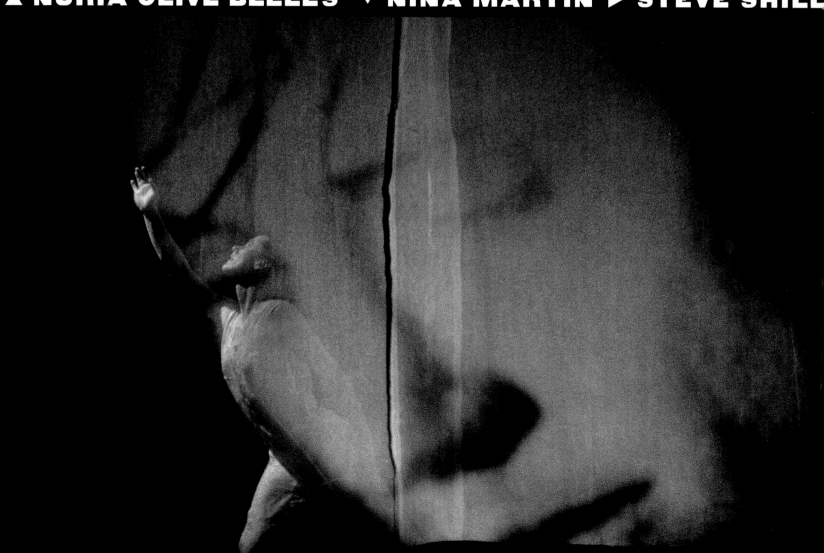

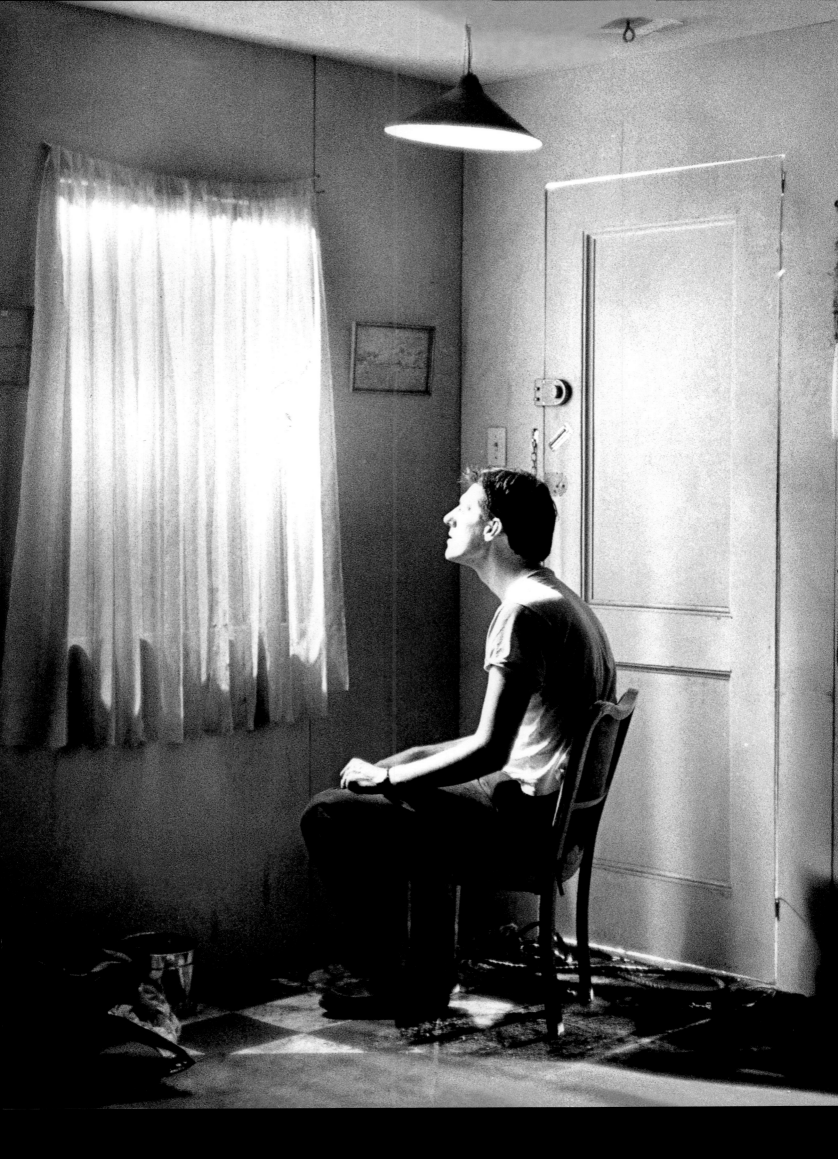

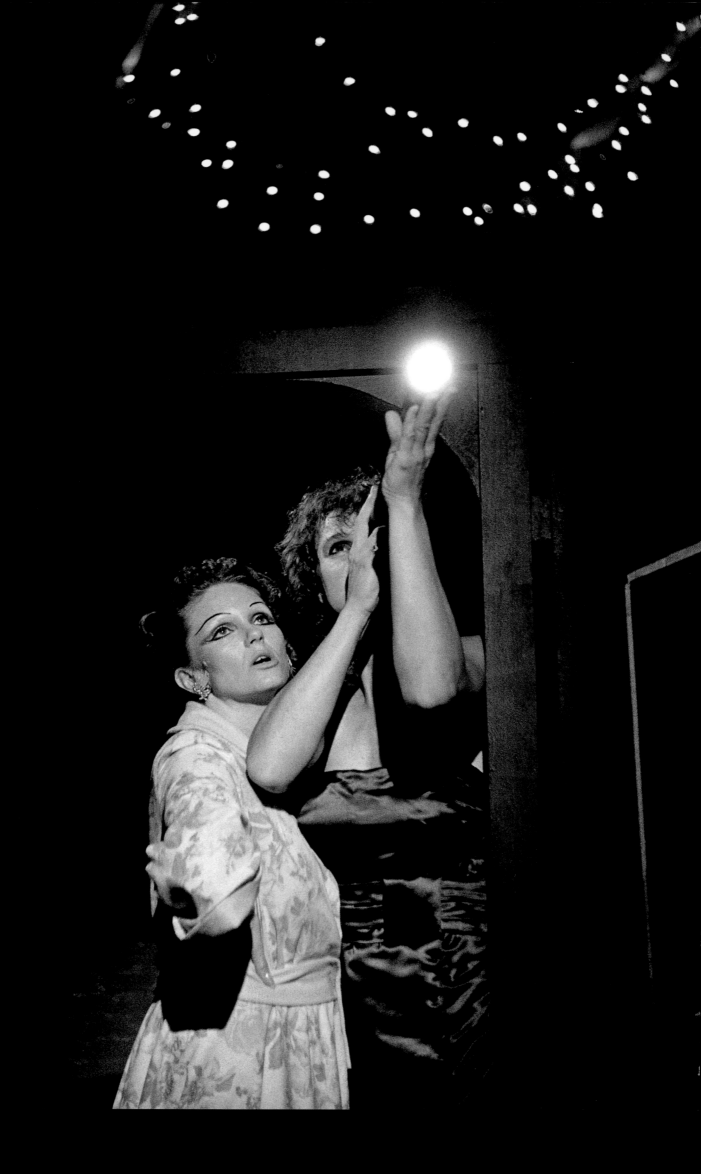

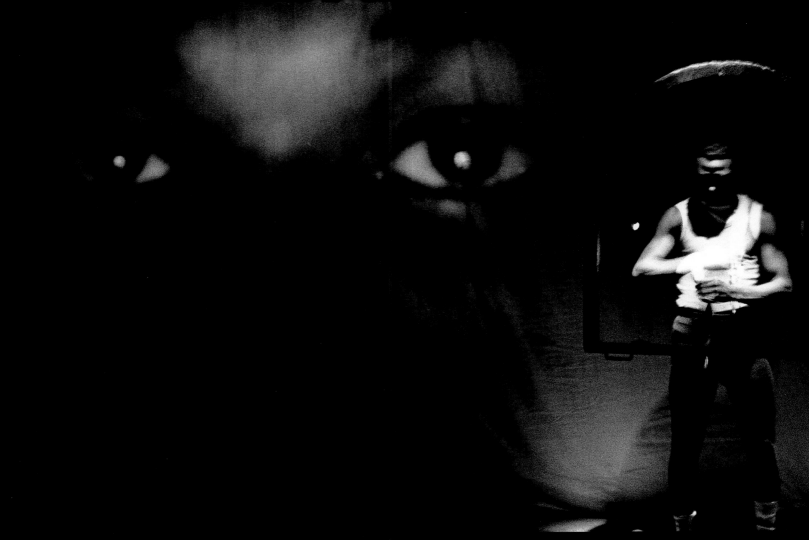

RED HOLLAND FRED HOLLAND FRED HOLLAND FRED HOLLAND

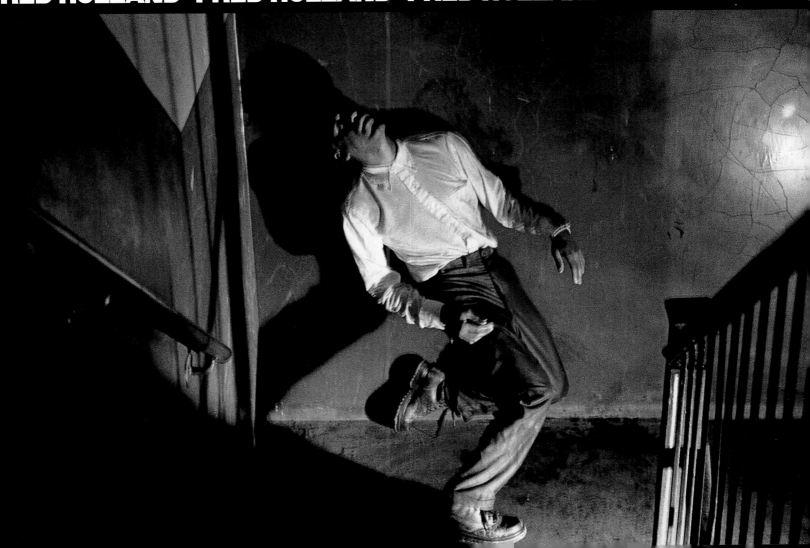

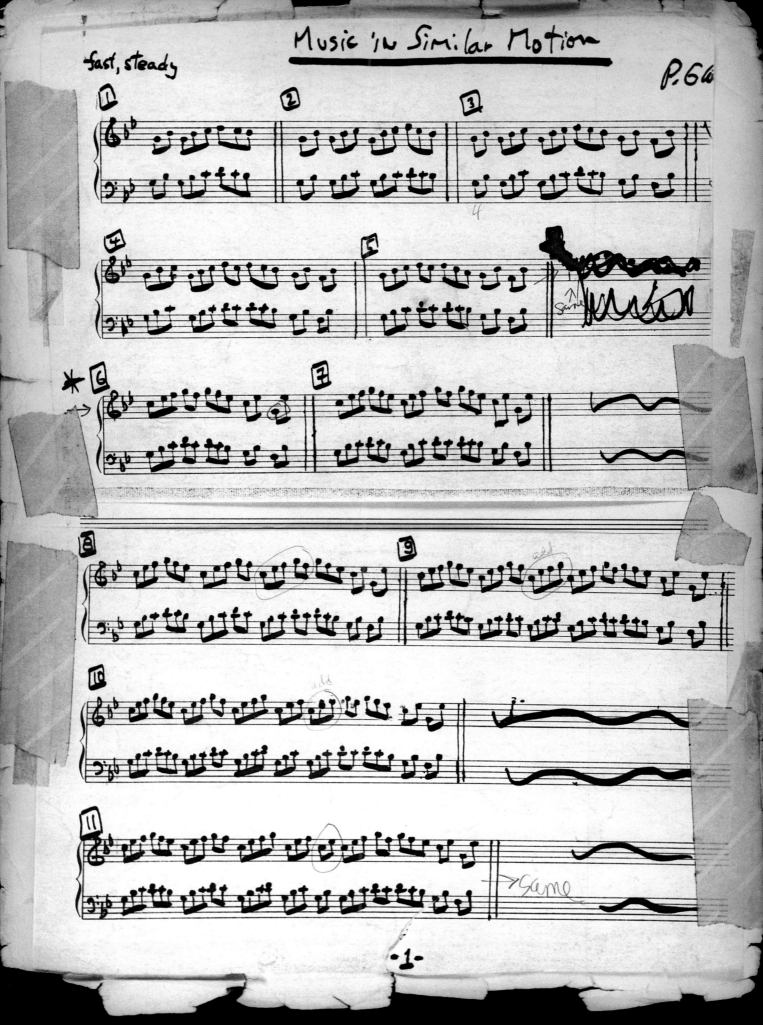

—PHILIP GLASS

Said the Presidential skeleton
I won't sign the bill
Said the Speaker skeleton
Yes you will

Said the Representative skeleton
I object
Said the Supreme Court skeleton
Whaddya expect

Said the Military skeleton
Buy Star Bombs
Said the Upperclass skeleton
Starve unmarried moms

Said the Yahoo skeleton
Stop dirty art
Said the Right Wing skeleton
Forget about yr heart

Said the Gnostic skeleton
The Human Form's divine
Said the Moral Majority skeleton
No it's not it's mine

Said the Buddha skeleton
Compassion is wealth
Said the Corporate skeleton
It's bad for your health

Said the Old Christ skeleton
Care for the Poor
Said the Son of God skeleton
AIDS needs cure

Said the Homophobe skeleton
Gay folk suck
Said the Heritage Policy skeleton
Blacks're outta luck

Said the Macho skeleton
Women in their place
Said the Fundamentalist skeleton
Increase human race

Said the Right-to-Life skeleton
Foetus has a soul
Said Pro-Choice skeleton
Shove it up your hole

Said the Downsized skeleton
Robots got my job
Said the Tough-on-Crime skeleton
Tear-gas the mob

Said the Governor skeleton
Cut school lunch
Said the Mayor skeleton
Eat the budget crunch

Said the Neo-Conservative skeleton
Homeless off the street!
Said the Free Market skeleton
Use 'em up for meat

Said the Think Tank skeleton
Free Market's the way
Said the S&L skeleton
Make the State pay

Said the Chrysler skeleton
Pay for you & me
Said the Nuke Power skeleton
& me & me & me

Said the Ecologic skeleton
Keep Skies blue
Said the Multinational skeleton
What's it worth to you?

Said the NAFTA skeleton
Get rich, Free Trade,
Said the Maquiladora skeleton
Sweat shops, low paid

Said the rich GATT skeleton
One world, high tech
Said the Underclass skeleton
Get it in the neck

Said the World Bank skeleton
Cut down your trees
Said the I.M.F. skeleton
Buy American cheese

Said the Underdeveloped skeleton
Send me rice
Said Developed Nations' skeleton
Sell your bones for dice

Said the Ayatollah skeleton
Die writer die
Said Joe Stalin's skeleton
That's no lie

Said the Petrochemical skeleton
Roar Bombers roar!
Said the Psychedelic skeleton
Smoke a dinosaur

Said Nancy's skeleton
Just say No
Said the Rasta skeleton
Blow Nancy Blow

Said Demagogue skeleton
Don't smoke Pot
Said Alcoholic skeleton
Let your liver rot

Said the Junkie skeleton
Can't we get a fix?
Said the Big Brother skeleton
Jail the dirty pricks

Said the Mirror skeleton
Hey good looking
Said the Electric Chair skeleton
Hey what's cooking?

Said the Talkshow skeleton
Fuck you in the face
Said the Family Values skeleton
My family values mace

Said the N.Y. Times skeleton
That's not fit to print
Said the C.I.A. skeleton
Cantcha take a hint?

Said the Network skeleton
Believe my lies
Said the Advertising skeleton
Don't get wise!

Said the Media skeleton
Believe you me
Said the Couch-Potato skeleton
What me worry?

Said the TV skeleton
Eat sound bites
Said the Newscast skeleton
That's all Goodnight
—ALLEN GINSBERG,
February 12–16, 1995.

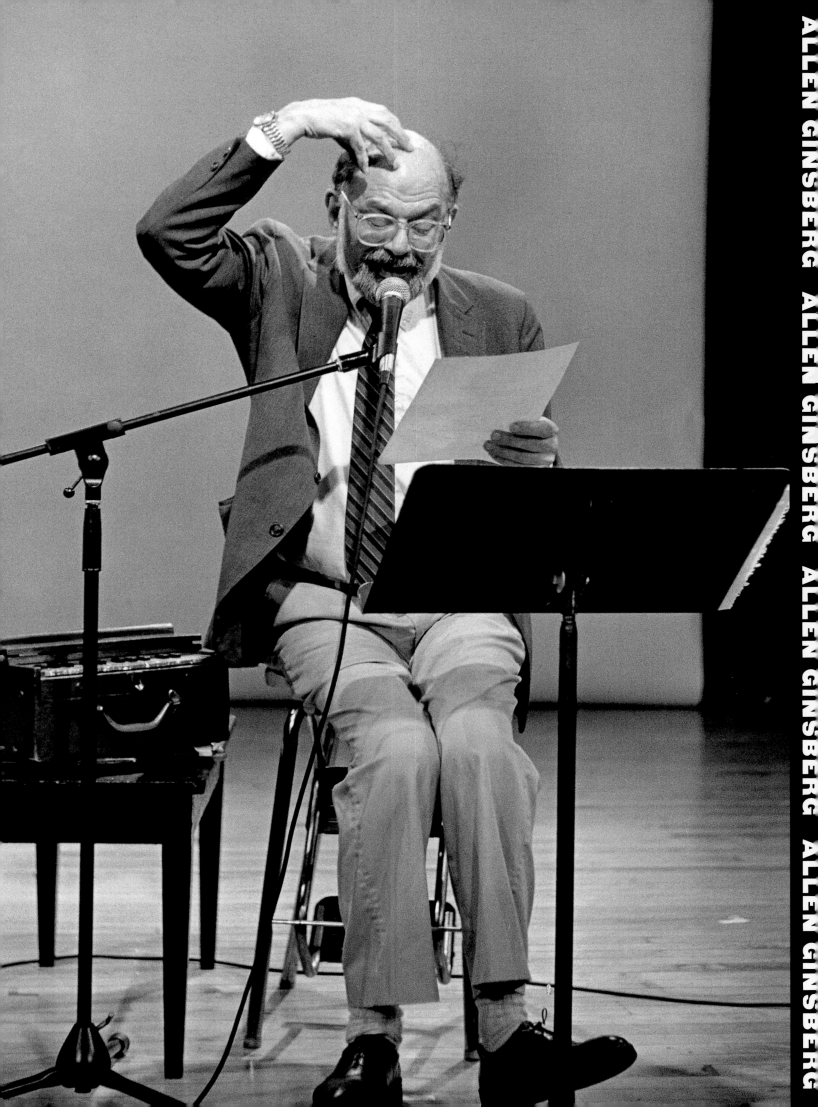

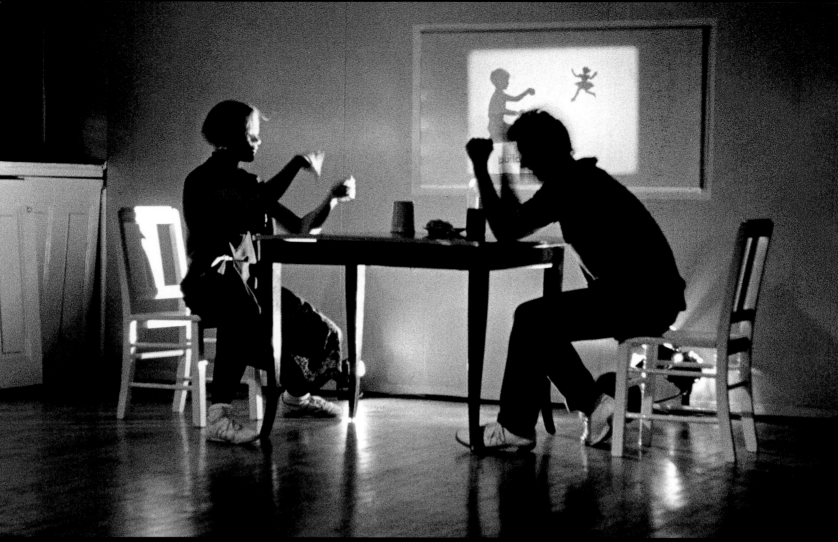

▲ **JEFF McMAHON** ▼ **GAY SWEAT SHOP** ▶ **LINDA AUSTIN**

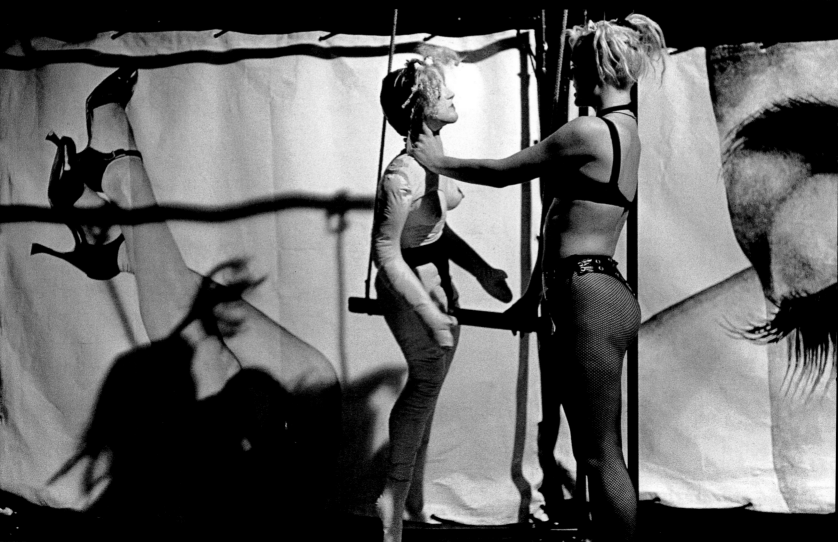

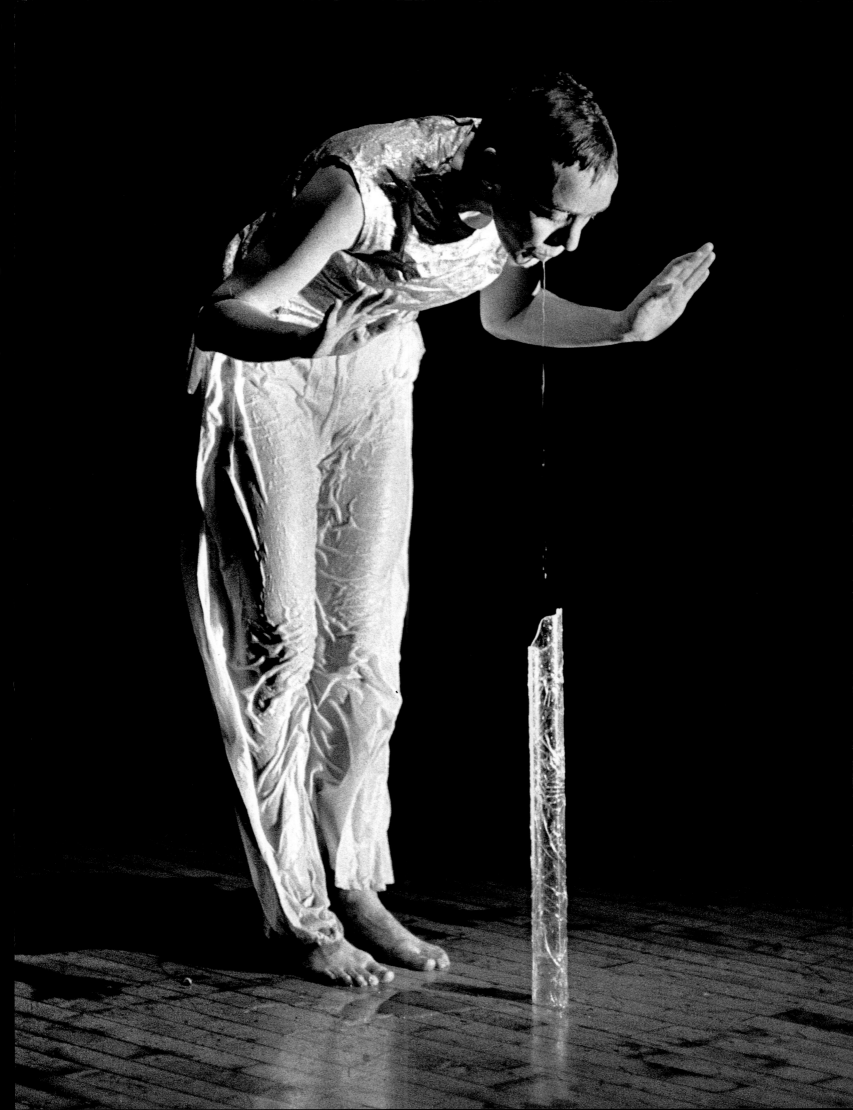

—JOHN BERND

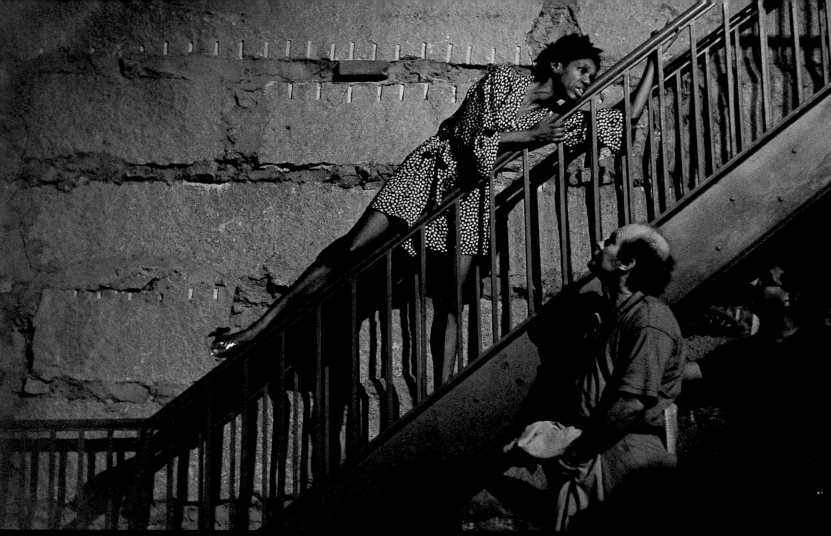

▲ ROBBIE McCAULEY & LAURIE CARLOS ▼ LAURIE CARLOS

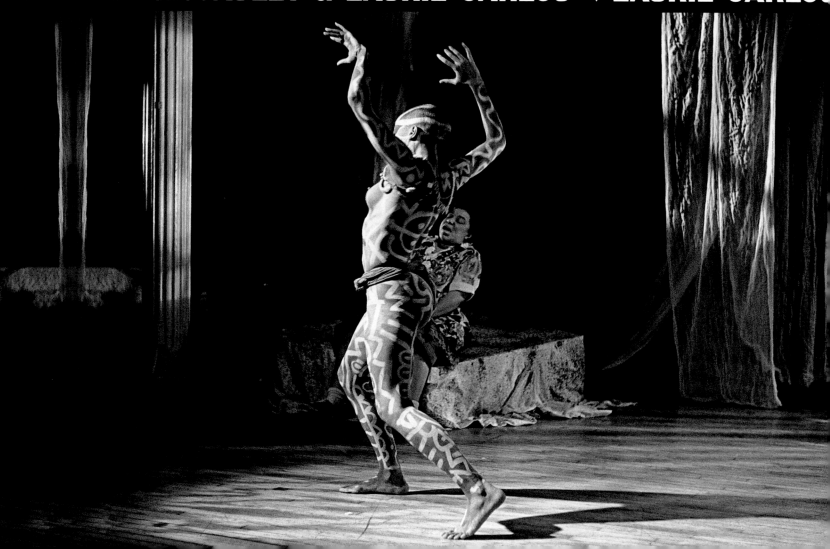

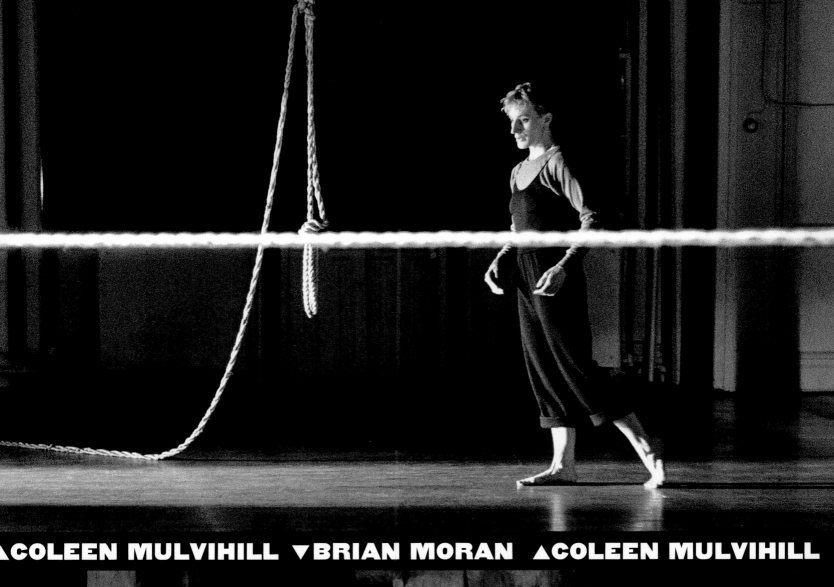

▲COLEEN MULVIHILL ▼BRIAN MORAN ▲COLEEN MULVIHILL

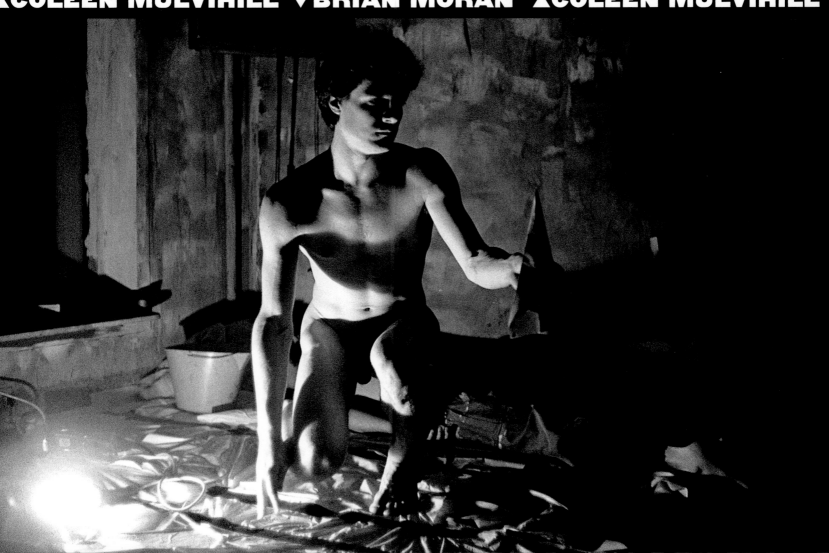

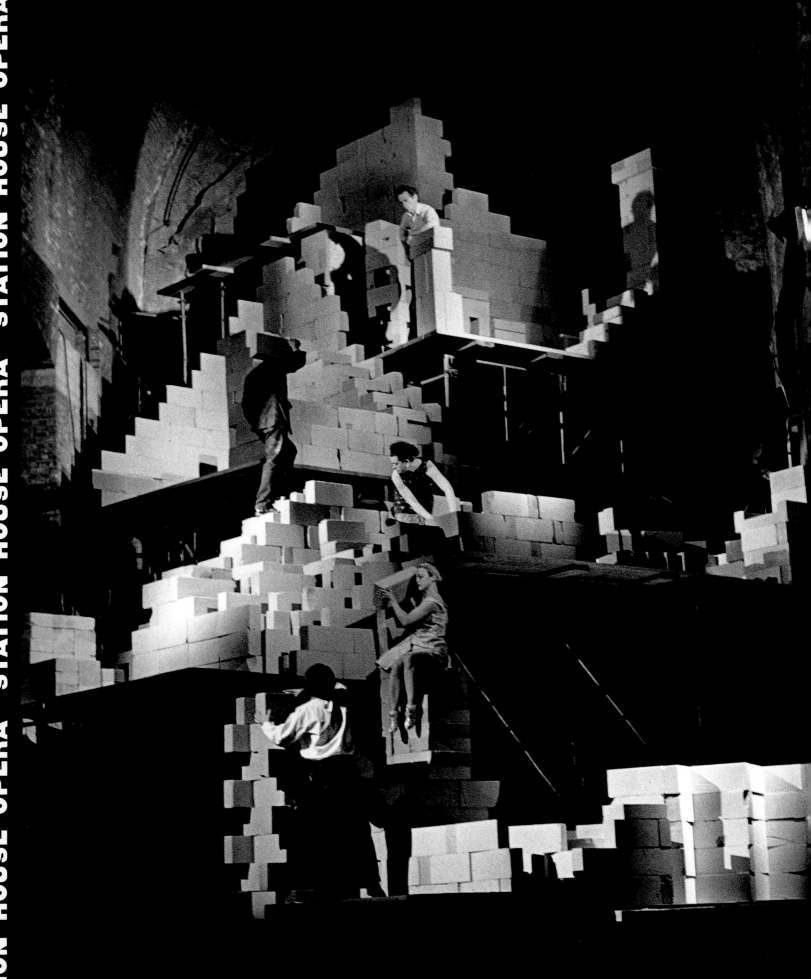

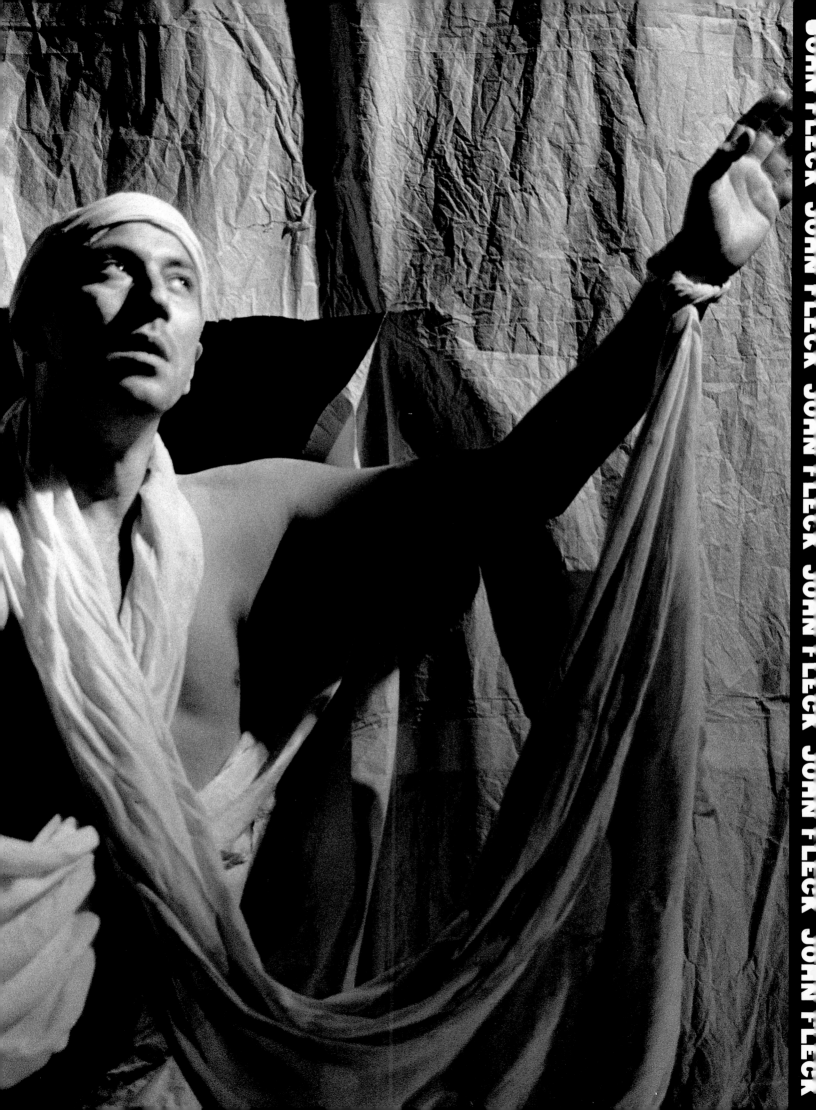

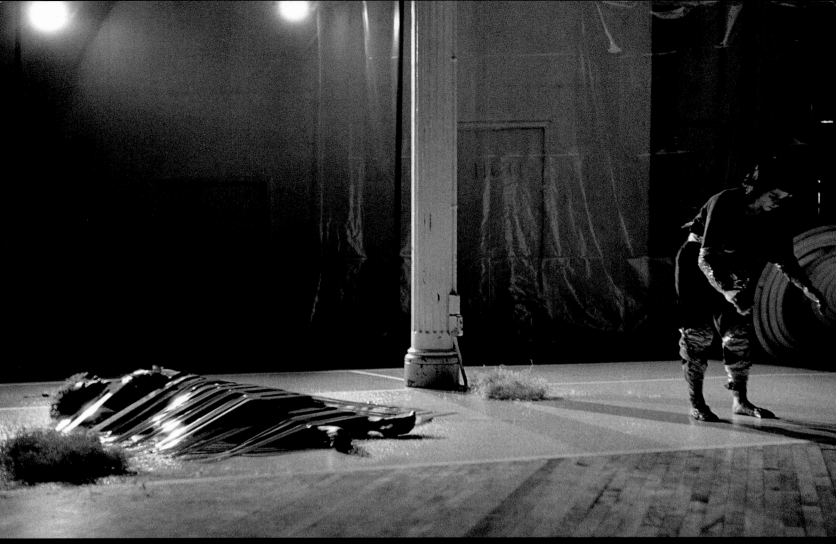

YVONNE MEIER YVONNE MEIER YVONNE MEIER YVONNE MEIER

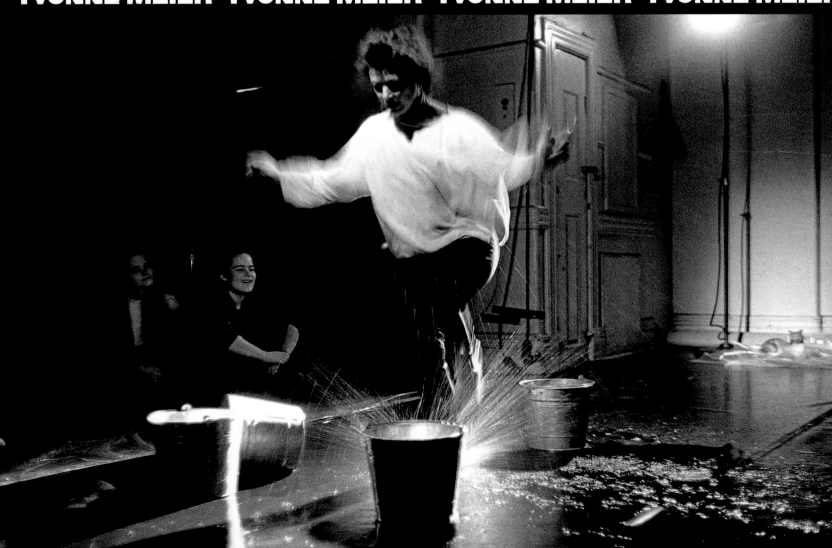

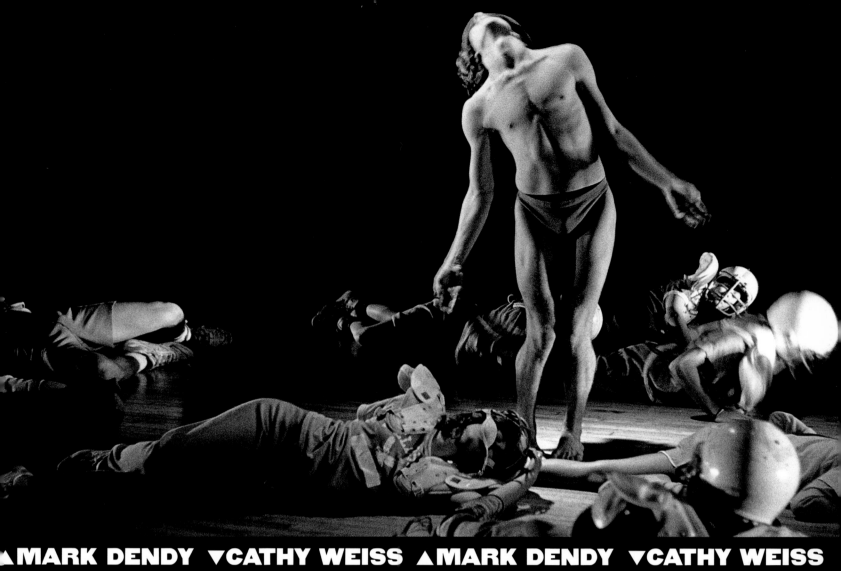

▲MARK DENDY ▼CATHY WEISS ▲MARK DENDY ▼CATHY WEISS

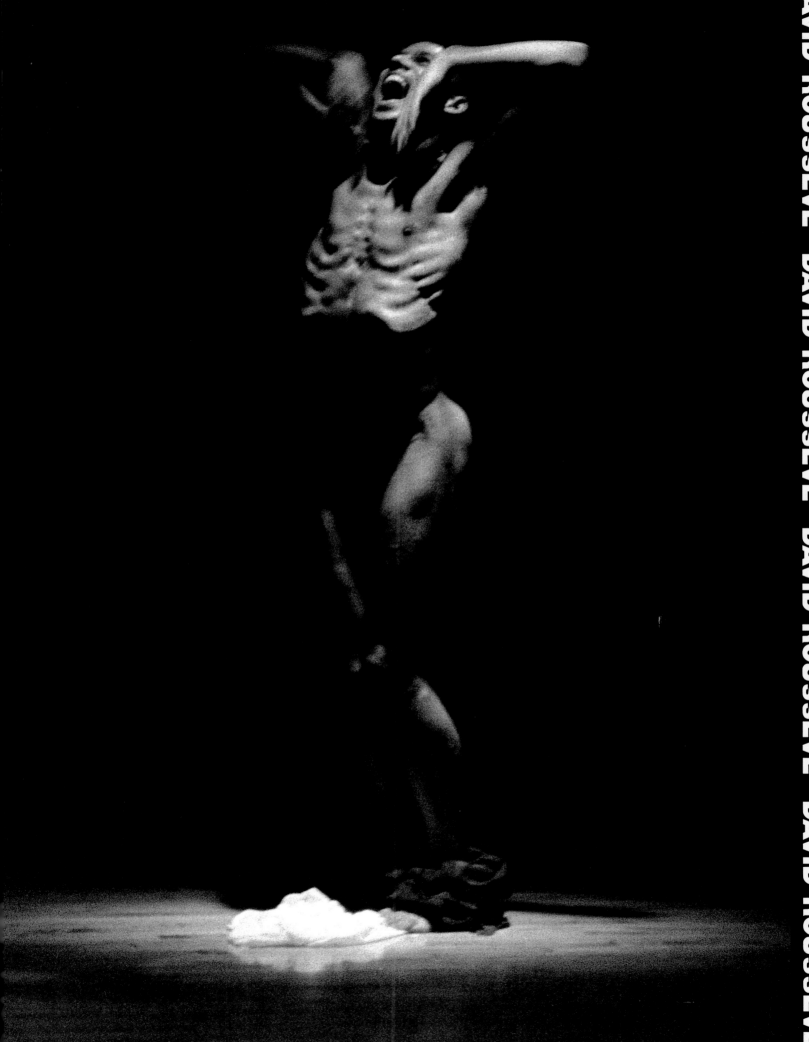

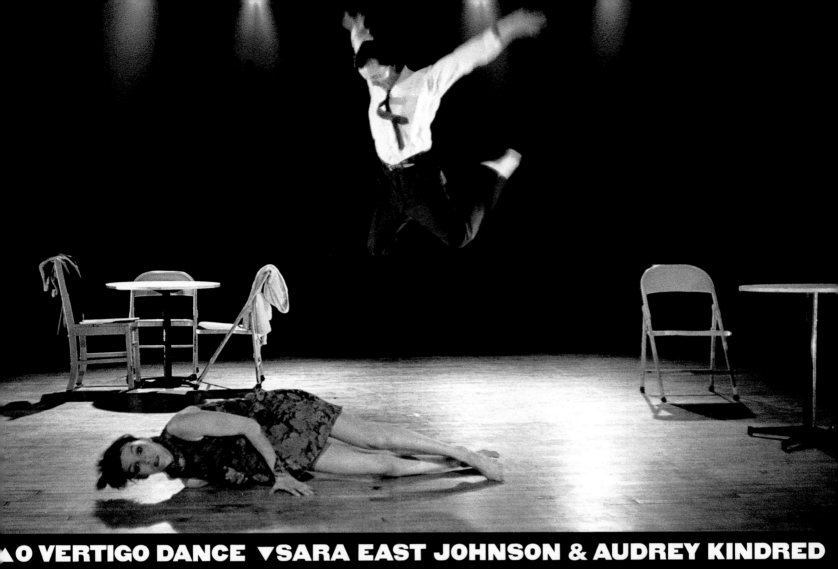

▲O VERTIGO DANCE ▼SARA EAST JOHNSON & AUDREY KINDRED

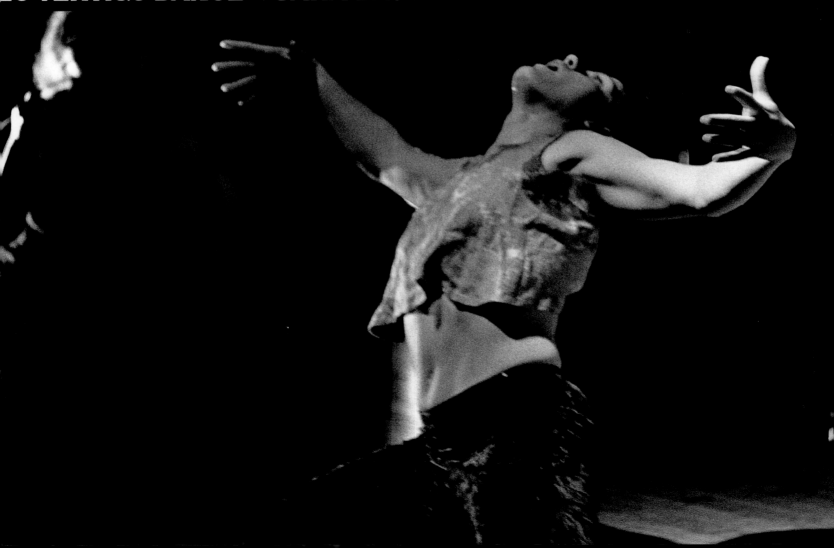

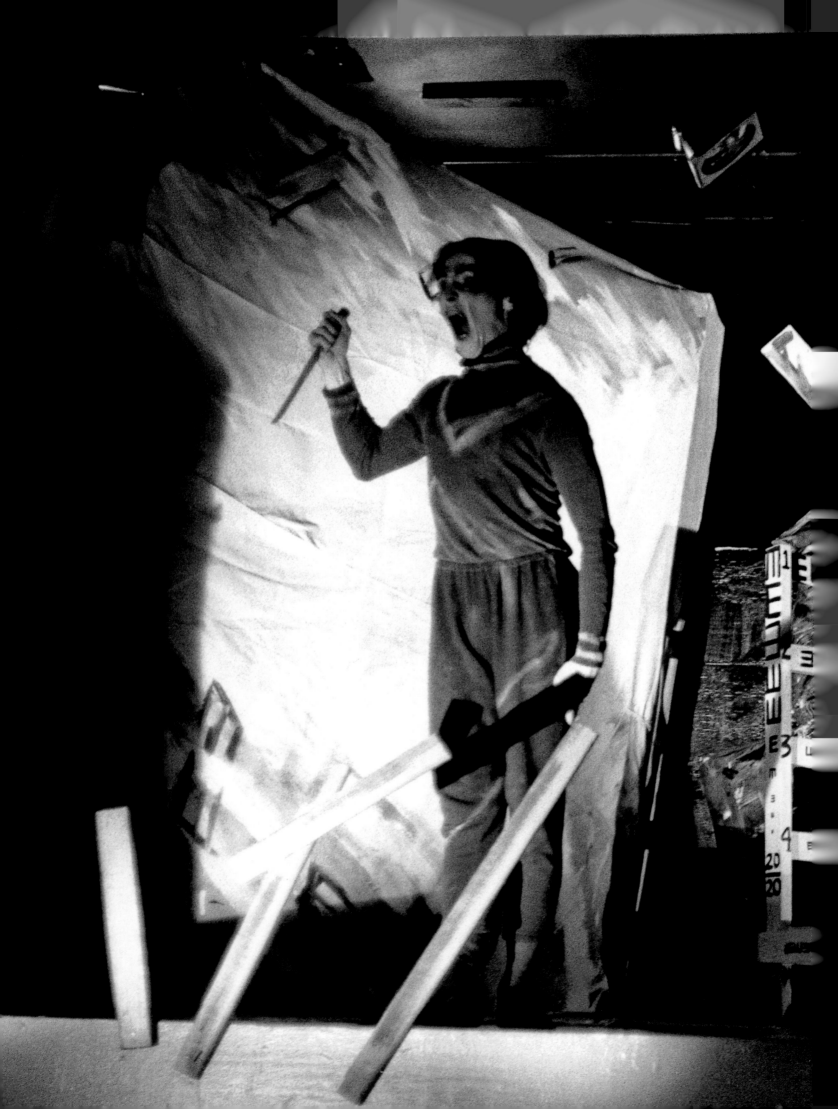

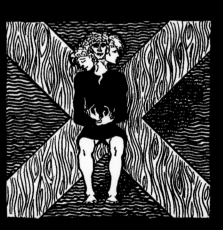

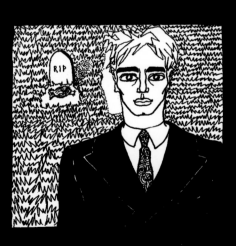

DEAD, DEAD, DEAD

I now have a new kind of Hero. Many are living, and too many are dead. They emerge daily in this plague, their ranks swell, challenging previous limits of compassion, raising the threshold of pain, submerging any Hollywood or Operatic version of grief into the muck. This new kind of Grief is joined with an ever-present desire for Sex and Life. And they are joined by Rage, which evens out the equation with a quiet but steady turning of the head, from one to the other, Desire and Grief, Grief and Desire. These Heroes remain in my Rolodex; in my erotic fantasies; in the memory of the times I may have made love with them; in my dreams, where they check in to see how I'm doing, and in the moments in my bed at night when I tell them that I miss them and love them. The presence of so many new and unexpected Heroes has changed my previously held equation of "what Hero" and "why Hero," refocusing my dreams of glory (and inspiration) into dreams of a reprieve. Heroes exist for a reason.

—JOHN KELLY

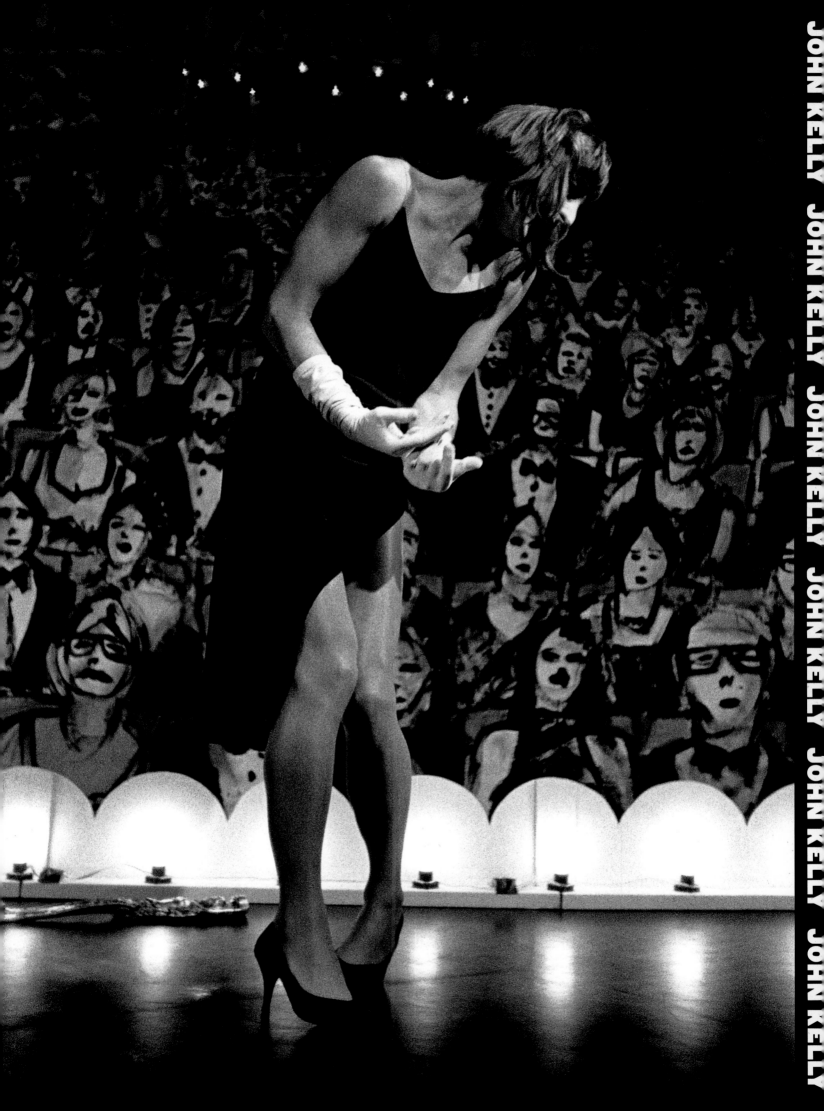

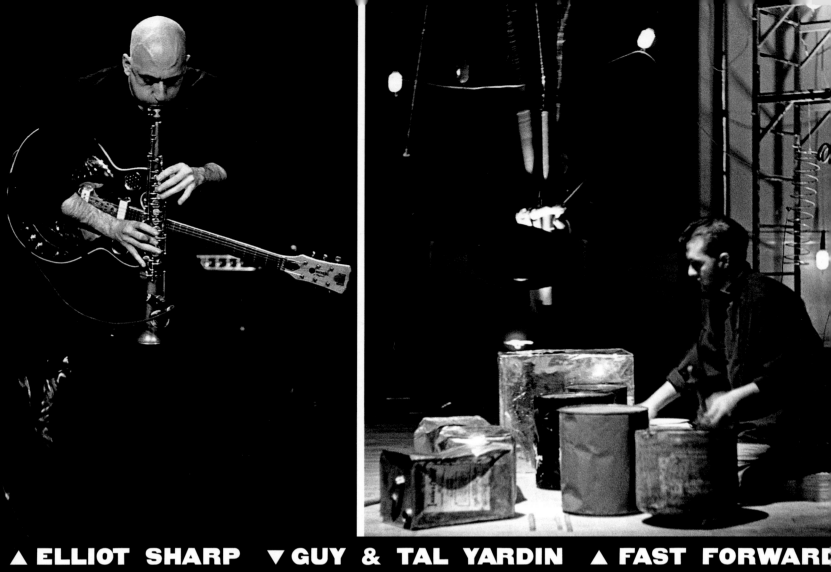

▲ ELLIOT SHARP ▼ GUY & TAL YARDIN ▲ FAST FORWARD

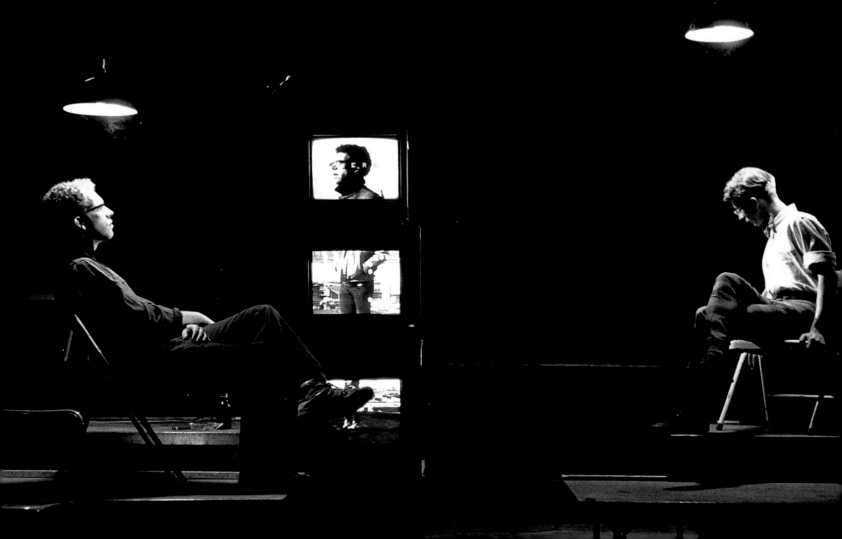

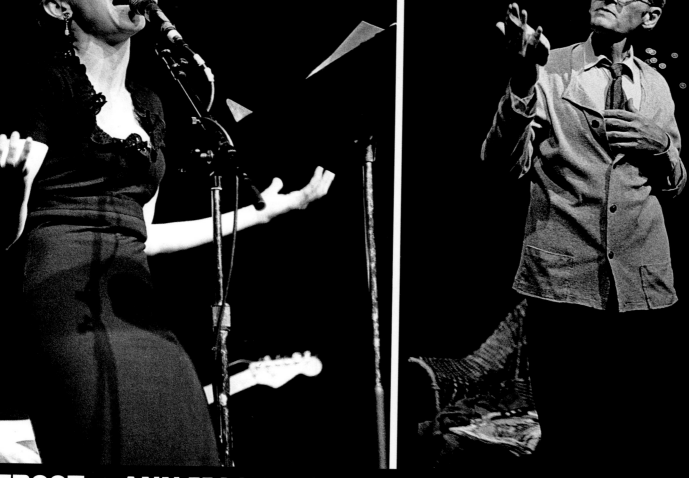

FROOT ▲ ANN MAGNUSON ▼JOHN ZORN ▲JERRY HU

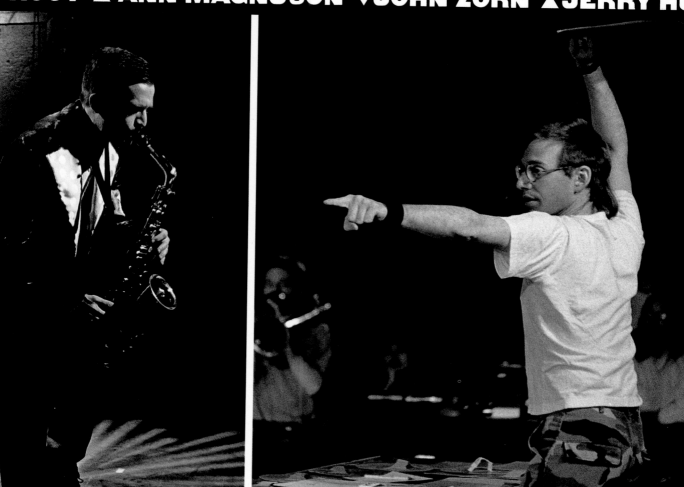

We live in a country that believes in freedom of expression for all its people. We are strong because of our diversity. We are stronger than these fanatics who are out to rob us of our freedoms.

They try to cut off my hands but I clench them in a fist. They cut off my fingers anyway. They don't realize I don't fight with my hands but from the truth. They don't realize that if I don't paint with my hands, I'll use my tongue. They don't realize that I don't speak from my mouth, I speak from my soul. I lost everything a long time ago so there is nothing left to lose.

They try to cut off my ears but I just stuffed 'em up. They cut off my lobes and they think they have me. They don't realize I hear my music from the inside. I compose my music from the inside.

They try to cut off my feet to stop me from dancing. My legs wouldn't let my feet go. They cut off my feet but they didn't realize that the most beautiful dancer is the willow tree.

They try to cut out my tongue but I hold on to it with my teeth—so hard that half of it I bit off. I held in those tears. They left me with half my tongue. They don't realize that actions speak louder than words.

They try to cut out my eyes—but I just closed 'em shut tight. And all they can do is cut off my eyelids. But baby, that just allows me to keep on staring at you. Giving you my own version of the evil eye—LOOKING AT EVIL RIGHT IN THE EYE. Yeah, you tried to cut out my eyes but you don't realize that we don't need our eyes to paint. We can still paint from the inner eye.

An inner vision that sees the world as it is and how it should be. As much as they try and distort and condemn us, they will never be able to touch the source of our power—our ability to create. Our power through the ages—Artists as historical recorders, passed on to us from cave paintings, from tombs from all walks of life. Creativity knows no color of skin, knows no religion, no gender, no blood. Knows no sexual orientation. Creativity knows no prejudice. Creativity unites us into one family of different voices of expression.

We artists can outsmart Evil. For our language, our gift, is the ability to change perception. Whether our code is called abstraction, metaphor, appropriation or inversion. We'll present an image that will effect people's thinking, create images that will take all of the hate and

Our history as artists

have previously shown great courage and we will now From the concentration camp walls used as the canvas to record the truth to the Great Negro Spirituals that survived the hate of this land. Our art will live on even when our bodies and tongues do not. For the greatest strength of art is that it will be here longer than the leaders of censorship, to speak the truth as a reminder of what happened and to teach us may it never happen again.

We will as artists unite and make the most powerful messages. We have our heroes and heroines standing ready to do battle. Across this land artists as warriors taking art into the street, creating important social changing ART NOW. They'll never get to our talents—we'll just out create them!

The fanatical right is out to destroy the artist because we possess the ability to convince the world to see things in a new way—without drugs, without armies, without inherited wealth.

Just look at our paintings—
and BECOME A HUMAN BEING.
Just read our books—and CHANGE.
Just hear our music—and UNDERSTAND.
Just witness our plays—and SEE THE OTHER SIDE.
Just feel our dances—and OPEN UP YOUR LIFE.
We are the True Real Power.

They tried to cut out my heart but once they cut it out the heart wouldn't stop beating. The zealots continued cutting out more and more hearts. The intense rhythm of the hearts made the zealots speak in rhyme. They began speaking as poets. The zealots became so fearful of being an artist that they cut out their own hearts. But where their heart was supposed to be was an empty space. The zealots picked up the beating hearts and put them into their own vacant cavities—but the hearts wouldn't go in. They'd just fall out of the zealots' chest. The zealots wondered how come they weren't dying since they didn't have a heart. But the hearts knew why. You can't die if you haven't lived.

These heartless creatures wandered the earth alone with nothing left to cut or destroy—a barren existence for soulless creatures. They were left to their own means to understand the true meaning of culture.—LIFE IS MORE IMPORTANT THAN ART BUT LIFE IS MEANINGLESS WITHOUT ART

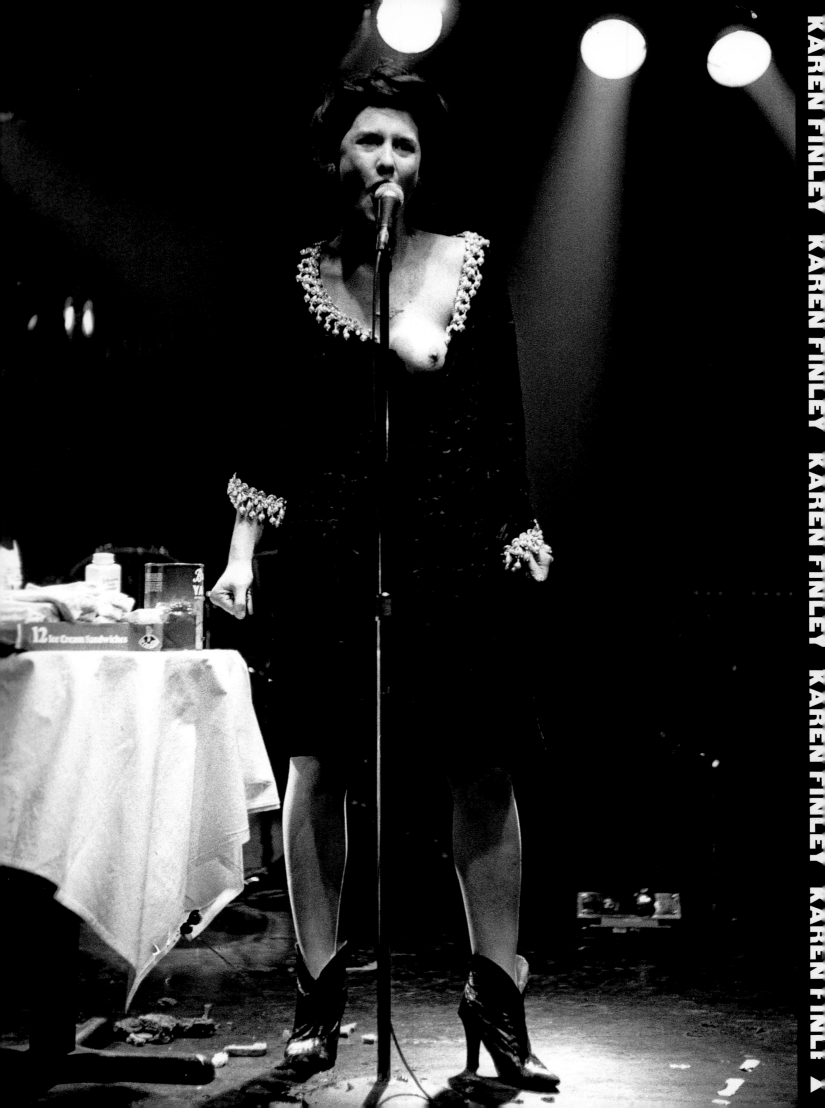

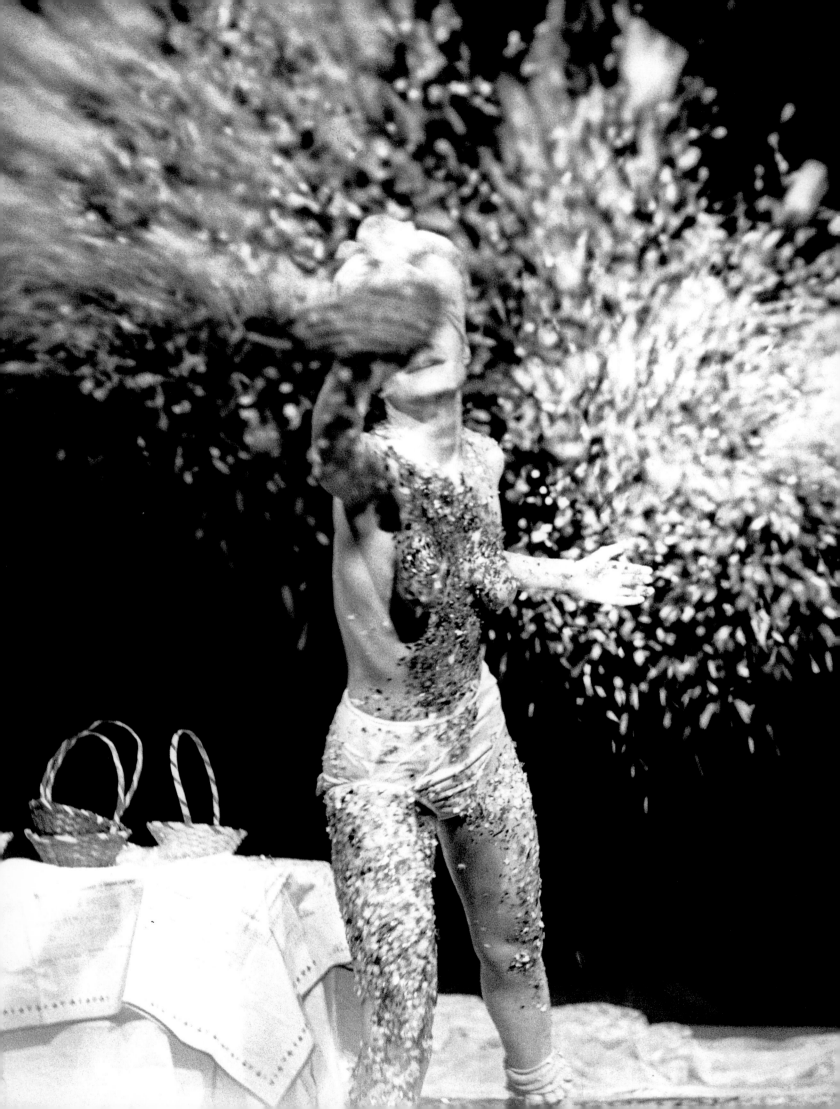

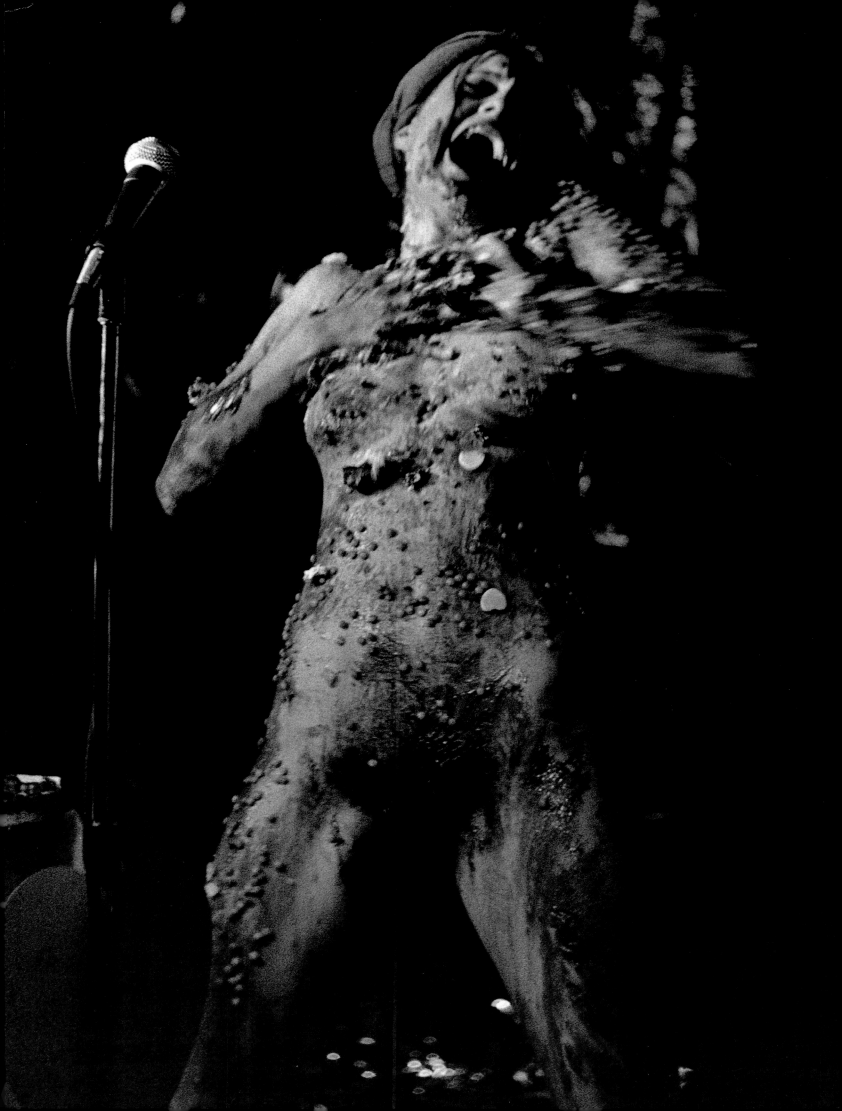

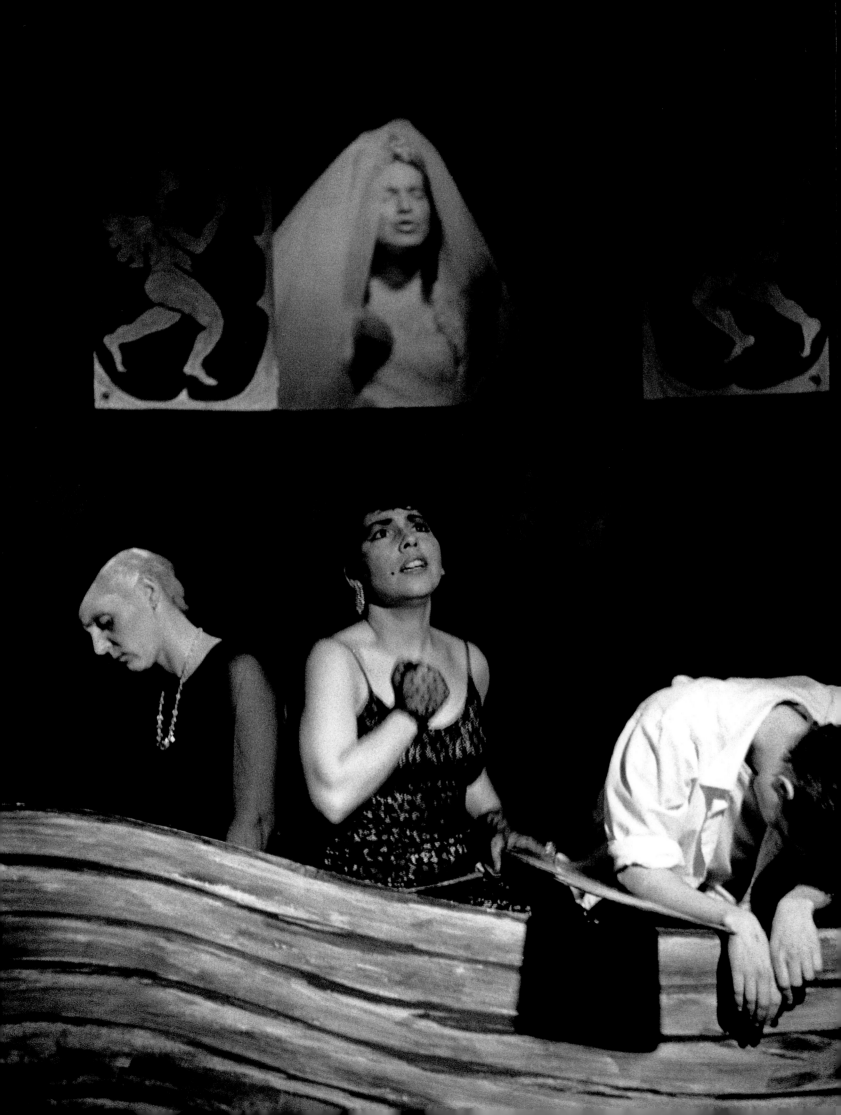

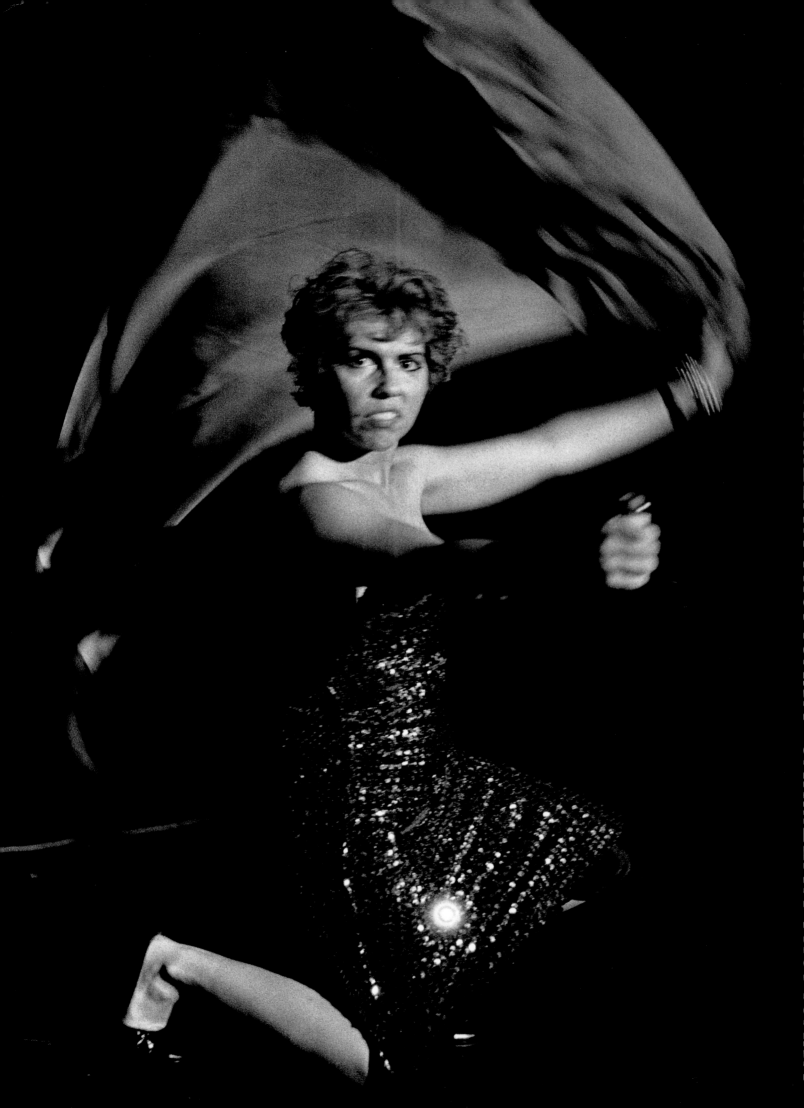

CARMELITA TROPICANA CARMELITA TROPICANA CARMELITA TROPICANA

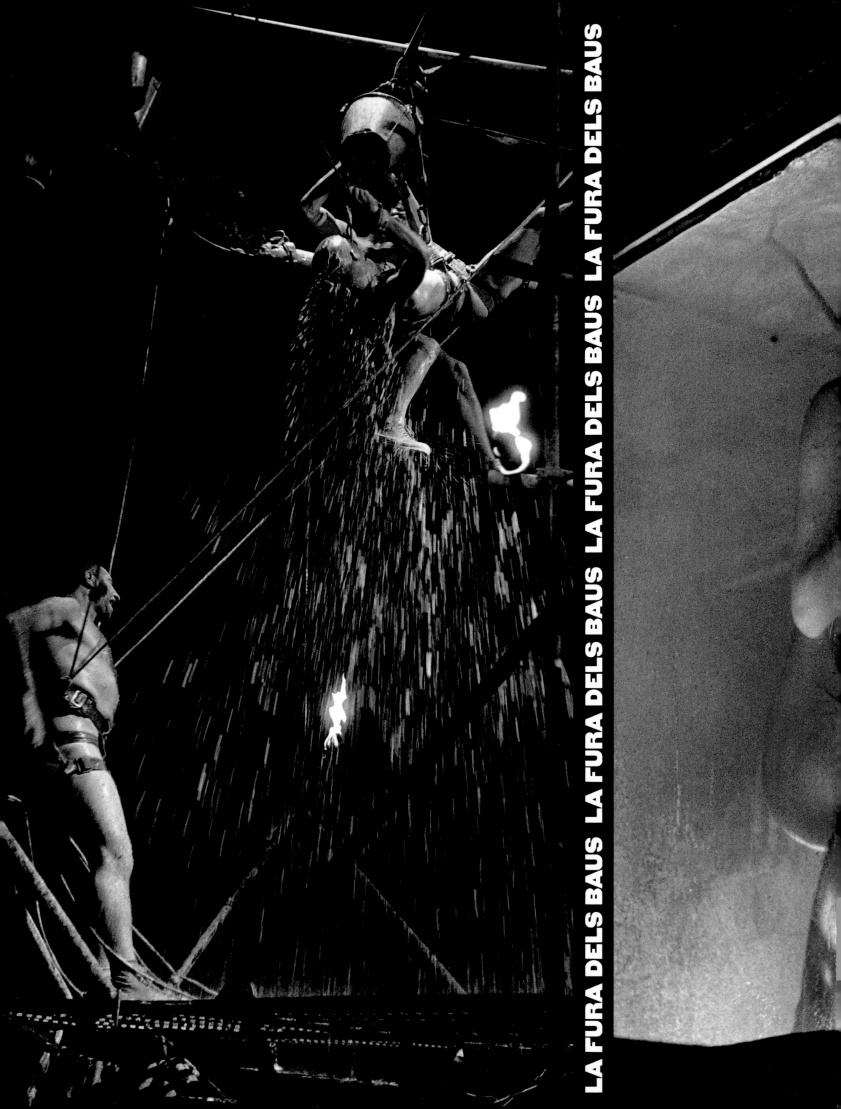

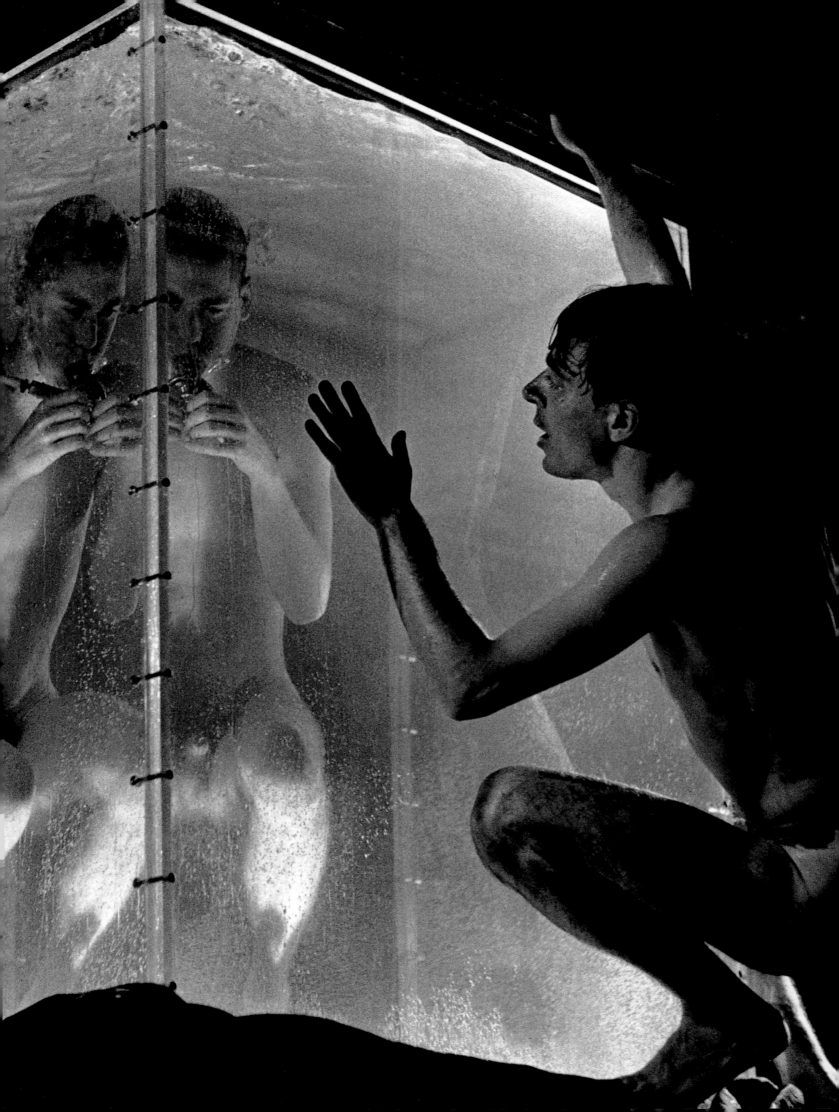

"You're all about to be placed under arrest. You are here in violation of federal law. National Endowment for Censorship Penal Code, yes, Penal Code S-Q-143-Q. If you do not disperse immediately you will be placed under arrest. You are now under arrest!! The charge is blocking a Federal Orifice. I mean Office! You are now under arrest!!!"

We linked arms and chanted furiously: "ACT UP! Fight Back! Save Art!" And for our bilingual number, "Alton a la censura! Art is not a crime!" (Which would, the next day, be reported in the newspapers as "Hola a la censura." *Ooops.*) We doffed our art criminal chain gang outfits and blockaded the Federal Building. Shutting that building down in protest of our government's attacks on the First Amendment and Freedom of Expression. . . .

This was the big moment, the time where all our careful training, our split-second organization, our carefully-honed message, no more rehearsing or nursing a part, we were about to enter—CIVIL DISOBEDIENCE WEEKEND!

We stood there: bicep to bicep, ego to ego. One by one, the cops took us away: Les and Adrian and Tom and Guillermo and Jordan and Kathy. . . . Finally it was my turn, and I felt the cold steel of those federal handcuffs so tight, so very tight around my wrists, so deliciously tight. And they lined us up underneath a picture of George Bush, our hands handcuffed behind us, in the perfect position to grab the crotch of the person behind. And then they marched us off and put the guys in one holding tank and the women in another.

It was a largish sort of smallish room. Square with a bench around the edge and two forlorn open toilets in one corner. The Federal Cop came in and said, "Well, I see we got twenty-four real *artfags* in here. Well, boys, since you got arrested so late on this Friday, we're gonna keep you here all weekend!" We protested: "But our dogs! Our jobs! Our boyfriends!"

But the Federal Cop just gave us a cold stare and said: "Tough luck, boys! Welcome to *civil disobedience weekend*!"

I was sitting next to the cute semiotics instructor from Cal-Arts who started rubbing something in his pants. It was not a book by Michel Foucault. It was not chopped liver. It was the beginning of civil disobedience weekend!!

He said, "Boy, these ACT UP civil disobedience anti-censorship actions sure get me all hot."

I said, "Yeah. Me, too."

He said, "Hey, I'm really stiff. How about a back rub?"

I said, "Sure, dude."

All eyes were on us. Hands began to move underneath "Action Equals Life" T-shirts, and that message took on a whole new meaning. One of the boys from Highways reached into the pants of one of the boys from the L.A. County Museum of Art and they began to kiss big wet sloppy larger-than-life tongue kissing. Like the kind you see on late-night TV. Like the kind I practiced on a towel the night before I took my girlfriend to Disneyland in eighth grade and we made out on the "Journey to Inner Space" ride. Those kind of kisses.

The semiotics instructor from Cal Arts has now pulled his dick out and is demonstrating the Theory of Signification to the graduate student from the Inland Empire . . . the pants are dropping . . . shirts are pulled over heads in a practical arabesque . . . generally stroking and soothing and generally fulfilling our foray.

Though the state may chain us, our crazed and juicy bodies and imaginations will not be imprisoned.

"With love's light wings did I o'erperch these walls,
For stony limits cannot hold love out:
And what love can do, that dares love attempt."

And this is our revolt, our disobedience most uncivil here in the bowels of George Bush's Federal Building. We will whip 'em out and cum on his Brooks Brothers' lapel, wipe it on his C.I.A. dossier, naked together on a burning flag in North Carolina, raising high the roofbeam, the standard, and anything else that's handy—including the sleeveless T-shirt stretched so tastefully behind the neck of the blond boy with the lovely butt who comes from the Simi Valley Anti-Censorship and Homophile Auxiliary who is being tended to by the ACT UP outreach coordinator who is, in fact, reaching out, from behind, pinching his nipples. . . .

I remain distant . . . observant . . . my job is to stay aware of what is going on . . . so it can be written down . . . it must be saved . . . this part of ourselves . . . the jump-off point . . . ready to speak truth to Caesar *and* jerk off on his best toga.

Everyone is on the act now. It is a flurry of safer activist sex! Skin is slapping. Thighs are clenching. Breath is racing. One after another we cum on the face of Jesse Helms. On a banner with the word "Guilty" burned across his forehead. He is now awash in the semen of twenty-four pissed-off artist fags . . . defiant even in the slammer . . . saying "no" to anti-sex, anti-life, anti-art nazis.

We fall on each other, spent. But, then, we hear footsteps. . . . We are being released! What has happened?

Now, out on the streets, there is a strange music in the air. There are thousands of people dancing in the streets. Carrying garlands of flowers and speaking dozens of languages. People of every cultural and community background. They have taken the street in front of the Federal Building. I look up to the sky and see the stars winking as Beethoven's 9th Symphony is played impromptu by the L.A. Philharmonic who have gathered on the Civic Center Mall.

Seid umschlungen . . . Millionen . . . Diesen Kuss der ganzen Welt! Be embraced . . . ye millions . . . this kiss for all the world!

We begin to hear snippets of what has happened. George Bush has been defeated and is in exile in Baghdad? Mmm. The Federal Police have given up and joined ACT UP? Mmmm. President Clinton has appointed Holly Hughes to be Chairwoman of the National Endowment for the Arts? Hmmmm. Jesse Helms has given up smoking and come out as a gay person? Yeeechhh! Oh please God, anything but that.

There is dancing and music . . . fireworks in the air. We hear more. A fax from Washington tells us that a special session of Congress has elevated the AIDS crisis to the top national priority. A telegram arrives from Yeltsin. He wants to meet with us immediately to form a world artists' government to address nuclear disarmament . . . economic restructuring . . . global warming. The world has been moved by our deeds! We have triumphed! The day is ours!

I think of the work left to be done and I glance up at the top of the Federal Building, which has now sprouted strange and beautiful vines, tendrilling into the night . . . testament to the seeds we planted there on this civil disobedience weekend . . . reaching up and rooting deep . . . growing towards something new.

Towards something that if we all put in a lot of vision . . . a little imagination . . . and tons of work. . . .

They're growing towards what just might. . . .

What just might be our future.

—TIM MILLER

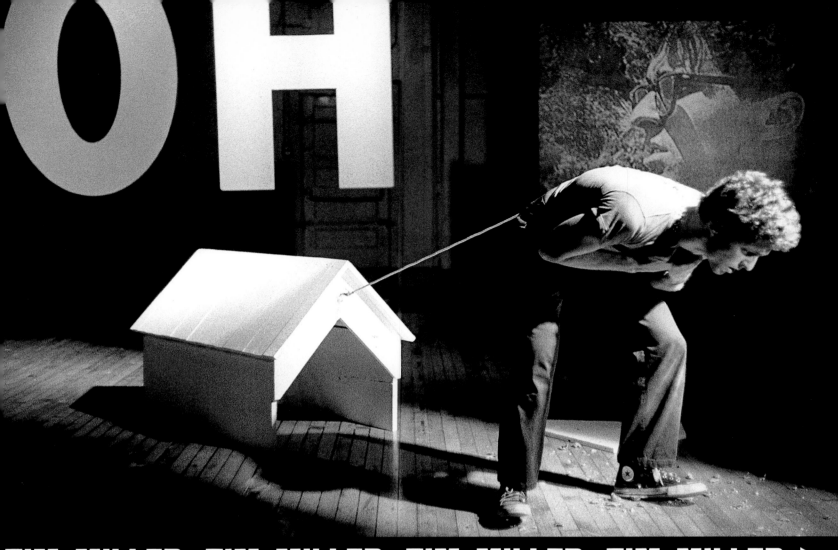

TIM MILLER TIM MILLER TIM MILLER TIM MILLER ▶

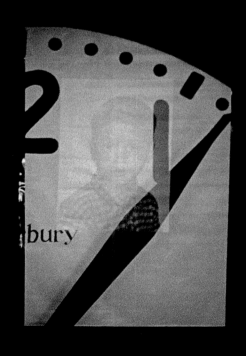
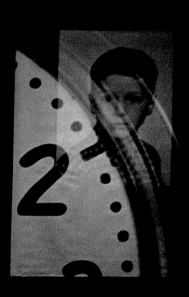

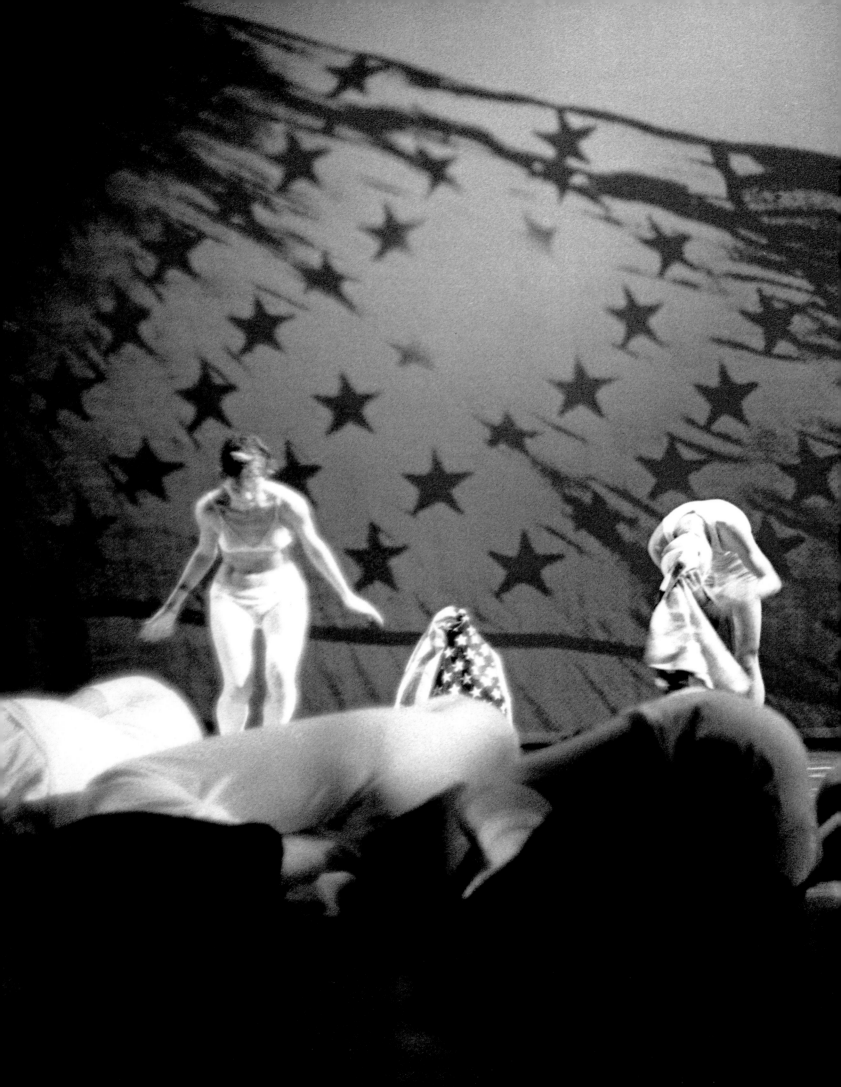

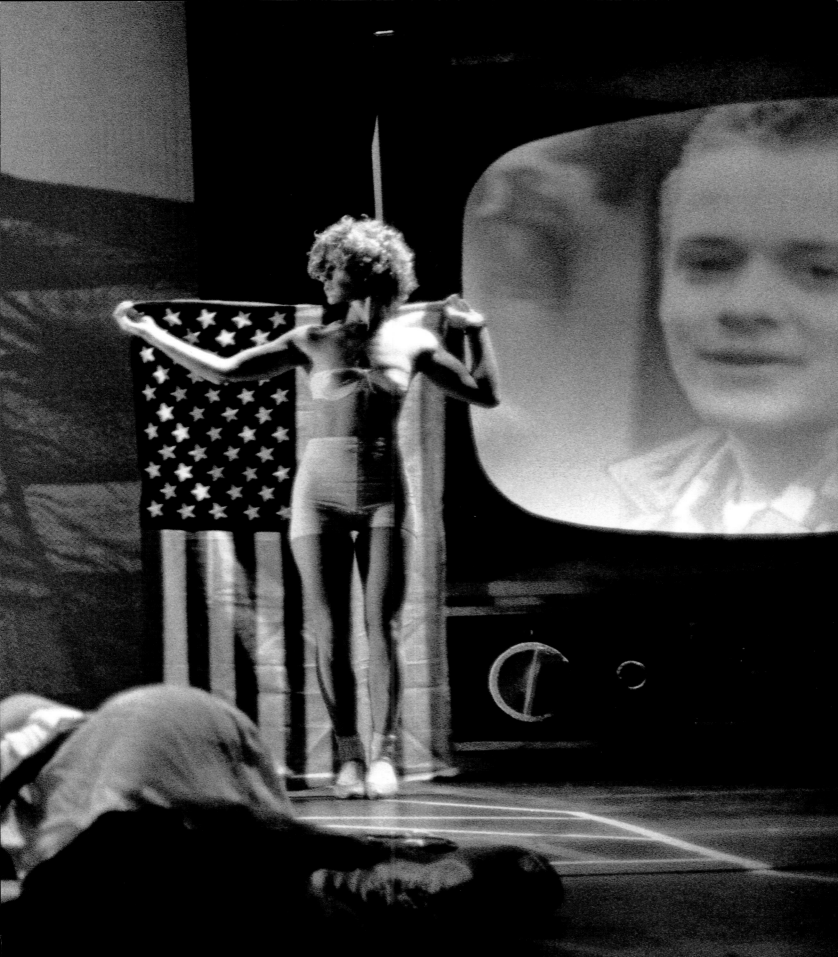

THE TROUBADOR

I sing this
silly little solo
in the thundering
blue, in the
towers of
the church

suppose
you know
I've taken
poison. Know
the Spring we
had last
year. That
was my
last

These lights are
nice

let me warble
like a nice
sad bird
if a bird
had knees
& sense
to kneel
in the
light. Winter
wounds
me. Nothing
inside
to make
resistance.
I soar
I soar inside.

I saw that
lighter. I never
miss a living
trick. It's
my last
winter. Never
again see
so much
white. I've
hit the
ceiling now
& the branches
of your
heart. This
death is
yours. Feel
it, taste
it. My
female victory
in the

Summer
oh that
Spring
I've got him to a fine
melt now.

June won't
do. Hope
you know
he's dying now
we gesture out.

The towers
more like candles
really. Pumpkins

a warmth
collides. A stray
figure, red
in front of the
heater. Where's
our death

he steps, he turns, he grabs

his crotch
she wails
his heart

The hands thunder
slapping, waving.

We need not live
in every dimension
he prays, he
sings Did I

ever live here.
 They grab
each other

Spring skips,
knows

this is beauty
a flowing rag
so much
blood, woman
stain down
my garment
I'm dying
love, feeling
belly burst
I'm another
old piece
of dirt
facing her
drain.

I know Sunday
she sings. I had

a home.
She think of his sad
little box. Scarred
by pebbles. Who
do you think you
are, I die

he sings. Nature
is beautiful now.
Think of my knees
she weeps. My
curving ankles
think how you stabbed
me last night
think how I
bled. It's
growing dark
Love

his arms wrap
her shoulders
the little angel
ready to fly
off. Everybody
knows. Oh I wish I
were her.

He is a man like history
Look out, another
day. See the birds

he see women
birds, women
suddenly she
dies

this is impossible
the warriors exclaim
more lovers
another madonna

Prettty, she took his
hand. Big
band. It's all
lips and snout
she is breast
& reach. Dad!
His heart breaks
& she she's my angel

two dying birds together
the cage is art
she soars
Man head in hands

she's suggesting
it's approximate

is there any such thing
as a man?

Only a baby
They only die.
Now everyone
lying down, standing
up. Death is beautiful.

there is nothing
we sing
pull yourselves together
I have a brain tumor
I have taken poison
whatabout her?
she was burned at the stake
she screams
perhaps she utters
like tiny delicate
steps

Who sees us?
it's culture
now. God is snoring.
Here he goes
baritone.
Pom pah
Pom pah
god is gentle
life is not
I'm only 40
liar
there's five of us now
How did we
start. 5.
We're five again.
Not a 3
not a four
oh everyone
we're five now
two are lit.
two come to

reach & lift
they hold the
man. Woman
falling slow,
gone now lights
towers withdrawn
don't leave
me. Dawn
& you are meant
to die.
The fire is
lit
& so is
the sky.

—EILEEN MYLES

EPILOGUE

These extraordinary photographs by Dona Ann McAdams provide an entry
point to the riveting work of a group of artists who, because of their unique
perspectives, talents, and energy, have challenged and transformed our
understanding of the very essence of dance, music, poetry, opera, and
theater. We are very grateful for their enthusiastic participation in this pro-
ject, and especially appreciate the generosity of spirit and collaboration of
those artists who, at our request, contributed various texts, scores, and
drawings so this book could be as vital as possible.

Epic stories of the sort told through the compilation of images seen here often have unsung heroes and
heroines—a supporting cast—and so does *Caught in the Act.* In this case, the divine intervention, the forces
that have helped the artists' (those pictured here and others) visions to be realized, are the alternative spaces
and their leadership. Often founded by artists, these venues have fostered their projects and a community of
interest, encouraged their experimentation and evolution, nurtured their works-in-process, and given oppor-
tunities to the young and emerging—without commercial pressures, yet always with minimal and ever-
shrinking resources.

At the same time, the alternative spaces have also greatly enriched the cultural life of
the cities in which they are somehow able to proliferate and, more recently, many have
taken a courageous stance against censorship—often risking their funding to do so.

As much as *Caught in the Act* is a celebration of the innovative individuals and
art it features, it is also a tribute to these remarkable organizations—Perfor-
mance Space 122, The Kitchen, Dance Theater Workshop, La Mama, Saint
Mark's Church, the Knitting Factory, Movement Research, Franklin Furnace,
Creative Time, and many more—that have given this work a home, a public,
and the freedom to breathe and grow.
—MELISSA HARRIS

IN ORDER OF APPEARANCE

Unless otherwise noted, the artist listed first as the creator of the work is also the subject of the photograph.

FRONT COVER: Karen Finley, *The Constant State of Desire*. Performance view at P.S. 122, 1987.

PAGE 1: Isla Pfeifer, "New Stuff" program. Performance view at P.S. 122, 1991.

PAGE 3: Ron Brown, *Combat Review*. Performance view at P.S. 122, 1993.

PAGE 5: Frances Becker, *A Little Murder Story*. Performance view at Cunningham Dance Studio, 1995.

PAGE 6: John Bernd, *Lost and Found*. Performance view at P.S. 122, 1983.

PAGES 10–11: Urban Bush Women, *Nyabinghi Dreamtime*. Performance view at The Kitchen, 1993. Choreography by Jawole Willa Jo Zollar.

PAGE 12 *(clockwise from top left):* Maria Cutrona, *The Doppler Effect*. Performance view at P.S. 122, 1987; pictured: Maria Cutrona and Adrienne Altenhaus. Clarinda MacLow, *Silence and Other Reformations*. Performance view at P.S. 122, 1990. Phillip MacKenzie and Simon Thorne, *Man Act*. Performance view at P.S. 122, 1985. Plan K (continued on p. 13), *Scanlines or the Paradise of Artifical Eye*. Both performance views at P.S. 122, 1984. Quentin Crisp, benefit performance for P.S. 122. Performance view at P.S. 122, 1994. Diane Martel, benefit performance for P.S. 122. Performance view at P.S. 122, 1985.

PAGE 13 *top:* Maria Cutrona, *The Doppler Effect*. Performance view at P.S. 122, 1987; *bottom:* Crowsfeet Dance Collective. Performance view at P.S. 122, 1986.

PAGES 14–15: Meredith Monk *p. 14: Volcano Songs*. Performance view at P.S. 122, 1994. *p. 15: Trekking Dance*, 1994, copyright © 1994 Meredith Monk. Superimposed on the *Trekking Dance* score is a sketch for the "Shrine Installation," from *Volcano Songs*, 1994, copyright © 1994 Meredith Monk.

PAGE 16 *top:* Guillermo Gómez-Peña, *Border Brujo*. Performance view at Dance Theater Workshop, 1990; *bottom:* Lorellen Green, *Fertile*. Performance view at P.S. 122, 1993; pictured: Lorellen Green, Susan Christensen, and Alain LeRazer.

PAGE 17: Mimi Goese, *Wig Warrior*. Performance view at P.S. 122, 1992.

PAGE 18: Annie Sprinkle, *Post Porn Modernist*. Performance view at The Kitchen, 1990.

PAGE 19: Alyson Pou, *To Us at Twilight. . . .* Performance view at P.S. 122, 1989.

PAGE 20 *top:* Grisha Coleman, *Black Alice*. Performance view at P.S. 122, 1994; *bottom:* Penny Arcade, *While You Were Out*. Performance view at P.S. 122, 1985.

PAGE 21: Penny Arcade, excerpt from *Andrea Whips*, 1985, copyright © 1985 Penny Arcade.

PAGE 22 *top:* Judith Ren-Lay, *Stake*. Performance view at P.S. 122, 1983; *bottom:* Mary Ellen Strom, *Witness*. Performance view at Dance Theater Workshop, 1993; pictured: Andrea Mills, and Janine Williams.

PAGE 23: Kate Lambert, *Letters from My Mother*. Performance view at Spring Street Pier, 1983.

PAGES 24–25: Diamanda Galás *p. 24:* excerpt from "There are No More Tickets to the Funeral. . . ," from *Plague Mass*, 1990, copyright © 1990 Diamanda Galás; *pp. 24–25: Plague Mass*, benefit performance for P.S. 122. Both performance views at P.S. 122, 1991.

PAGE 26: John Cage, benefit performance for P.S. 122. Performance view at P.S. 122, 1983.

PAGE 27: Courtesy of the John Cage Trust, New York.

PAGES 28–29: Bill T. Jones/Arnie Zane Dance Company *pp. 28–29:* untitled duet, benefit performance for P.S. 122. Performance view at P.S. 122, 1993; pictured (from left to right): Bill T. Jones and Arthur Aviles; *p. 29 top: Absence Bunty*. Performance view at P.S. 122, 1991; pictured (from left to right): Justice Allen, Bill T. Jones, and Arthur Aviles; *bottom: Continuous Replay*. Performance view at P.S. 122, 1991; pictured (from left to right): Justice Allen, Bill T. Jones, and Andrea Smith. Choreography by Arnie M. Zane.

PAGES 30–31: DANCENOISE *p. 30 (clockwise from top left): Full Moon Show; performance* from the "Cement Beach" program; *1/2 a Brain;* benefit performance for P.S. 122; *Full Moon Show; All the Rage; p. 31 (clockwise from top middle):* benefit performance for P.S. 122; benefit performance for P.S. 122; *Full Moon Show;* benefit performance for P.S. 122; *All the Rage;* benefit performance for P.S. 122; benefit performance for P.S. 122. All performance views at P.S. 122, 1987–89.

PAGES 32–33: Pamela Sneed *p. 32:* excerpt from "Passages," from *Barricade Against the Wind,* 1995, copyright © 1995 Pamela Sneed; *pp. 32–33: Barricade Against the Wind*. Performance view at P.S. 122, 1995.

PAGES 34–35: Blue Man Group, *Tubes*. All performance views at P.S. 122, 1989; pictured: Philip Stanton, Chris Wink, and Matt Goldman.

PAGES 36–37: Ron Athey *p. 36: Four Scenes in a Harsh Life*. All performance views at P.S. 122, 1994; *(clockwise from top left; pictured from left to right):* Ron Athey and Pigpen; Ron Athey; Pigpen, Darryl Carlton, Ron Athey, and Julie Tolentino Wood; Mark Seitchek, Julie Tolentino Wood, Steak, Ron Athey, and Pigpen; *p. 37: Martyrs and Saints*. Performance view at P.S. 122, 1993.

PAGES 38–39: Poppo, *A New Model of the Universe*. Performance view at P.S. 122, 1989; pictured: The Go-Go Boys.

PAGES 40–41: Ethyl Eichelberger *p. 40 (clockwise from top left): Klytemnestra—The Nightingale of Argos*. Performance view at P.S. 122, 1987; pictured (from left to right): Katie Dierlam and Ethyl Eichelberger; "We Are Women Who Survive," originally written as the final song for his solo work *Lucrezia Borgia,* 1982, copyright © 1982 Ethyl Eichelberger; *Klytemnestra—The Nightingale of Argos*. Performance view at P.S. 122, 1987; pictured (from left to right): Ethyl Eichelberger and Mr. Fashion; *p. 41: The Tempest Chim Lee*. Performance view at P.S. 122, 1987.

PAGE 42: Bill Irwin, benefit performance for "Artist Call

Against Intervention in Central America." Performance view at St. Mark's Church in the Bowery, 1984.

PAGE 43 *top:* Jim Neu and S. K. Dunn, *Mutual Narcissism.* Performance view at The Kitchen, 1984; *bottom:* Susan Rethorst, *Little by Little, She Showed Up.* Performance view at P.S. 122, 1995; pictured: Susan Rethorst, Stephanie Artz, Colleen Blair, Susan Braham, Lisa Bush, Nancy Coenen, Kande Culver, Linda Larson, Renee Lemieux, Sarah Perron, Pat Roberts, Janet Shuman, Jennifer Weaver, I Wang, Celeste Neland, and Ede Thurrell.

PAGE 44: Eric Bogosian, "Melting Pot," from *The Essential Bogosian: Talk Radio, Drinking in America, Funhouse & Men Inside*, New York: Theater Communications Group, 1994, pp. 105–108, copyright © 1986, 1987 Eric Bogosian; Jo Bonney, untitled, 1996, copyright © 1996 Jo Bonney.

PAGES 44–45: Eric Bogosian, *Notes from the Underground.* Both performance views at P.S. 122, 1993.

PAGES 46–47: *both pages top:* GhettOriginal Productions Dance Company *p. 46: Live to Die—Die to Live Again*; *p. 47: Peace.* Both performance views at P.S. 122, 1995; pictured: Richard "Crazy Legs" Colon, Steve "Mr. Wiggles" Clemente, Gabriel "Kwikstep" Dionisio, Ken "Ken Swift" Gabbert, Anita "Rock-a-fella" Garcia, Antoine "Doc" Judkins, Masami Kanemoto, Adesola "D'Incredible" Osakalumi, Jorge "Fabel" Pabon, and Ereina "Honey Rockwell" Valencia; *p. 46 bottom:* Danny Mydlack, *My Name is Danny.* Performance view at P.S. 122, 1986; *p. 47 bottom:* Stephanie Skura, *It's Either Now or Later.* Performance view at Dance Theater Workshop, 1983.

PAGE 48: Reno, *Son of Reno.* Performance view at P.S. 122, 1987.

PAGES 49–51: Yoshiko Chuma and the School of Hard Knocks *p. 49 top: 24 Hours.* Performance view at P.S. 122, 1984; pictured: Yoshiko Chuma; *bottom: 24 Hours.* Performance view at P.S. 122, 1984; *pp. 50–51: Crash Orchestra.* Performance view at the Japan-American Society, 1995; pictured (from left to right): Robert Black and Rocky Bornstein.

PAGES 52–55: Holly Hughes *p. 52:* excerpt from "Clit Notes," in *Clit Notes: A Sapphic Sampler*, New York: Grove/ Atlantic, Inc., p. 208, copyright © 1994 Holly Hughes; *p. 53: Clit Notes.* Performance view at P.S. 122, 1994; *pp. 54–55: The Lady Dick.* Performance view at WOW Café, 1985.

PAGE 56: Linda Mancini *(clockwise from top left): Cake.* Performance view at P.S. 122, 1990; pictured: Lori E. Seid and Linda Mancini. *Not Entirely Appropriate.* Performance view at P.S. 122, 1990. *Glances.* Performance view at Home, 1989; pictured (from left to right): Amy Karp, Linda Mancini, John Wells, and Lisa Love.

PAGE 57 *top:* Byron Suber, *Loss, Denial, and Desire.* Performance view at P.S. 122, 1994; pictured: Byron Suber, Felipe Barreuto-Cabello, Amina Blacksher, Tess Borden, Isaac Bowers, Alejandra Bronfman, Evelyn Chan, Matt Gagnon, Evelyn Michelli, Adrienne Mildon, and Heather Turgeon; *bottom:* Tamar Rogoff, *Sleep Disturbances.* Performance view at P.S. 122, 1988; pictured (from left to right): Alice Farley, Tamar Rogoff, audience member, Lisa Deppe, audience member, and Paula McKinnon.

PAGE 58: Ishmael Houston-Jones, "The End of Everything," 1988, copyright © 1988 Ishmael Houston-Jones;

Dennis Cooper, excerpt from the text for *Them*, 1986, copyright © 1986 Dennis Cooper.

PAGE 59: Ishmael Houston-Jones, *The End of Everything.* Performance view at The Kitchen, 1988.

PAGE 60 *top:* Direction by Ishmael Houston-Jones, text by Dennis Cooper, and music by Chris Cochrane, *Them.* Performance view at P.S. 122, 1986; pictured (from left to right): Dennis Cooper, Julyen Hamilton, and Donald Flemming; *bottom:* Keith Hennessy, Patrick Scully, and Ishmael Houston-Jones, *Unsafe, Unsuited.* Performance view at P.S. 122, 1995.

PAGE 61: Nancy Swartz as "Regine," benefit performance for WOW Café. Performance view at P.S. 122, 1990.

PAGES 62–63: Carol McDowell *p. 62: What's Your Favorite Color?* Performance view at P.S. 122, 1985; *p. 63: Horizon.* Performance view at B.A.C.A. Downtown, 1990.

PAGE 64 *(clockwise from top left):* Kate Bornstein, *The Opposite Sex is Neither.* Performance view at P.S. 122, 1993. Kate Bornstein, text from *Virtually Yours: A Game for Solo Performer with Audience*, 1994, copyright © 1994 Kate Bornstein; Salley May, *The Calls Are Coming From Inside the House.* Performance view at P.S. 122, 1994. Jennifer Miller, *Circus Amok.* Performance view at Fez, 1995.

PAGE 65: Sarah Skaggs, *Higher Ground.* Performance view at Irving Plaza, 1993.

PAGE 66 *top:* Brian Routh as Harry Kipper (of the "Kipper Kids"), *A Little of This and a Little of That.* Performance view at P.S. 122, 1985; *bottom:* Wooster Group, *Hula*, benefit performance for P.S. 122. Performance view at P.S. 122, 1984; pictured (from left to right): Kate Valk, Peyton Smith, Willem Dafoe, and Ron Vawter.

PAGE 67 *(clockwise from top left):* Johanna Went, *Twin Travel Terror.* Performance view at Franklin Furnace, 1987; pictured (from left to right): Lucy Sexton, Anne Iopst, Johanna Went, and Pat Cammack. Phranc, *Hot August Phranc.* Performance view at Dance Theater Workshop, 1993. Mike Bidlo, *The Original Schnabel Simula Crum.* Performance view at P.S. 1, 1984; pictured: Tom Corn. Alien Comic, *Nite of Dreams.* Performance view at P.S. 122, 1987. Spalding Gray, benefit performance for P.S. 122, 1986.

PAGES 68–69: David Wojnarowicz *p. 68:* reading from *Tongues of Flame* for "The Decade Show." Performance view at The Studio Museum of Harlem, 1990; *p. 69:* excerpt from *Memories That Smell Like Gasoline*, San Francisco: Artspace Books, 1992, pp. 60–61, copyright © 1992 the Estate of David Wojnarowicz.

PAGES 70–73: Pat Oleszko *p. 70:* "The Patechism of Cliché," 1992, copyright © 1992 Pat Oleszko. *p. 71:* "Hansel and Grettle; Which, Witch" from *Blue Beard's Hassle; The Writhes of the Wives.* Performance view at P.S. 122, 1990; *p. 72 (clockwise from top left):* "Utter Delight" from *Blue Beard's Hassle; The Writhes of the Wives*; benefit performance for P.S. 122. Performance view at P.S. 122, 1987. "Delight Fool," from *Blue Beard's Hassle; The Writhes of the Wives*; *p. 73:* benefit performance for P.S. 122. Performance view at P.S. 122, 1991.

PAGE 74: Beth Lapides *top: Big Books.* Performance view at In Roads, 1983; *bottom: Having Fun in the Dark.* Performance view at Musical Theater Works, 1984.

PAGE 75: Ann Carlson, *Sara*, benefit performance for P.S. 122. Performance view at P.S. 122, 1988.

PAGE 76 *top:* Nuria Olivé-Bellés, *The Bulls at the Ball.* Performance view at The Kitchen, 1991; pictured (from left to right): Tasha Taylor and Nuria Olivé-Bellés; *bottom:* Nina Martin, *Changing Face.* Performance view at La Mama, 1989.

PAGE 77: Steve Shill, *Dark Water Closing.* Performance view at the Theater for the New City, 1986.

PAGE 78: Co-creation by Holly Hughes and performers Lois Weaver and Peggy Shaw, *Dress Suits for Hire.* Performance view at P.S. 122, 1987. Text by Holly Hughes.

PAGES 79–80: Jeannie Hutchins *p. 79: Duet*, benefit performance for P.S. 122. Performance view at P.S. 122, 1993; *p. 80: Slippery Little Devils.* Performance view at P.S. 122, 1988.

PAGE 81: Fred Holland *top: Shade dem Eyes.* Performance view at P.S. 122, 1986; pictured: Anthony Bowman; *bottom: Delicate Prey.* Performance view at Church Street, 1985.

PAGES 82–83: Philip Glass *p. 82:* benefit performance for P.S. 122. Performance view at P.S. 122, 1991; *p. 83: Music in Similar Motion*, 1969, copyright © 1969 Dunvagen Music Publishers.

PAGES 84–85: Allen Ginsberg *p. 84:* "The Ballad of the Skeletons," February 12–16, 1995, in *Selected Poems*, New York: HarperCollins, 1996, copyright © 1995 Allen Ginsberg; *p. 85:* benefit performance for P.S. 122. Performance view at P.S. 122, 1991.

PAGE 86 *top:* Jeff McMahon, *Your Helping Hand.* Performance view at P.S. 122, 1985; pictured (from left to right): Kaja Gam and Jeff McMahon; *bottom:* Gay Sweat Shop, *In Your Face.* Performance view at P.S. 122, 1994; pictured: Melissa King. Text by Jan Maloney.

PAGE 87: Linda Austin, *Where Fish Drown.* Performance view at P.S. 122, 1990.

PAGES 88–89: John Bernd *p. 88: Monkey Go West.* Performance view at P.S. 122, 1985; *p. 89:* drawings from *Surviving Love and Death*, ca. 1983.

PAGE 90 *top:* Robbie McCauley and Laurie Carlos, *Persimmon Peel.* Performance view at Brooklyn Anchorage, 1990; pictured (from left to right): Robbie McCauley and audience member; *bottom:* Laurie Carlos, *White Chocolate for my Father.* Performance view at P.S. 122, 1992; pictured (from left to right): Cynthia Oliver and Laurie Carlos.

PAGE 91 *top:* Colleen Mulvihill, *How They Make Hawaiian Music.* Performance view at P.S. 122, 1985; *bottom:* Brian Moran, *Challenger.* Performance view at King Tut's Wah-Wah Hut, 1989.

PAGE 92: Station House Opera, *Piranesi in New York.* Performance view at Brooklyn Anchorage, 1988.

PAGE 93: John Fleck, *I got the He-Be-She-Be's.* Performance view at P.S. 122, 1988.

PAGE 94: Yvonne Meier *top: Limpopo Trilogy.* Performance view at P.S. 122, 1987; pictured (from left to right): Michael Stiller and Yvonne Meier; *bottom: Tell Me.* Performance view at P.S. 122, 1988.

PAGE 95 *top:* Mark Dendy, *Torn.* Performance view at P.S. 122, 1987; pictured: Jamie Martinez, Chrysa Parkinson, Sara Perron, and Joni Weaver; *bottom:* Cathy Weiss, *A String of Lies.* Performance view at P.S. 122, 1995; pictured (from left to right): Cathy Weiss and Jennifer Monson.

PAGE 96: David Cale, *The Red Throats.* Performance view at P.S. 122, 1987.

PAGE 97: David Rousseve, *Colored Children Flyin' By.* Performance view at P.S. 122, 1990.

PAGE 98: Jerri Allyn, *Machine Scream.* Performance view at P.S. 122, 1986.

PAGE 99 *top:* O Vertigo Dance, *Up the Wall.* Performance view at P.S. 122, 1985; *bottom:* Sarah East Johnson and Audrey Kindred, *Wave, Cut, Notch.* Performance view at P.S. 122, 1993.

PAGE 100–103: John Kelly *pp. 100–101: Diary of a Somnambulist.* Performance view at Limbo Lounge, 1985. Sets by Huck Snyder; *p. 102:* storyboard illustrations for *Born with the Moon in Cancer*, 1986, copyright © 1986 John Kelly; "Dead, Dead, Dead," from *I Want Your Myth*, 1993, copyright © 1993 John Kelly; *p. 103:* The Dagmar Onasis Story. Performance view at Dance Theater Workshop, 1990.

PAGE 104 *(clockwise from top left):* Elliot Sharp, from the music series "The Hearings." Performance view at P.S. 122, 1990. Fast Forward, *The Caffeine Effect.* Performance view at P.S. 122, 1987. Guy and Tal Yardin, *Where My Home Is.* Performance view at P.S. 122, 1990.

PAGE 105 *(clockwise from top left):* Ann Magnuson with Bongwater, benefit performance for P.S. 122. Performance view at Irving Plaza, 1993. Jerry Hunt and Karen Finley, *The Finley-Hunt Report.* Performance view at The Kitchen, 1992; pictured: Jerry Hunt. John Zorn, *Cobra.* Performance view at P.S. 122, 1990. Dan Froot, *Jazz Section.* Performance view at P.S. 122, 1988.

PAGES 106–109: Karen Finley *p. 106:* "Our Beating Hearts," 1995, copyright © 1995 Karen Finley; *p. 107: I'm An Ass Man (Club Show).* Performance view at The Cat Club, 1987; *p. 108 (and front cover): The Constant State of Desire.* Performance view at P.S. 122, 1987; *p. 109: St. Valentine's Day Massacre.* Performance view at The Pyramid Club, February 14, 1989.

PAGES 110–111: Carmelita Tropicana *p. 110: Memorias de la Revolución.* Performance view at P.S. 122, 1986; pictured (from left to right): Jeep Ries, Carmelita Tropicana, and Peggy Healey; *p. 111: Greek Flames, Find Me A Virgin.* Performance view at P.S. 122, 1988.

PAGES 112–113: La Fura Dels Baus, *Suz/O/Suz.* Both performance views at Kaufman Astoria Studios, Stage G, 1991.

PAGES 114–117: Tim Miller *p. 114:* excerpt from "Civil Disobedience Weekend, or, Activism as Street Theater and Erotic Fairy Tale," 1992, copyright © 1992 Tim Miller; *p. 115 top: Buddy Systems.* Performance view at P.S. 122, 1986; *bottom: Post War.* Performance view at The Wilma Theater, Philadelphia, 1983; *pp. 116–117: Democracy in America.* Performance view at Brooklyn Academy of Music, 1984; pictured (from left to right): Mari DePedro and Carol McDowell.

PAGES 118–119: Eileen Myles, "The Troubador," 1994, copyright © 1996 Eileen Myles.

PAGE 126: Ann Carlson, *Mirage.* Performance view at Brooklyn Anchorage, 1994; pictured: Andrea Mills as "Aquila, The One-Winged Bird/Vegas Showgirl."

PAGE 128: Steve Gross, *Life Out of Bounds.* Performance view at P.S. 122, 1988.

BACK COVER: Tim Miller, *Stretch Marks.* Performance view at P.S. 122, 1990.

Aperture gratefully acknowledges the kind support of The Buhl Foundation and
Henry Buhl toward the funding of *Caught in the Act*.

Library of Congress Catalog Card Number: 96-83973
Hardcover ISBN: 0-89381-680-9

Francesca Richer, Designer
Kristi Norgaard, Designer
Terence Wight, Typography
Printed and bound by L.E.G.O. / Eurografica, Vicenza, Italy

The Staff at Aperture for *Caught in the Act* is:
Michael E. Hoffman, Executive Director
Melissa Harris, Editor
Ivan Vartanian, Editorial Assistant
Ron Schick, Executive Editor
Stevan Baron, Production Director
Helen Marra, Production Manager
Michael Lorenzini, Assistant Editor
Meredith Hinshaw, Production Work-Scholar

Aperture Foundation publishes a periodical, books, and portfolios of fine
photography to communicate with serious photographers and creative people everywhere.
A complete catalog is available upon request. Address: 20 East 23rd Street, New York,
New York 10010. Phone: (212) 598-4205. Fax: (212) 598-4015.

First edition
10 9 8 7 6 5 4 3 2 1

BOOK DESIGN BY YOLANDA CUOMO, NYC

ACKNOWLEDGMENTS

For the past thirteen years I've had the privilege to witness and become part of an amazing community of artists. They invited me in to photograph and document their work, and to them I owe the greatest gratitude.

I also wish to thank the administrators and curators of all the performance spaces, as well as every technical director and lighting designer and all the labor behind the scenes who created the context and backdrop for the work. I want to especially thank the P.S. 122 Community Center and the staff (past and present) of Performance Space 122. None of the work here would have been possible without the support and love of the many friends I consider my extended family who have kept me through the years.

The making of this book would not have been possible without the support of Beth Lapides, Karen Finley, Trevor Lloyd, and Brad Kessler. As to its production, I wish to thank Yolanda Cuomo, who conceived and created its form. I'd also like to thank Michael Hoffman and the entire staff of Aperture, Michael Lorenzini, and especially Ivan Vartanian who kept all the pieces together. I owe the most, however, to Melissa Harris, without whom this book would not exist. She gave birth to the project and nursed it along with her passion and commitment to both photography and performance art.

Finally, I'd like to acknowledge and commemorate those in the community who have died prematurely—most of them from AIDS. Some of them appear in this book. Most of them do not. Their disappearance, and our loss, is devastating, beyond words.

—DONA ANN McADAMS

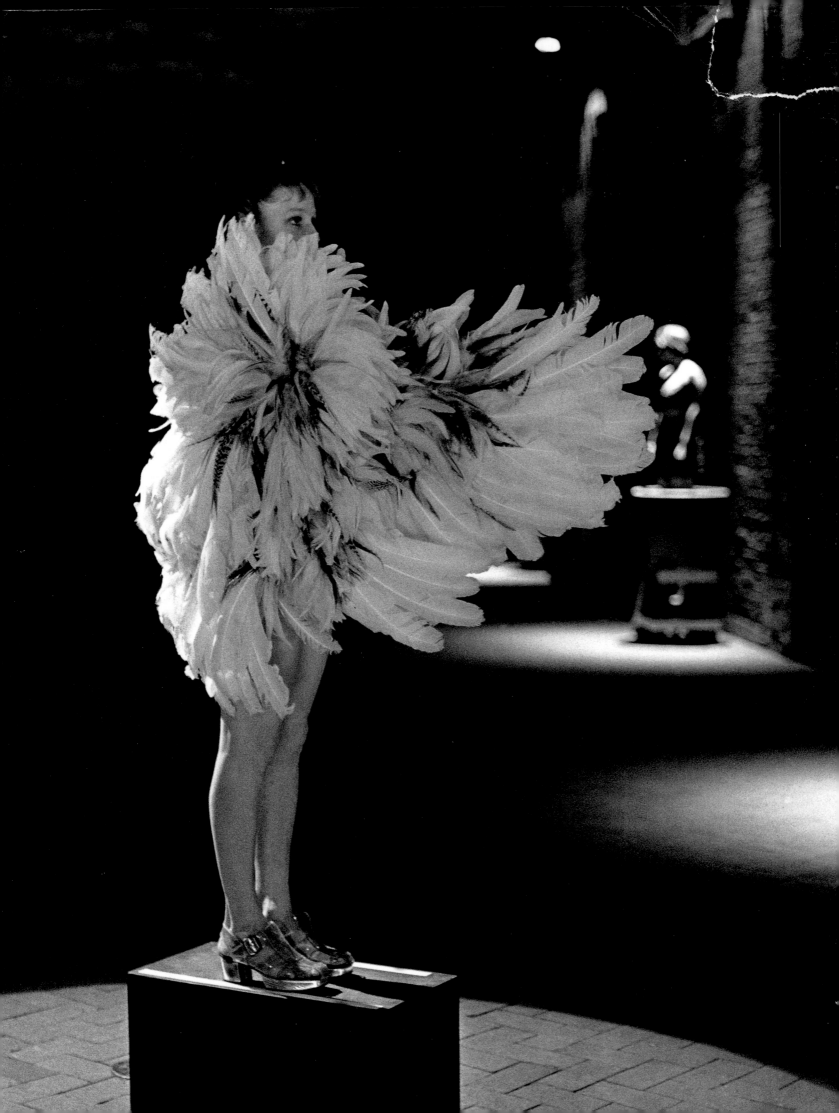